A School of Dolphins

Charles Avery

A School

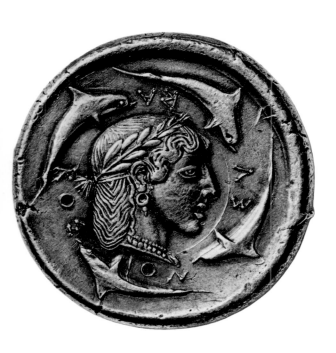

of Dolphins

On the cover: details from 'The Triumph of Galatea' by Raphael, in the Villa Farnesina, Rome, 1511 (Photo Scala, Florence)

On the endpapers: one of the 17th-century Dutch tiles on the walls of the kitchen of the Musée de l'Hospice Comtesse, Lille

On the title page: a silver coin from Syracuse, Sicily, 5th century BC

First published in the United Kingdom in 2009 by Thames & Hudson Ltd, 181A High Holborn, London WC1V 7QX

www.thamesandhudson.com

Copyright © 2009 Thames & Hudson Ltd, London

British Library Cataloguing-in-Publication Data
A catalogue record for this book is available from the British Library

ISBN 978-0-500-23861-5

Research by Anthony Ashby
Picture research by Georgina Bruckner

Designed by Derek Birdsall RDI
Typeset in Monotype Poliphilus with *Blado Italic* by Shirley & Elsa Birdsall

Printed and bound in Italy by Editoriale Bortolazzi-Stei srl

Contents

PROLOGUE

Man & Dolphin: Species in Harmony

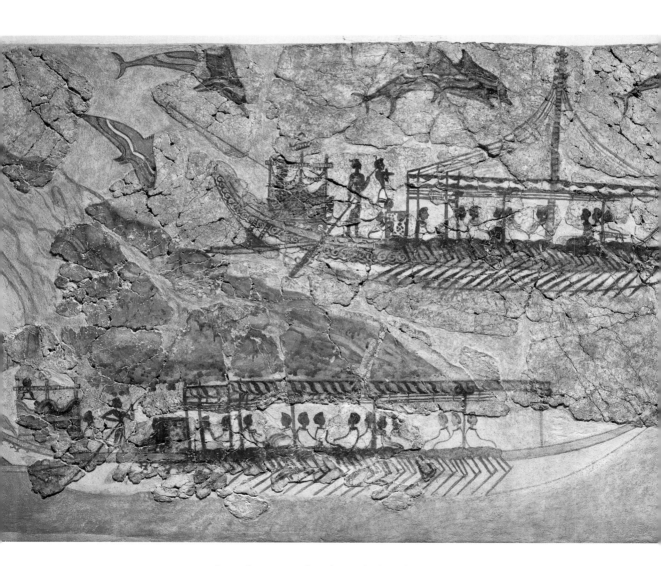

A fresco of c. 1500 BC from the Greek island of Thera, the missing parts restored. In covered pavilions on two galleys passengers elegantly seated opposite one another converse happily above the heads of the serried ranks of oarsmen, while prettily striped dolphins sport round them in a calm sea.

Where the dolphin loves to follow,
Weltering in the surge's hollow,
Dear to Neptune and Apollo;
By the seamen understood
Ominous of harm or good;
In capricious, eager sallies,
Chasing, racing round the galleys . . .

Aristophanes, *The Frogs* (translated by John Hookham Frere)

Our idea of the dolphin is today most likely derived from childhood visions of the creature in benign captivity in dolphinaria. There it is to be seen at close quarters, performing clever tricks, leaping from the water and plunging back into it to circle mysteriously in the depths: it responds to and communes happily with human beings. Later in life, as fortunate tourists, we can sometimes further our distant acquaintance with dolphins when cruising in the Mediterranean or other seas, as they skip in whole schools alongside ships, seeming to rally joyfully round the bows even of a powerful motor vessel. Their curious behaviour was brilliantly encapsulated (around 434 BC) by the Greek playwright Aristophanes in his comedy *The Frogs*, in which he puts the words above into the mouth of the dramatist Aeschylus. More prosaically, several centuries later, Pliny described the same noteworthy behaviour: 'It is not afraid of a human being as something strange to it, but comes to meet vessels at sea and sports and gambols round them even when under full sail.' The sudden appearance of dolphins literally 'out of the blue' was generally construed as benign and protective to the vessels that they chose to sport alongside.

A similar belief continued for a millennium or more, but dolphins were also thought to presage danger. On Saturday 27 May 1458, Gabriele Capodilista was cruising down the coast of Dalmatia in a Venetian galley, and just after they had passed Cataro (Kotor) they were becalmed and had to rely solely on the oarsmen. In the evening 'there appeared a huge quantity of dolphins which, as the sailors say, are ambassadors of some change of fortune at sea'. This proved to be true, for on the Sunday morning the dreaded scirocco rose, blowing against them from the south and 'lashing the sea into great waves that repeatedly broke over the prow and sides of the galley: about fifty of the biggest dolphins drew near, but the crew were not pleased because they feared even greater danger, seeing as they could not even find anywhere to shelter from the force of the contrary wind and they had to entrust themselves instead to the mercy and grace of God.'

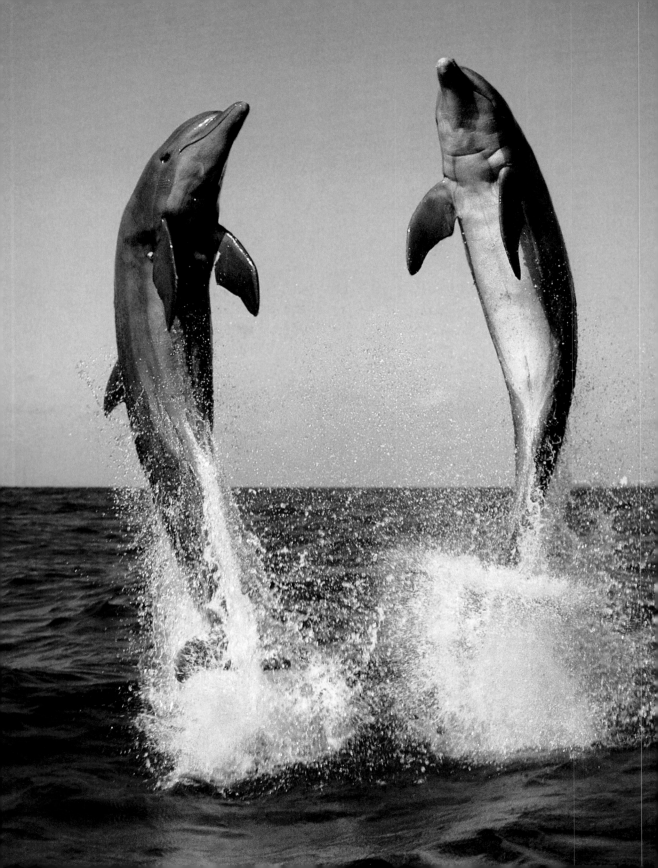

Nearly a quarter of a century later, on 13 June 1480, Santo Brasca, on pilgrimage to the Holy Land, had a similar experience: he was also sailing south with a following wind off the coast near Spalato (Split), 'where there appeared a very large number of dolphins, which came up behind the galley, jumping out of the water, which is said to be a sign of future danger. And so it came to pass.' Three days later, 'about sunrise, there appeared again some dolphins in still greater numbers than the first ones, and then suddenly there was a really great danger, such that, five miles [8 km] from Lesna, we had to turn back and take refuge between two rocks, and drop anchor about midday and wait there until Sunday morning on account of the danger caused by a terrible scirocco wind.'

The series of leaps that dolphins perform are of course partly occasioned by their need as mammals to breathe fresh air regularly, through a blow-hole on their back, before regaining momentum by paddling with their fins and strong tails, once back in the water. From the slow-moving and fragile craft of the olden days, their presence and antics would have been far more impressive, even awe-inspiring, than when viewed from above in the safety and comfort of a modern vessel. Aristotle in his *History of Animals* states of the dolphin: 'it appears to be the swiftest of all animals, whether marine or terrestrial. They will leap over the sails of large ships.' He repeats the surprising statement a few lines further on: 'And when they have to return from a great depth, they hold their breath, as if they were reckoning the distance, and then they gather themselves up, and dart forward like an arrow, desirous of shortening their distance from a breathing-place. And if they meet with a ship they will throw themselves over its sails.' (For Aristotle on the dolphin, see also p. 211.) It is hard to know what the height of such a leap might be, but bearing in mind the modest size of the craft of his day, it may not be impossible. In an early fresco from Thera – modern Santorini (p. 6) – dolphins indeed appear to be leaping over a ship, but this may be due rather to the artist's lack of knowledge of the rules of perspective.

The concept of a dolphin plunging dangerously downward at the end of such a leap led to its name being applied to a heavy mass of lead suspended from the bows of a war-vessel, to be dropped into an enemy ship at close quarters, to hole the hull: hence Aristophanes wrote in *Knights*, 'Let your dolphins rise high while the enemy is nearing' and 'Quick haul up your ponderous dolphins.'

Dolphins jumping vertically out of the water –
believed in the old days to be a sign of dangers to come.

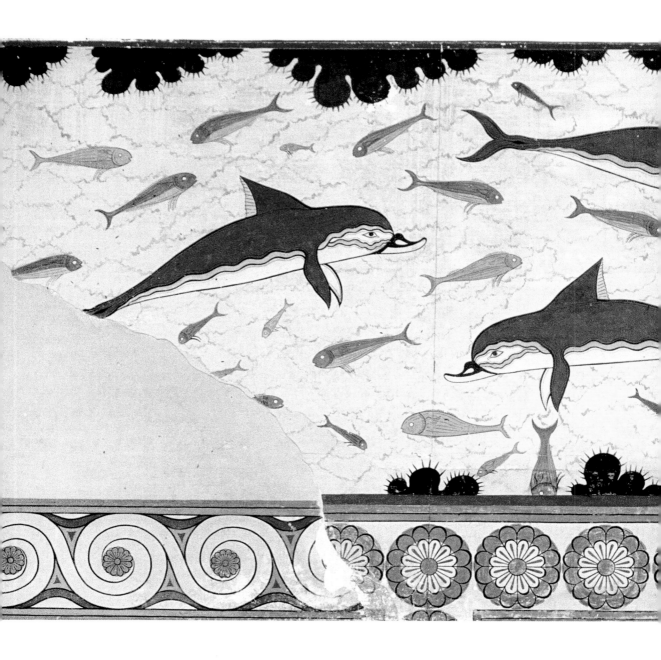

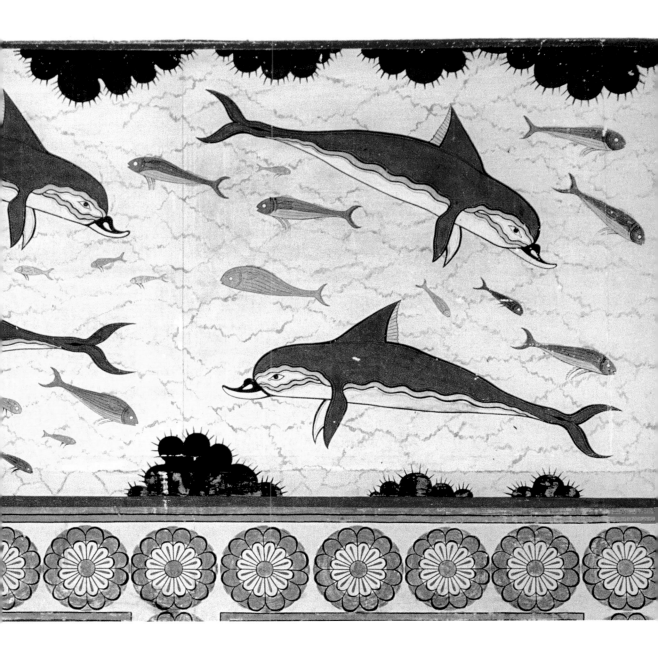

A gaily coloured fresco from excavations at Akrotiri on the island of Thera. Dating from the Bronze Age, it is a classic example of the visual culture disseminated from Knossos on Crete. Dolphins were evidently admired for their own sake in the seaborne civilization that developed round the islands and shores of the Mediterranean Sea.

That the seafaring ancient Greeks really observed dolphins carefully and admired them for their speed and agility is indicated by some extraordinarily realistic depictions, for example on frescoes and ceramic vessels produced under the Minoan maritime civilization around Knossos on Crete. The free flight of dolphins in mid-air as they seem to skip from wave to wave, and their tendency to swim in circles, were picked up by the potter-painter of a vessel from Thera. The borderline between ceramics and sculpture is permeable, as is shown by some dolphins modelled in three dimensions on another ancient vase. Later, a goldsmith was able to hammer thin gold sheet into a creditable likeness, as a pendant for an earring or a necklace.

François Chamoux has acutely observed that the Greek artists, who excelled in the portrayal of animals, marvellously captured the shape of this interesting creature: they rendered with success the curved body, the back arched in the act of jumping, the dorsal fin in the form of a scythe, the tail shaped like a crescent moon, the beak-like snout, the alive and expressive physiognomy and the powerful and supple form. The deliberate simplification of forms accentuates the decorative character of the animal.

Dolphin behaviour was admirably conveyed with bold curving brushstrokes on this kymbe by some prehistoric Picasso on the island of Thera, c. 1500 BC.

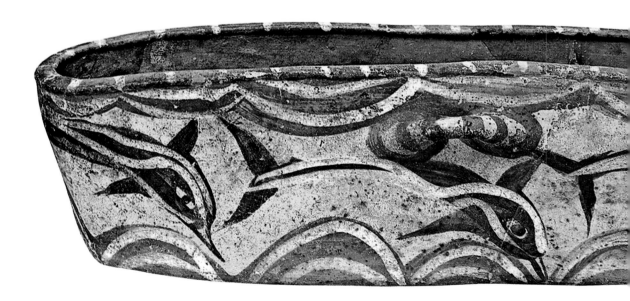

Dolphin pendant made by a Roman goldsmith in the Greek tradition.

Middle Minoan vase from Phaistos on Crete. The streamlined convex curves of dolphins plunging into the depths between shell-encrusted rocks, seaweed and waves are effectively modelled in clay.

The quasi-historical mariner-heroes of Greek legend appear with dolphins helping to set the scene of their exploits: for instance, on a Greek vase, a dark-coloured dolphin is to be seen nose-diving into the deep, between Odysseus/Ulysses, who has had himself lashed to the mast of his ship, and a siren on a nearby rock, whose tempting call would lead him to destruction.

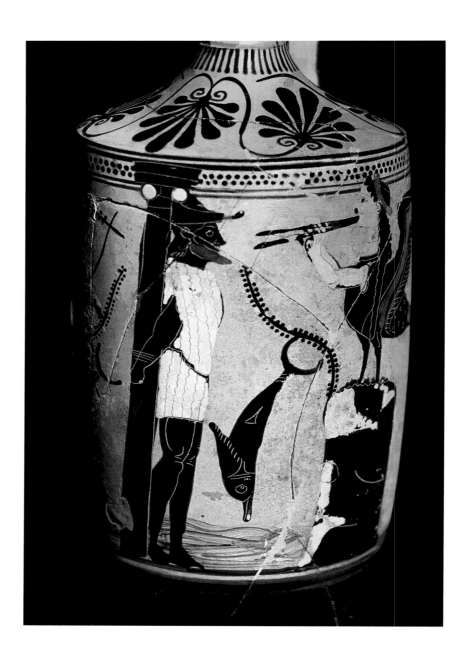

Recent research has revealed that the dolphin's empathy with us, which we in general reciprocate, is (as in the case of the elephant) the result not only of a shared biological descent, but also of a roughly equivalent size of brain in proportion to body-mass. Dolphins are of course not fish – though many later representations in areas where they are less familiar show them with scales – but mammals (i.e. they give birth not to eggs but to miniature creatures like themselves which they suckle), or, more strictly speaking, cetaceans. Aristotle was already well aware of this distinction: 'For the dolphin is a viviparous animal, wherefore it has two mammæ, not indeed above, but near the organs of reproduction. It has not evident nipples, but, as it were, a stream flowing from each side. From these the milk exudes, and the young ones suck as they follow the mother. This has been distinctly observed by some persons.' The *Encyclopaedia Britannica* tells us that 'The female brings forth a single young and is a devoted parent.' Like whales and seals, they gradually evolved from land animals – quadrupeds – into aquatic creatures.

As has recently been explained by Jean-Baptiste de Panafieu, 'Cetaceans, such as the whale and the dolphin, are the mammals most profoundly transformed by their adaptation to the marine environment. Their bones are spongy and rich in fat, which increases their buoyancy. The spindle shape of their body and the absence of hind feet make for a considerable reduction in water resistance. The dorsal fin is supported by a tight structure of connective tissue. The animal moves by vertical beating of the [tail] fin. Their arms are flattened into swim paddles, and serve mainly to sustain the body's balance. Cetaceans breathe through a blowhole, the nasal opening located on top of the head. This arrangement allows them to keep the head almost entirely submerged; they swim faster even as they expend less energy. The top of the skull, strongly concave, bears the "melon," a sac full of complex fats that focuses sounds emitted by the blowhole. These sounds project onto surrounding objects – fish, rocks – and their echo returns to the animal, channelled through the lower jawbone to the middle ear, whose small bones, the ossicles, have been profoundly transformed.'

A dolphin cavorts while Odysseus stalwartly resists siren-calls from a nearby cliff on this Athenian black-figure lekythos.

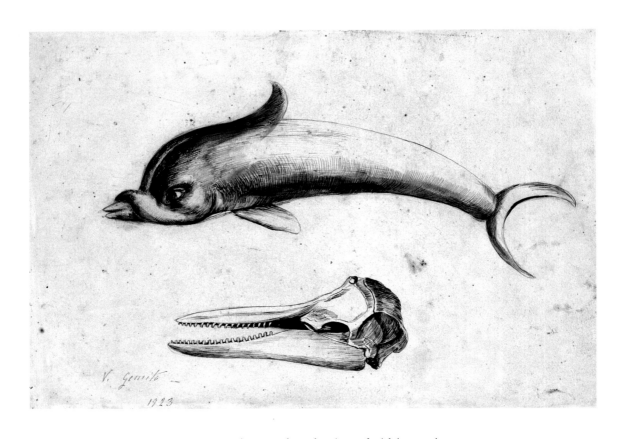

A comparison between a classical rendering of a dolphin — perhaps
a marble relief or terracotta model — and an actual skull, drawn
in 1923 in ink and wash by Vincenzo Gemito, the brilliant
draughtsman and sculptor of Naples. The contrast between the
suave, streamlined rotundity of the creature and the sharp, angular,
indented forms of its naked skull must have caught his attention.

A Greek pottery model of a dolphin, dating from c. 330–310 BC.

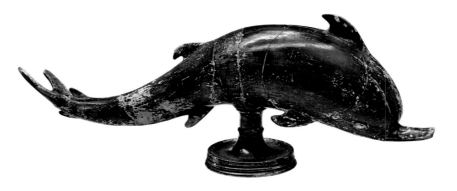

The backbone of the common dolphin (*Delphinus delphis*) of the Mediterranean and Atlantic is 6–8 feet (1.8–2.4 m) long and flexible. The concavity in the skull surprises, for the bulging forehead of the dolphin is one of the features that distinguish it from most fish: furthermore, we now know that it is full not of brain but of amazing natural radar equipment. The contrast in shape caught the attention of the Neapolitan sculptor Vincenzo Gemito when he was quite old, even though he had spent most of his life near the sea, in the Bay of Naples, drawing fisher folk from life. He must have seen the creature quite often, but here he drew the dolphin from a pre-existing – already stylized – work of art, probably an ancient Roman relief in marble or model in terracotta.

The elastic, curving back of the animal, especially when it leaps spectacularly in mid-air (p. 8), lends itself perfectly to encapsulation by an artist's eye within a circular or an oval shape such as a coin, cameo or gem, as well as on a convex surface such as a shield or vase. Dolphins feature on the coinage of Zankle and Argos and, interestingly, in the 20th century a dolphin also ornamented Italy's first post-war five-lire coin, reflecting, presumably, its Mediterranean habitat, as well as the general docility and benignity of the new republican regime. The goddess Athena is frequently shown with one, or sometimes two, dolphins on her shield: they feature on upwards of thirty of the surviving black-figure amphorae connected with the Panathenaic festival, as well as on a dozen or so of the slightly later ones painted with red figures.

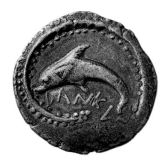

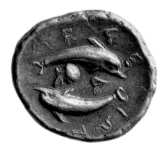

A coin of Zankle (modern Messina, in Sicily) struck around 500 BC shows a disproportionately large dolphin entering the sickle-shaped harbour of the city to the left. The crudeness of the lettering indicates the difficulty the engraver had in cutting his letters into the iron die.

A silver coin from Argos shows how, by around 370–350 BC, the designer could manipulate the shapes of his two dolphins into a harmonious composition, echoing the encompassing curve of the rim. (It resembles, if it did not inspire, the redesign of the logo of Thames & Hudson.)

Dolphins share with only a few other species of higher primates a capacity once judged to be unique to humans, indeed a distinguishing feature – that of altruism, especially in regard to a different species. Some lifeguards swimming off the coast of New Zealand were recently saved by a school of dolphins from a great white shark: this is a creature the dolphins themselves fear, but they circled tightly round the lifeguards at high speed for a considerable length of time – perhaps three-quarters of an hour – in order to repel the predator. There was no perceptible advantage to themselves.

This protective behaviour, circling ever more tightly in close formation swimming, has also been noted by artists throughout the ages. In the 5th century BC, some silver coins of Syracuse that were struck to commemorate a victory over Carthage bear creditably lifelike images. In one, a school of four dolphins seen from different angles circles tightly round the large profile head of the city's mythical foundress, the nymph Arethusa. This circling, as we now know, reflects their actual protective behaviour and may not be just an example of pretty artistic design.

An opposite visual effect, one of discord and panic, was achieved by a gifted Greek painter of pottery in Eretria around 500 BC: by the simple expedient of turning all the dolphins outward, so that their curves conflict with the enclosing circular rim of the cup, he managed to create a centrifugal, staccato, effect of alarm in this shoal as it is threatened by the outstretched, roving tentacles of two monstrous octopuses: maybe he had in mind the perennial struggle between Good and Evil. As we shall see, over the centuries, the dolphin accrued many meanings for the ancients, all of them positive, with only a few of which we are still familiar today.

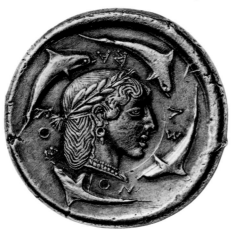

On this silver coin from Syracuse in Sicily dolphins circle protectively around Arethusa, whose magical fountain of fresh water, springing up near the seashore and surrounded by papyrus, one can still admire today. The designer has cleverly arranged the Greek characters of the city name, 'SY/RA/KOS/ ION', counter-clockwise inside the dolphins' path, perhaps to indicate how the creatures helped to protect it from the Carthaginians in 479 BC.

A phiale or drinking vessel from Eretria, of c. 500 BC, is decorated in superimposed colours – white for the four dolphins and two octopuses, and maroon for four further dolphins, which are also shown smaller, so as to look further away in the ocean deep.

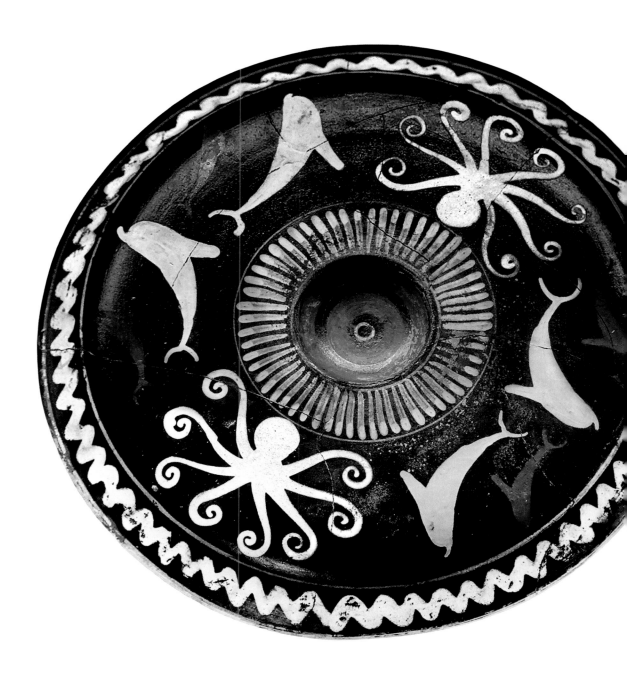

I

MYTHS, LEGENDS
& THE ORIGINS OF DOLPHIN LORE

The Boy on a Dolphin

> ...*parting day*
> *Dies like the dolphin, whom each pang imbues*
> *With a new colour as it gasps away,*
> *The last still loveliest, till – 'tis gone – and all is gray.*

Byron, *Childe Harold's Pilgrimage*

As has been remarked, dolphins suckle and nurture their young outside their own bodies. Aristotle noted: 'the young follow their dam for a long while, and it is an animal much attached to its offspring'. So the concept of love, or at least concern, being projected on to some surrogate young, even of another species – especially when wounded – does not seem beyond the bounds of possibility.

Their protective behaviour lends credence to a number of stories that circulated in the ancient Greek world about boys or men communing with, and being rescued from the sea by, dolphins. The variation of the *dramatis personae* from place to place suggests that these tales may recall actual occurrences – albeit rarely and at long intervals – in the waters of the Aegean and adjacent Mediterranean, where schools of dolphins were part of the common experience of the sea-going peoples of the coasts and islands.

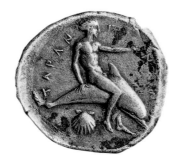

A silver coin from the Greek city of Tarentum in southern Italy, struck around 344 BC, shows Taras, mythical founder of the city, jauntily astride a dolphin in mid-air, above a scallop shell.

The best-known story (see pp. 212 and 213-14) tells how a dolphin became so friendly with a boy playing near the water's edge that it allowed him to ride on its back – presumably clinging for dear life to its dorsal fin, for its streamlined sides would be slippery with water and would afford little purchase to the knees or feet. One can imagine that an agile fisherboy or, as in some stories, a young athlete might briefly have managed such a feat, with the cooperation of a dolphin that had become accustomed to his swimming alongside. Nevertheless, as in all extreme sports, danger is part of the thrill, and in some of the variations on the theme the boy dies, or is accidentally speared on the dorsal fin (though this is not really possible), whereupon the dolphin somehow manages to convey the little corpse back to land, seemingly in mourning, and then expires beside it, or at least makes a habit of revisiting the spot thereafter.

In Aelian's account of the tragic ending, the people of the boy's town, Iassus, raised a double tomb for the innocently amorous pair, with a sculpture on top showing the handsome boy riding on the dolphin, and 'struck coins of silver and of bronze and stamped them with a device showing the fate of the pair and they commemorated them by way of homage to the operation of the god who was so powerful'. The god was of course Eros (Cupid), of whom more anon. The sculpture may have been carved out of marble or – more likely in view of its probable shape – cast in bronze, but no such example has survived from Antiquity. However, the coinage of Tarentum (modern Taranto, on the 'instep' of Italy) is indeed struck with the image of an athletic youth riding on a dolphin and sometimes not even holding on.

The image of a man riding on a dolphin as though it were a horse is so appealing that it travelled right across Europe, from Greece to Denmark, to reappear in an artistically unsophisticated version that was hammered out on the surface of the Gundestrup Cauldron, where apparently it has something to do with the story of the stag-god Cerunnos (overleaf).

The idea that such 'human' behaviour on the part of a dolphin might be represented in art out of gratitude also inspired a variant of the story which was told at Zacynthus, to the effect that Telemachus, son of the great seafarer Odysseus, once fell into the sea as a child, but was rescued by a dolphin. In gratitude, Odysseus commemorated the miracle by having a dolphin depicted on his shield, as well as on his signet ring.

This northern Celtic or Gallic 1st-century AD rendering of the boy on a dolphin is on a copper cauldron plated with silver and gold that was found in the moor near Gundestrup in Jutland.

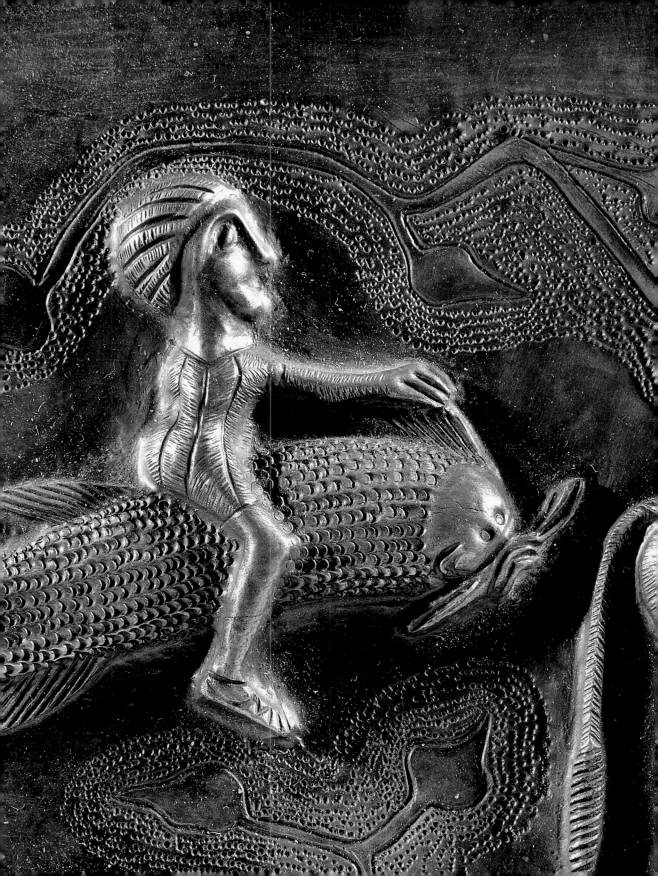

Over a millennium was to pass before a sculptor again addressed the theme of Aelian's tale, and then under slightly sinister circumstances. In the age of the Grand Tour British noblemen were keen to acquire examples of Graeco-Roman statuary as ornaments that would attest to their degree of education and taste. These they displayed in their country houses, in grand halls, libraries or specially constructed galleries. In fact anything with an ancient subject was welcome. So when in the 1760s one of the most talented and best-known restorer-dealers in Rome, Bartolomeo Cavaceppi, came up with a luscious-looking marble group whose subject was clearly Aelian's boy on a dolphin, whose designer was purported to be no less an artist than Raphael, and whose carver was said to have been his associate on the Chigi Chapel in Santa Maria del Popolo, Il Lorenzetto, there was great excitement among the 'milordi' and their agents. The sculpture depicts a plump infant boy with legs crossed and arms outspread, lying on his back and as it were cradled in the curls of a scaly dolphin, with his right foot resting neatly on a fin of the tail and his head falling backwards beside its head. The mouth of the creature – which is stylized in the classical manner rather than realistically depicted – is open with its teeth showing, and its large, protuberant eyes are open wide, presumably in anxiety at the death that it has accidentally caused.

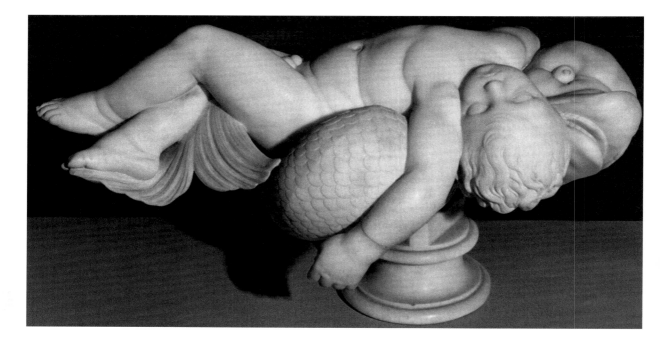

So far, so good: but today the story of the sculpture's origins during the High Renaissance is severely doubted, and it is held to be a clever forgery by the unscrupulous Cavaceppi himself, perhaps based in part on some classical original, such as a gem. Nevertheless, it fooled everyone until the end of the 20th century, and curators at the Hermitage Museum in St Petersburg (whither it arrived through purchase by the Empress Catherine the Great from the English collector Lyde Brown) are understandably still loathe to let go of their 'Renaissance masterpiece' and admit that it was run up some two hundred and fifty years later with the deliberate intention of deceit. So convinced were Cavaceppi's British 'connoisseur' contemporaries that they were falling over themselves to acquire copies, which were manufactured by an impoverished English sculpture student, Joseph Nollekens, who was visiting Rome to further his knowledge and to hone his technique under Cavaceppi. First in the queue was the 2nd Viscount Palmerston, on the advice of the painter Gavin Hamilton, while after him were the Earl of Exeter (for Burghley House); Earl Spencer (for Althorp); and the Earl of Bristol (his version is now at Ickworth). Other marble copies also exist, while the actor David Garrick owned a terracotta and the painter Anton Raphael Mengs a plaster cast. Thus the serial reproduction of Cavaceppi's forgery served to make a name for Nollekens, who returned to London in 1770; while the spread of his copies in the United Kingdom made it the best-known image of a dolphin and gave renewed circulation to Aelian's romantic tale.

This marble carving of Aelian's tragic tale of a boy who was accidentally speared to death on the dorsal fin of a dolphin with which he used to play caught the public imagination in the mid-18th century, because it was supposed to have been designed by Raphael: in fact the 'original' in St Petersburg is a forgery made c. 1762-64 by the Roman sculptor Bartolomeo Cavaceppi, while this copy is by an assistant from London, Joseph Nollekens.

On the north bank of the River Thames in London, opposite Albert Bridge, there has stood since 1975 another remarkable sculpture depicting a boy with a dolphin. Unlike the compact, funereal, group of dead child and mourning dolphin carved out of marble by Nollekens, this group by David Wynne was modelled for casting in bronze, and so its sculptor was able to exploit the tensile strength of metal to create a joyous, centrifugal flow of lines, notably in the boy. Hanging on for dear life to the dorsal fin, he appears as though flying through the air — or is he being drawn down into the depths of the ocean by his powerful, streamlined friend? The model for the sprightly boy was the sculptor's own ten-year-old son, Roland: by a tragic irony this was to become his memorial, for he died, still relatively young, in 1999 and so the classical image has been given a new poignancy.

The power, speed and benign nature of the dolphin are thus celebrated in the cold northern climate of London.

David Wynne's cleverly contrived group of a boy supported by one hand on the back of a dolphin, of 1975, stands on Chelsea Embankment in London.

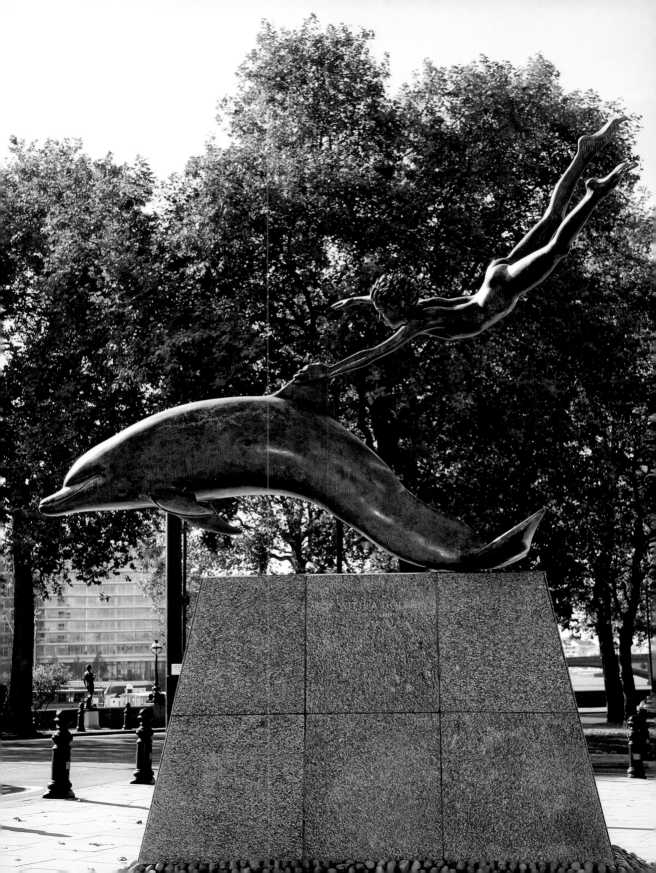

Arion & the Dolphin

'Like Orion on the Dolphines backe'

Shakespeare, *Twelfth Night*

A favourite variant of the dolphin-rescue story features, instead of the boy, an adult, a musician-poet by the name of Arion. Eunice Burr Stebbins, a diligent student of delphinology, summarized it in her doctoral dissertation of 1927: 'The best known literary record of Arion is the lyrical fragment which purports to be a first hand account of the rescue of the traditional inventor of the dithyramb by dolphins that conveyed him to Cape Taenarum, after pirates had boarded his ship and compelled him to throw himself into the sea. This story is also the most famous of the anecdotes about the dolphins' love of music, for it was the sound of Arion's song to the lyre that attracted his rescuers.' Herodotus sets the story in a historical context, but this seems not to be justified. The Roman fabulist Hyginus also connects Arion with Periander, ruler of Corinth, but he allows the god Apollo a role, first by warning Arion that he is about to be betrayed by the sailors and later by setting Arion and the dolphin among the stars, where constellations still bear their names (Orion and Delphinus) today.

The interest of this myth for us lies in the alleged fascination of the dolphin with man-made music. Might this not be a reflection of the fact that the animal has extremely good and long-range hearing, communicating a wide variety of messages or emotions by emitting high-pitched squeaks underwater? It also navigates by picking up echoes that bounce off its surroundings, like modern radar systems. Could Greek mariners have observed that if they played their pipes, dolphins were attracted by the unfamiliar sounds towards their boats?

In any case, in classical and Italian Renaissance art Arion was viewed as the marine equivalent of Orpheus, who entranced land-animals with the music of his lyre. An image with an alternative instrument shows him curly-haired and naked, save for a pearl necklace slung rakishly over one shoulder and round his body, clasping his knees tightly round the flanks of his marine mount and playing a flute with his daintily extended fingers. Is the upward turn of the dolphin's head, i.e. of its hearing apparatus, meant to indicate that it is listening attentively, even perhaps ecstatically?

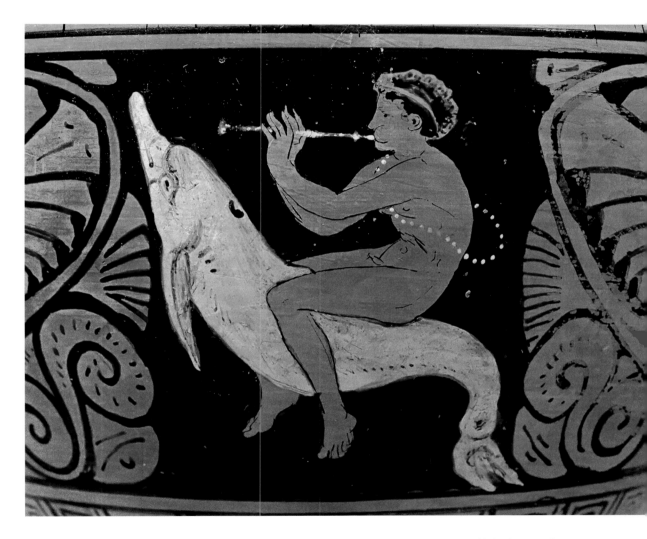

Arion's golden-brown skin is rendered characteristically by the reserved terracotta of the earthenware vessel; the dolphin, to distinguish it, is pale, with some internal detail painted on top, so as to suggest its three-dimensionality. This red-figure stamnos, from the 'Alcestis Group' of vases, was produced around 360–340 BC in Etruria, in central Italy.

Predictably in the Italian Renaissance Arion became a popular hero in view of his musical and poetic ability – a model for cultivated man in that New Golden Age. For instance Filippo Maserano chose him for the meaningful representation on his personal medal of 1457 by the Venetian medallist Giovanni Boldù: there on the reverse Arion is shown semi-nude and laurel-crowned, with his mantle flying over his shoulder, riding over waves on his dolphin.

In the tale as told by Hyginus Arion was eventually accorded justice against his captors by King Periander, who went on to erect a monument to the rescuing dolphin – a lost work of art, if ever it existed. His action illustrates the example of a good ruler who protects his subjects. This may be why, centuries later, Arion was accorded no fewer than two of the triangular compartments in the masterly fresco cycle in the Camera degli Sposi of the Ducal Palace in Mantua by Andrea Mantegna – to associate his patron, Francesco Gonzaga, with Periander's virtue, as well as with his implicit patronage of the arts, especially music and poetry. Arion is made the equal of other mythological heroes – Orpheus, the musician and like Arion a player of the lyre, and Hercules, who personified instead the force which a ruler must occasionally use to protect his people. Mantegna put the awkward shape of the field to good advantage, using the apex to contain Arion's head and the spreading foot of the triangle to depict the seaborne dolphin.

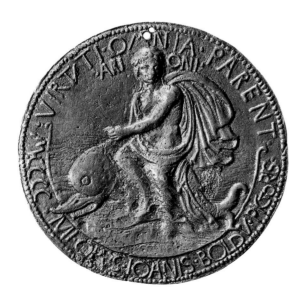

Reverse of the medal of Filippo Maserano, designed and cast in 1457 by Giovanni Boldù. It bears the artist's signature and the inscription 'VIRTVTI OMNIA PARENT' (All things are clear to virtue).

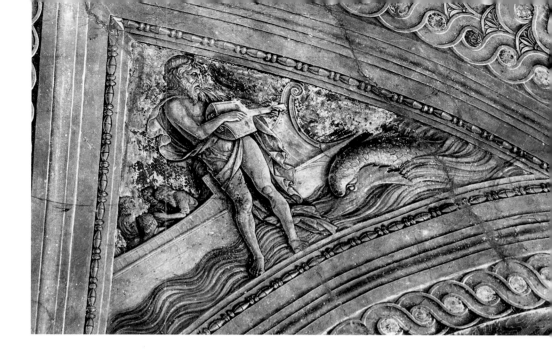

Mantegna created a fictive Roman architectural setting for his famous fresco cycle in the
Camera degli Sposi in the Ducal Palace at Mantua of c. 1465-74, depicting the court of
Francesco Gonzaga in gay, contemporary costume. On its ceiling, between classical
bead-and-reel mouldings he painted fictive reliefs celebrating ancient heroes, including Arion.
In one scene, pirates plot in the galley behind while Arion appears to walk Christ-like on
the waters, as his dolphin is drawn to his rescue by the strumming of his lyre. In the other,
Arion looks back with relief as he escapes his captors at high speed on his novel form of lifeboat.
Mantegna takes pleasure in melding the sinuous shape of the dolphin and its thrashing tail
with the undulations of the water that, like a wake, serve to indicate the dolphin's speed.

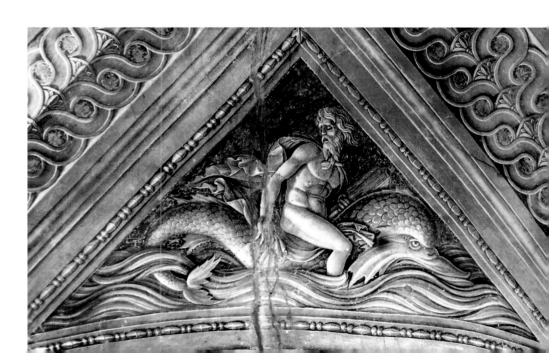

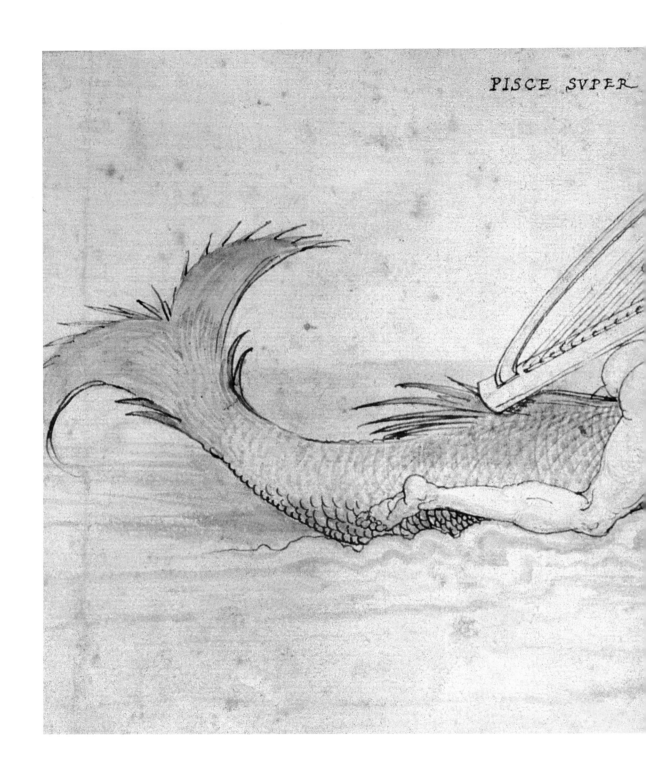

VO VECTVS CANTABAT ARION

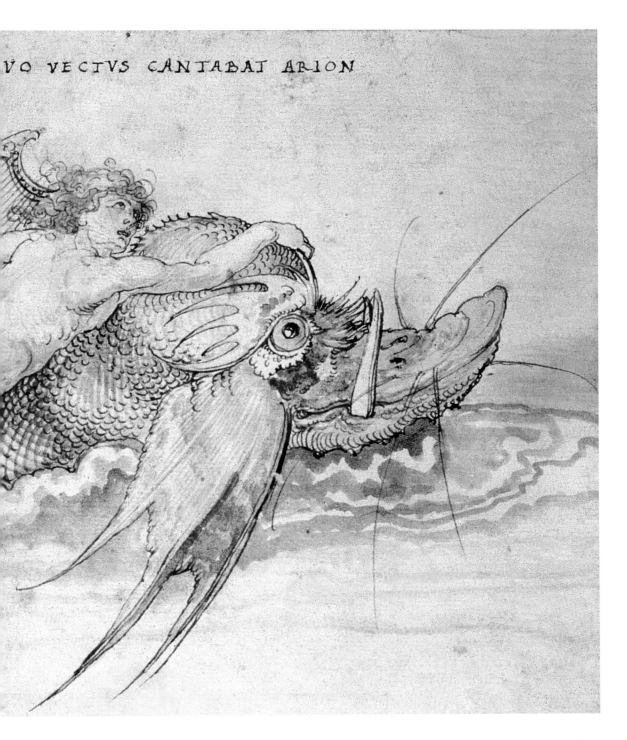

*In this watercolour of 1514 Albrecht Dürer dramatized Arion's
miraculous rescue by the fierce-looking but benevolent dolphin.*

Across northern Italy, in the university city of Padua, Arion was accorded the signal honour of an individual bronze statuette by the famous Renaissance sculptor Andrea Riccio (now in the Louvre). He is strumming his lyre and singing for all he is worth, while seated on an ornate pedestal from which protrudes a dolphin, but it is so diminutive as not to merit illustration.

Meanwhile the Renaissance was reaching southern Germany, whose greatest painter, Albrecht Dürer, visited Venice to catch up with what was going on there in the art world. Presumably a result of this – and maybe even of an unrecorded visit to Mantua, not far away, to see the Mantegnas – is his magnificent watercolour of Arion clinging to the bulging forehead of the dolphin, his other arm hooked through the strings of his precious harp-like lyre (pp. 32-33). Dürer contrasts the rescuing dolphin's fierce appearance, with whiskers and elephant-like tusks, with Arion's beautiful body and head, tilted back to sing: for the inscription – in learned Latin – tells us, 'Arion was singing as he was carried on the curve of the fish'.

Thereafter, from the mid-16th century, the image of Arion serenely playing his instrument on the back of a pacific beast, sometimes even being able to stand up on its back so gently does it swim, became standardized, usually in connection with the calming effect of music. For example, in 1628, a German engraver combined a picture of Arion as an elderly, bearded king (rather like Neptune) riding on a super-sized dolphin with a fleet of German merchantmen, in front of a view of Calicut in India, as a subsidiary label tells us. The main Latin heading, however, reads in translation, 'Music calms even the ferocious monsters of the sea', while a line of Latin poetry and its translation into German doggerel below tell us that Arion regained his homeland safely partly thanks to wonderful music: it is as though the message of the ancient story has been deflected into a different direction, with Arion setting out merely to tame a sea-monster (which this image to some extent resembles), rather than being rescued from death by a benevolent and sympathetic fellow-mammal.

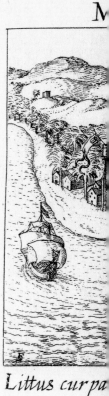

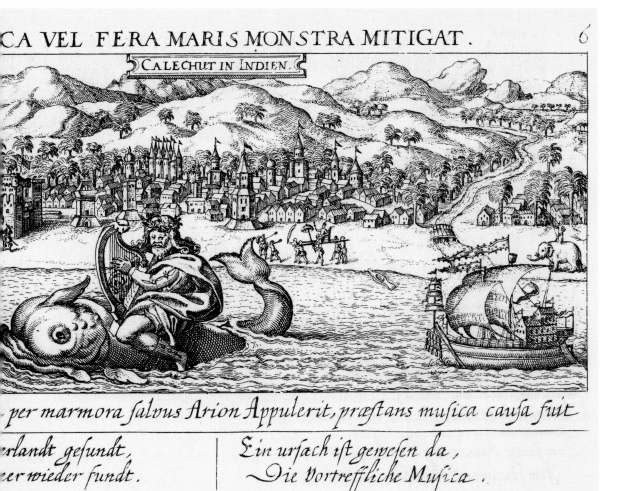

CA VEL FERA MARIS MONSTRA MITIGAT. 6

CALECHUT IN INDIEN.

...per marmora salvus Arion Appulerit, præstans musica causa fuit

...rlandt gesundt, | Ein ursach ist gewesen da,
...er wieder fundt. | Die vortreffliche Musica.

Arion and the dolphin appear offshore of Calicut, on the west coast of India, in
Daniel Meisner's 'Thesaurus philo-politicus, das ist: Politisches Schatzkästlein',
a collection of topographical views with emblematic features in the foreground
published at Frankfurt-am-Main by Eberhard Kieser in 1628.

Meanwhile, the image of Arion and the dolphin was chosen for his printer's mark by Johann Oporin of Basel, just as the dolphin and anchor had been chosen as his emblem half a century earlier by Aldus Manutius of Venice (see p. 117). However, Oporin was not content with a standardized trademark, like a common merchant or artisan, but commissioned his blockmaker to create imaginative variations on the theme over the years for his various titles. Earliest, in 1543, Arion (his name labelled above) appears playing a harp and crowned with laurel to denote his victory in various ancient Greek music competitions: his docile, though ferocious-looking, dolphin has its mouth wide open and tongue moving, perhaps to indicate that it is singing to Arion's tune. The picture is surrounded by Latin tags, seemingly as mottoes: above, 'The Fates find a Way'; below, 'May I escape from Unwanted Pirates' (perhaps a reference to piracy among book publishers in Oporin's day); and running up and down on either side: 'No Way is Impassable to Virtue'.

Fata uiam inueniunt.

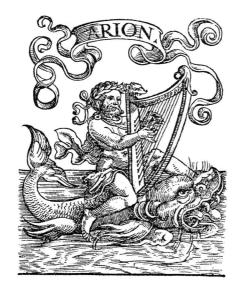

INVIA VIRTVTI

NVLLA EST VIA.

Inuitis piratis euadam.

The colophon that Johann Oporin used in Juan Luis Vives, 'De veritate fidei Christianae', printed by him in Basel in 1543.

A variant of the theme of Arion and the dolphin appears in the colophon Oporin used when he printed the second part of John Bale's 'Scriptorum illustrium maioris Brytanniae Catalogus' in Basel in 1559. Two years earlier, for the first part of Bale's anthology, he had used a less sophisticated, distinctly more Germanic-looking, rendering of this interpretation of the theme: Arion is laurel-crowned, but clad in a girdle of fig-leaves, for all the world like a traditional Adam.

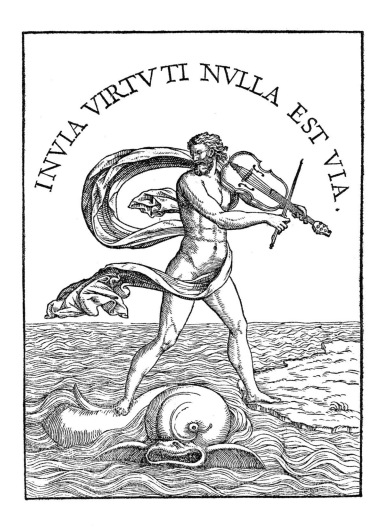

The last motto reappears like a rainbow above a more elaborate and more classical rendering of Arion stepping ashore from the dolphin's back as he plays a violin, which Oporin used in 1559, on the title page of an anthology of the writers of Great Britain by John Bale, Bishop of Ossory.

Not many decades after the publication in Latin of these great tomes on British authors, one to become still more celebrated than most of them, William Shakespeare, included in his play *Twelfth Night* a simile that shows he was familiar with the classical story: the shipwrecked hero, Sebastian, binds himself to a floating mast and appears 'like Orion on the dolphin's back'. (Either Shakespeare or his printer made a mistake over the spelling of the name.)

Arion remained a popular theme, partly on account of the interesting variations offered to an artist by the sinuous form of the dolphin: a monumental sculpture projected for the gardens of Versailles late in the 17th century used it to embody the mutation of two of the Four Elements, air and water, with the dolphin appearing to skim over the surface of a pool of real water; while a century and a half later, also in France, a designer of an ormolu mantel-clock flicked the tail up into an S-bend to accommodate the clock-face (which bears a picture of Venus seated in her scallop-shell), while Arion, playing his lyre and being hurled off his rescuer's back, has been transmogrified into Cupid by the addition of wings – which are spread to break his fall into the notional waters below. This elegant caprice belongs to the tradition of the dolphin-support, which is the theme of a later chapter, while the transmutation of Arion into Cupid leads us to consider the latter in his role of the 'boy on a dolphin'.

As late as the mid-19th century, under King Charles X of France, a clockmaker could rely on his clients' knowledge of the classical myths of Arion, Venus and Cupid to rationalize his curious, eye-catching design.

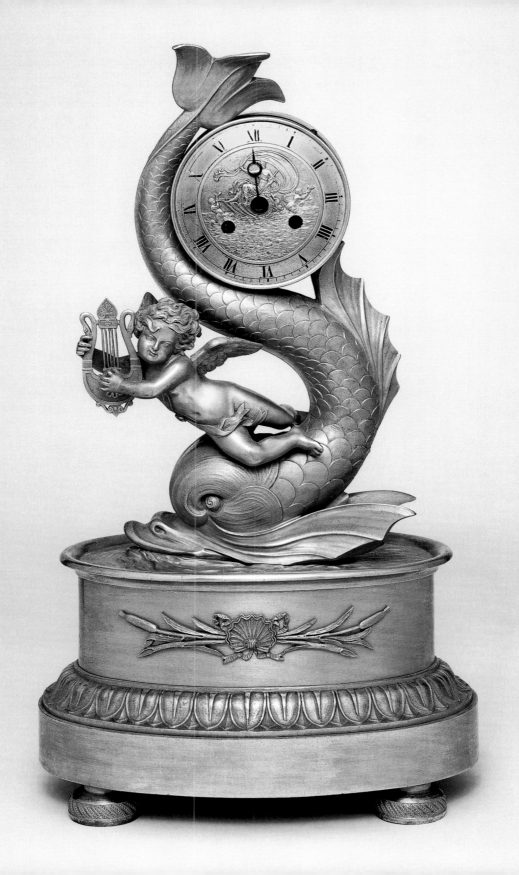

II

GODS & DOLPHINS

Cupid on a Dolphin

In the imagery of the Hellenistic period, the boy on the dolphin's back is often given wings, which transform him from a human being into the harbinger of love, Eros or Cupid. Son of Aphrodite/ Venus, goddess of love, he is inevitably associated with the friendly creatures which, according to myth, helped to bring her to shore, after she had been born out of the foam of the sea, propelling her on an outsize cockle-shell, like horses drawing a chariot. Typical is the delicate design picked out in clay-coloured and white slip, with yellow outlining of details, on a black-glazed ewer. Whereas in a rendering of Arion and the dolphin of almost the same date (p. 29) Arion is dark and the dolphin pale, here Cupid is white, perhaps to denote the pale colour of infant skin, while the dolphin is pinkish-brown. Cupid is shown confidently astride his mount (like a bareback, stirrup-less, classical horse rider). He is crowned with pearls amidst his golden hair, while he extends in his right hand twin circlets of pearls (or a single strand looped twice) above the dolphin's head – pearls being of course a luxury product of the sea. A series of curved and paired white brushstrokes below them indicate ripples on the sea's surface: they are meant to be leaping through the air in characteristic fashion. Related vases sometimes show as a pretty pair to this design one of Aphrodite/ Venus riding on a swan.

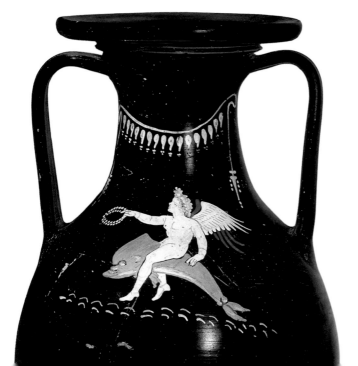

Cupid appears as a comely youth with well-defined muscles, but with a graceful elegance that would have appealed to a lady of the period, on a fine pelike produced in a Greek settlement in the region of Matera in southern Italy, c. 330-320 BC.

Cupid and the dolphin on a bronze mirror-cover of c. 380 BC from Corinth.

Of slightly earlier date, from Corinth in mainland Greece, a still older and even more confident Cupid, seated backwards on his dolphin and with his feet trailing in the waves, decorates a decidedly feminine utensil, a mirror-cover. Though he has a cloak thrown over his raised arm – in which he holds his mother's symbolic love-bird, the turtledove – the naughty boy reveals his manhood at the centre of the disc. On the polished metal surface behind, its owner could descry her own features and arrange her hair and make-up, while dreaming of the love promised by the image of Cupid tantalizingly depicted on the other side.

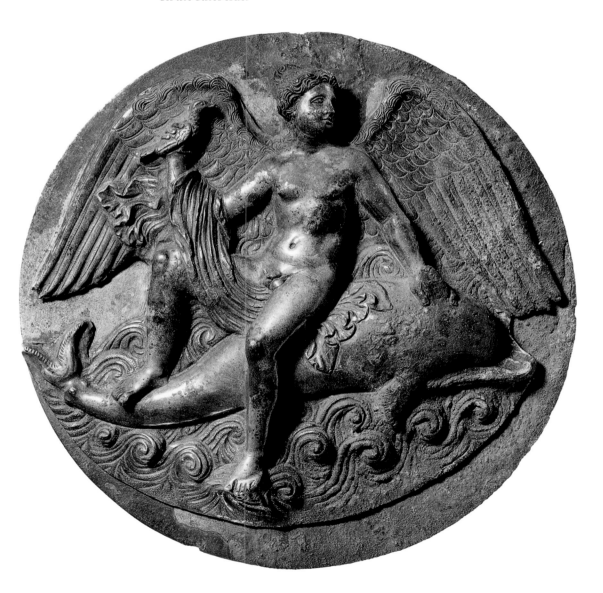

Speed and concentration characterize the action of an entwined pair of dolphins that a tiny, standing Cupid is attempting to control with elaborate harnesses composed of strings of pearls, framed in a triangular field above a wave pattern in a floor mosaic on the island of Delos: he may also be doubling up as the spirit of their master, god of the sea, Neptune/ Poseidon. As François Chamoux has pointed out, what three centuries earlier was a scene charged with deep religious significance had become a simple decorative theme. Three centuries later still, his efforts are echoed in a fresco at Pompeii that shows Cupid – rather improbably – riding on the waters in a baby racing chariot, leaning eagerly forward as he whips his errant, aquatic steeds onwards. The wavering lines of whip, flying ribbons and bridles, laid on by a hand as rapid and confident as Picasso's, marvellously convey the impression of wind, waves, motion and all the excitement of a real chariot race in a Roman stadium.

The artist of this mosaic on the island of Delos in the middle of the Aegean Sea must have known his dolphins very well, for he adroitly represents their playful leaping and acrobatic intertwining as they skip through the waves. On the floor of the main room of the House of the Dolphins, it dates from the 2nd century BC.

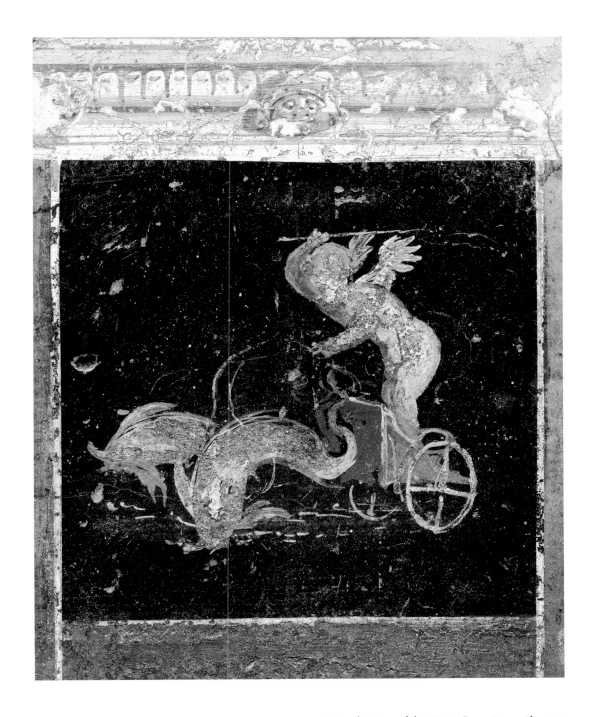

From the House of the Vettii in Pompeii, a seaside resort of the Romans at the foot of Mount Vesuvius, this deftly delineated fresco of the 1st century AD plays a variation on the theme of Cupid controlling dolphins.

Quantity, rather than quality, of imagery marks an apsidal mosaic floor
from the period of the late Roman Empire in Tunisia. Perhaps the designer
had in mind a *naumachia*, or artificial sea-battle, such as used occasionally to be
staged in Roman arenas. The design has a naïve, cartoon-like quality, as the
artist rehearses every imaginable variant of the standard theme of Cupids on –
and off – a dolphin. Some fight each other, others clamber on or tumble off,
while one, in the centre foreground, swims happily alongside his former
mount. Sea-anemones, crabs, eels and fish fill every gap in this manically
crowded composition.

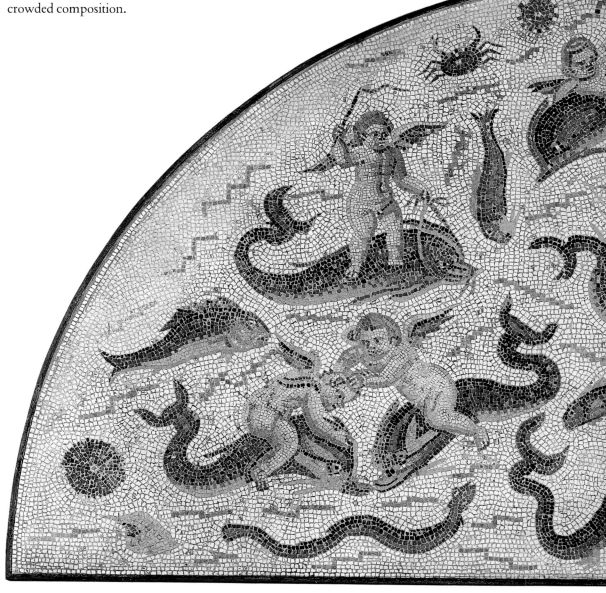

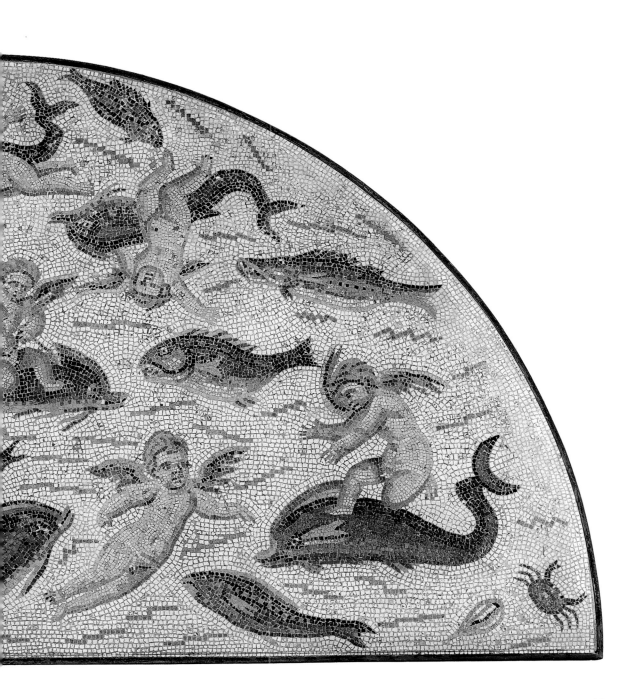

The motif of Cupid on a dolphin lived on well into the Christian era in Rome. It features, for instance, in a great mosaic in the apse of San Clemente, created in the 12th century; but its position there seems, surprisingly, to indicate that it was deemed to embody some kind of monstrous demon, rather than a charming and benign presence, as it would have done in Antiquity.

This pot-bellied rendering of Cupid in the apse of San Clemente in Rome may betray the designer's incapacity to copy accurately an ancient prototype, or more probably in this Christian context may be a deliberate deformation to suggest the presence of paganism, and hence of evil.

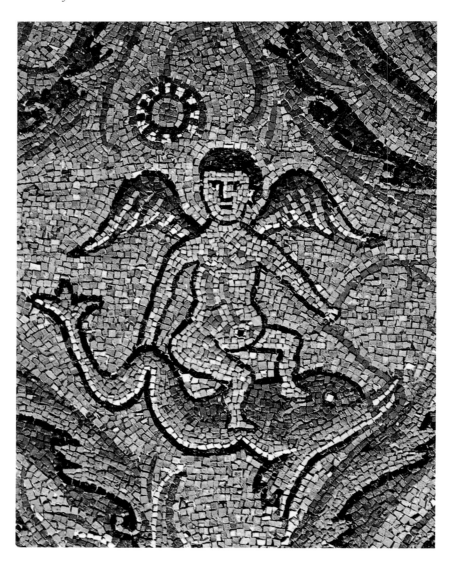

On this bronze lamp of c. 1507-10 by Andrea Riccio the ornamental dolphin ridden by Cupid forms the lid of the oil reservoir.

A medallic image such as a Roman coin of 74 BC, struck with a charming image of the god of love in miniature, riding his bucking dolphin with the help of a bridle, must have been shown some fourteen hundred years later by a humanist professor at Padua University to the bronze sculptor Andrea Riccio (whom we met in passing as author of a statuette of Arion). He incorporated the idea in three dimensions, but still on a minute scale, as the handle of the lid of the reservoir for oil on a boat-shaped lamp: he also engages our attention by turning Cupid's head (his mouth open, as though gasping for breath or in excitement) to face us, while the dolphin's head is enhanced with ornamental acanthus leaves, like some aquatic 'green man'. Dolphins also appear elsewhere in Riccio's work, though none so prominently – for instance, all but indecipherably, amidst the curlicues on the elaborate ornamental helmet of his masterpiece, the Leonardesque statuette of a *Shouting Horseman* (in the Victoria & Albert Museum in London). Perhaps it is there to symbolize the speed of a light cavalryman's attack, or to identify him with the god of war, Mars, bearing a favour from his mistress, Venus.

Last of our selection of images from Antiquity – though by no means chronologically so – is a bronze sculpture whose composition presages in miniature a Renaissance statuette designed to function as an inkwell, created a generation later than Riccio. The backward-leaning figure on a dolphin, found beneath the sea at Ephesus, on the west coast of modern Turkey, and of undefined date, recalls the pose of Cupid on the Roman coin mentioned earlier. The inkwell, on the other hand, dates from the period of Italian Mannerism and is attributed to a Roman sculptor, Taddeo Landini, on account of the similarity between the open, athletic poses of its boy and of Landini's four almost life-size youths, with their feet resting on dolphins, who support the bowl of the Fountain of the Tortoises in Piazza Mattei, Rome (see pp. 180-81).

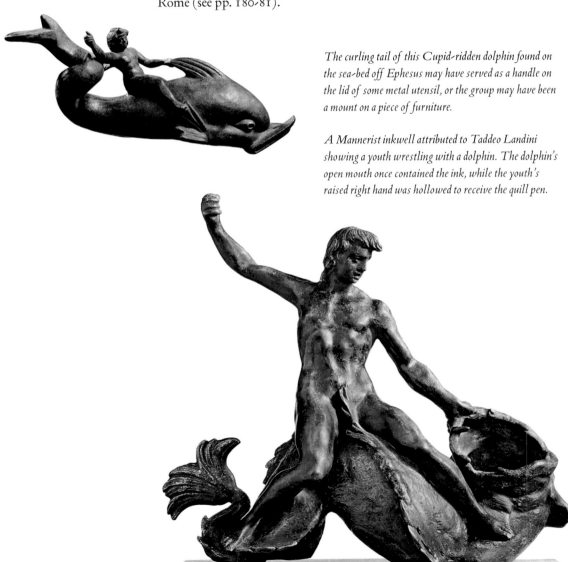

The curling tail of this Cupid-ridden dolphin found on the sea-bed off Ephesus may have served as a handle on the lid of some metal utensil, or the group may have been a mount on a piece of furniture.

A Mannerist inkwell attributed to Taddeo Landini showing a youth wrestling with a dolphin. The dolphin's open mouth once contained the ink, while the youth's raised right hand was hollowed to receive the quill pen.

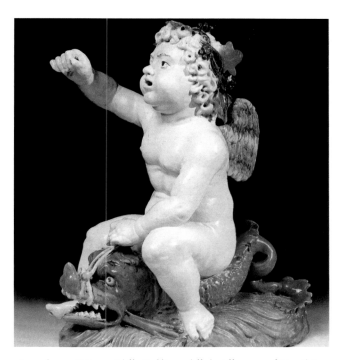

Around 1520 Giovanni della Robbia modelled a jolly group of Cupid, in the guise of Bacchus, astride a dolphin, in the colourful glazed earthenware that had been pioneered by his forebear Luca in the 1440s.

Small bronze figures of Cupid holding a dolphin were made from quite early in the Renaissance – maybe from the 1440s – by sculptors of the standing of Donatello and Verrocchio, but they do not qualify for inclusion here as they do not actually ride on the creature: they were piped so as to emit water through the mouth of their captives and thus to function as amusing indoor fountains, and will be considered later (pp. 173-75). However, a late derivative of the motif was invented in the High Renaissance by Giovanni della Robbia, in which the infant does ride on a comically stylized dolphin and so conforms to the standard composition that we have been considering. Giovanni also reprised a novel motif that had been introduced by Donatello: the water (or even wine) spurting from the chubby hero's lips would have played on the sails of a child's windmill (probably a real one made in metal – now missing), thus rotating it and scattering droplets agreeably over the assembled company. Such mechanical toys were much prized at the period, and reflect some knowledge of Greek treatises on mechanics and hydraulics, which were just coming to light.

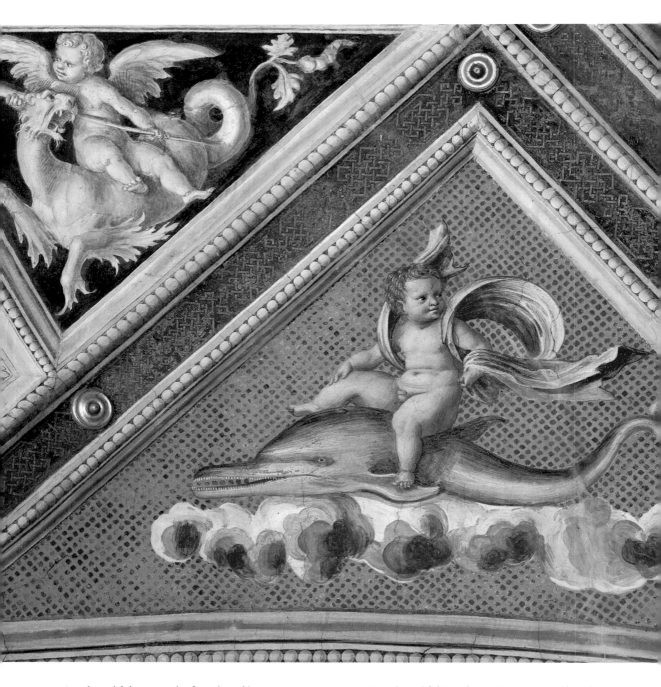

Cupid on a dolphin, painted in fresco by Baldassare Peruzzi c. 1511 on the ceiling of the Sala di Galatea in the Villa Farnesina, Rome.

Cupid on a dolphin with amorini was engraved by Adamo Scultori after a lost design attributed to Raphael or Giulio Romano: it was derived from a classical cameo in the Medici collection, which might have been brought to the artist's attention by Raphael's patron, Pope Leo X, a Medici.

A Raphaelesque Interlude

As is so often the case with interesting Renaissance compositions, the source of Giovanni della Robbia's design may have been a classical cameo from the Medici collection (now in the Museo Archeologico, Florence). This was also known to Raphael and his collaborators, for its outlines feature in their works. Baldassare Peruzzi used it straightforwardly, like some of the ancient mosaicists and like Mantegna, to fill an awkward triangular field in a ceiling of the Villa Farnesina in Rome. His child is good-looking and cheerful, while the naturalistic, greyish-blue, dolphin may have been studied from life (or, at least, from death – on the shores of the Tyrrhenian Sea, or even in the fishmarket in Rome). It rides unusually not on waves, but on a bank of clouds against a background of fictive golden mosaic, for this is a ceiling painting in a very 'all'antica' scheme of frescoes for Raphael's best patron, the rich banker Agostino Chigi (see pp. 82-83). Two fu rther, more elaborate, compositions by Raphael and/or Giulio Romano are known now only from later engravings. One, by Adamo Scultori, shows a boy – with any wings hidden – on the back of one dolphin and clinging with his left hand to its encircling tail, while another dolphin turning away squirms beneath them. He is accompanied by half-length flanking figures with obvious wings – perhaps riding the other dolphin, or yet further ones, concealed save for their tails. The oval shape of the gem that inspired the design is indicated by the inward curve of a pair of bulrushes which close the rectangular composition on either side. The picture later came to be captioned 'Amor omnia vincit', or 'Love conquers all'.

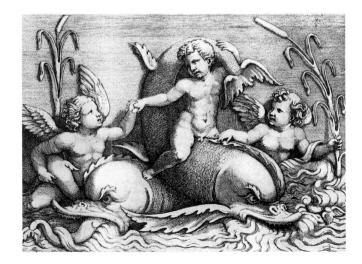

Another engraving after Raphael or Giulio Romano features Cupid (seen from a more dramatic frontal point of view) goading his dolphin with one of his arrows, beside his mother Venus, who is clinging uncomfortably to a second dolphin, with the leonine face of a sea-monster. They are driven by two conflicting wind-gods in the clouds above along a bay, in front of a distant port. This swirling, uneasy composition seems to betray a combination of two separate groups. By Marco Dente da Ravenna, it probably records a fresco by Raphael – long since lost – in the gardens of the Farnese family behind their famous palace in Rome. This was noted with admiration by the English visitor John Evelyn in his famous *Diary*, on 13 February 1645: 'and thence had another sight of the Farnesi's gardens, and of the tarrace where is that admirable paynting of Raphael, being a *Cupid playing with a Dolphin*, wrought *à fresca*, preserv'd in shutters of wainscott, as well it merites, being certainely one of the most wonderful pieces of worke in the world'. The composition of Cupid astride the dolphin, seen from the front and brandishing his arrow, was put to good use by Raffaello da Montelupo, a sculptor from Raphael's immediate circle, in a marble wall fountain. In order to adjust the group gracefully to the concave semi-dome of the shallow niche in which it is set, he appears to have substituted the flaring acanthus-like tail of the dolphin ridden by Venus in the engraving for the less dramatic one belonging to Cupid's mount. Water seems to have flowed not only from the dolphin's gaping jaws, but also from Cupid's person!

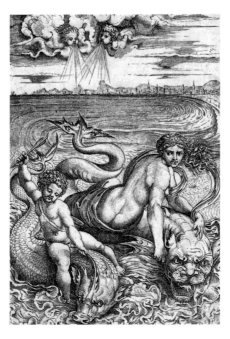

'Venus and Cupid carried by Dolphins' was engraved probably after a lost composition by Raphael by his contemporary, Marco Dente da Ravenna.

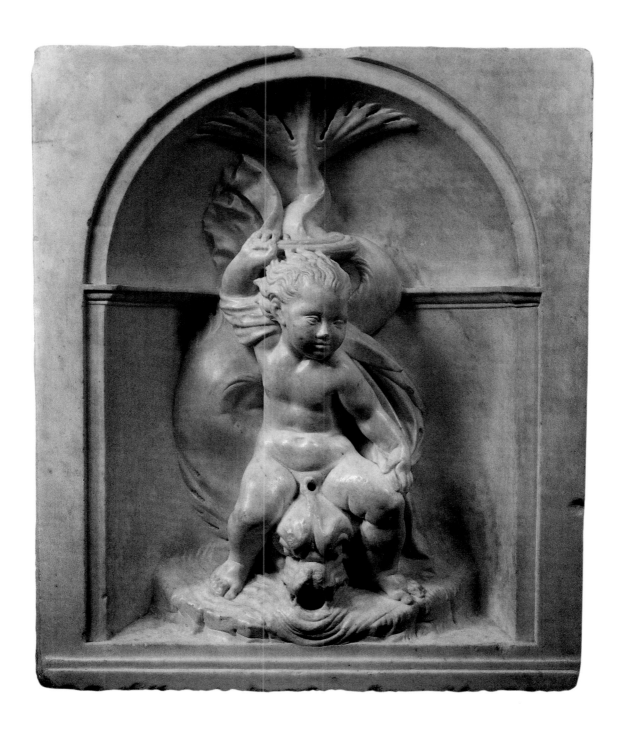

Wall-fountain of Cupid on a dolphin
by Raffaello da Montelupo, c. 1530.

A Mannerist 'Dolphinarium'

Half a century later, Cupid reappears on an inkwell in the Victoria & Albert Museum in London, one of nearly a dozen in the form of dolphins swimming along with riders on their backs which seem to have been produced in Rome or Loreto; he is shown wingless – simply a handsome youth drawing an arrow from his quiver as he stands on a platform, which rests precariously on the top of the head and the dorsal fin of the dolphin, while a shell to hold ink is gingerly balanced on the tail fin. Most of the other riders, usually a little boy or a girl, are better integrated with their mounts and firmly grasp the shell containers: one boy brandishes a mace and clings on to the shell for dear life as he leans back in the active pose of a water-skier. The children's hairstyles sometimes – as here – recall that used in Florence by Giambologna on his images of little boys, though this does not mean that they were produced in his workshop, for their rougher, waxy-looking finish and dark varnish are unlike those of his bronzes. In other related inkwells the dolphin has no human company; instead, in one case it is accompanied by a baby dolphin, in another it has a cockle-shell in its mouth and a larger one on its back, and a third has a small conch-shell balanced elegantly on its tail. In a catalogue published by Christie's in 2006, these evoked a new tongue-in-cheek pseudonym for their

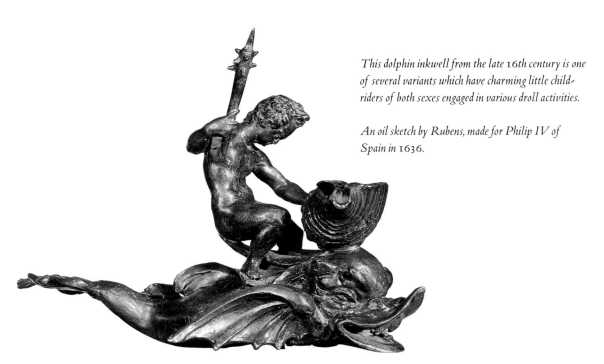

This dolphin inkwell from the late 16th century is one of several variants which have charming little child-riders of both sexes engaged in various droll activities.

An oil sketch by Rubens, made for Philip IV of Spain in 1636.

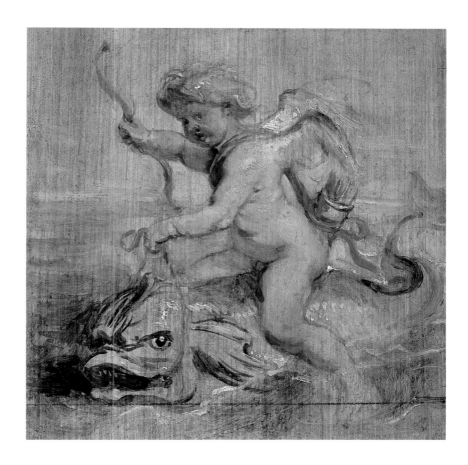

anonymous creator, 'The Master of the Duplicated Dolphins'. They may be early pieces by Francesco Fanelli, who later worked for King Charles I.

One wonders if Rubens knew – or even perhaps owned – one of these inkwells, so close in appearance and spirit to them is a sketch that he dashed off in oils on a little wooden panel. This is one of fifty designs that he was called upon to produce by King Philip IV of Spain in 1636. They were for a series of mythologies to decorate the new royal hunting box, the Torre de la Parada, which the king had built outside Madrid. The dolphin in the finished picture (painted by Erasmus Quellinus and now in the Prado, Madrid) even has the hue and gleam of patinated bronze: so it resembles the creatures shown in the bronze inkwells even more closely than the sketch by Rubens does.

The tradition of making bronze statuettes of Cupid on a dolphin continued into the next generation and the 16th century with several miniatures certainly by Francesco Fanelli, some seemingly designed as finials for chairs or cabinets.

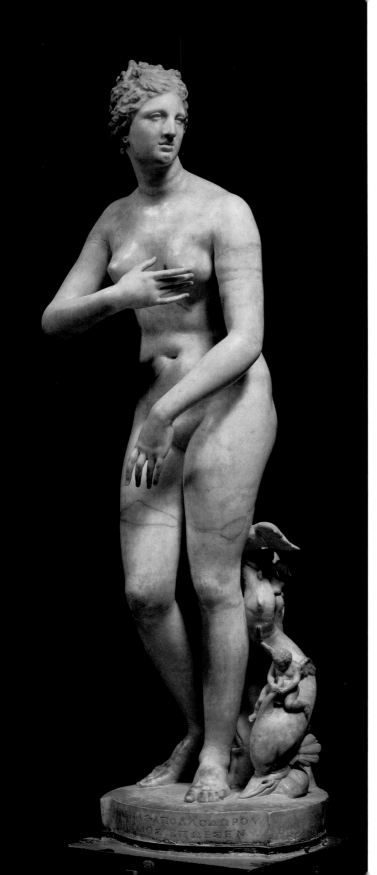

Venus & Cupid with a Dolphin

A dolphin carrying Cupid on its back accompanies Cupid's mother, Venus, in the 'Venus de' Medici'. This 1st-century AD copy of a Greek original by Praxiteles was recorded in the Villa Medici, Rome, by 1638 and transferred to Florence by 1677.

A bronze handle of the period of Augustus from some large – probably ritual – vessel is cleverly formed from confronted dolphins, diving to devour an octopus. Their eyes are inlaid in silver.

A type of door-knocker popular in Venice in the 16th century shows Venus flanked by twin dolphins ridden by Cupids, in a composition that recalls that of the ancient Roman bronze handle.

In a whole class of Graeco-Roman statues (the *Venus Pudica* or Modest Venus, over one hundred in number, of which today the *Venus de' Medici* in Florence is by far the best-known), an up-ended dolphin instead of the more usual drapery or tree-stump is introduced to give support to the vulnerable legs and ankles of the unclad figure. For it to perform this function, sculptors had to reduce the dolphin in size and deform it slightly by flattening its beak and head unnaturally on to the ground, while adapting its curvaceous body and thrashing tail to echo the contours of the female figure.

On rare occasions such severe deformation is avoided by having the dolphin, a symbol of good, devour an evil octopus that is writhing in stylized waves below. That motif animates a fantastic bronze handle of the Augustan period in which a pair of dolphins, with their tails curved into complete circles on a horizontal plane to give a good grip, are seizing on an octopus set centrally among some fish below. Could some such antiquity have inspired the Venetian Renaissance creator of a remarkably similar bronze door-knocker? Flanking a graceful figure of Venus on the central axis, the dolphins have their tails curled up into double loops behind her shoulders (like a bow), while their bodies belly out into the lyre-like form that was standard for such door-furniture in 16th-century Venice. Then their beaks are directed back inwards, so as to seize the rim of the shell on which the goddess is riding to shore: its humped hinge in the centre resembles the sac of the octopus in the classical bronze. Can such similarities be purely coincidental?

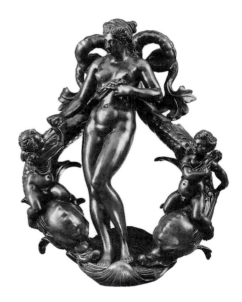

Quite frequently – as in the case of the *Venus de' Medici* – the dolphin is also ridden by Cupid, who is depicted on a diminutive scale appropriate to the size of the dolphin rather than that of his mother, who towers over both. Interestingly, though it is not often commented on, a similar Cupid on a dolphin stands beside the bare right leg of a colossal statue of the Emperor Augustus. Augustus proudly, if bizarrely, had it included in this statue of military might because his family, the *Gens Julia*, claimed descent from Venus. The marble statue (now in the Vatican Museums) was found on the estate of his wife Livia at Prima Porta to the north of Rome.

(A less prominent and attractive dolphin accompanies another type of statue of Venus, where she is shown kneeling and wringing out her hair at the water's edge, after her birth at sea. The original statue was carved by Doidalses of Bithynia in the 3rd century BC; one of the best-known later copies, found at Hadrian's Villa near Tivoli, is now in the Museo Nazionale Romano delle Terme in Rome.)

There is one celebrated group in which the two symbolic figures are on their own: the dolphin, head down, has its body and tail entwined – rather like a boa constrictor – round the body of Cupid, whom it is holding up in mid-air, as though they were diving together.

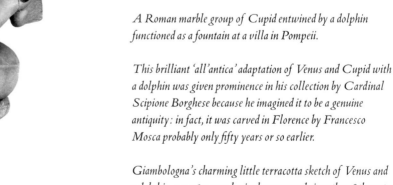

A Roman marble group of Cupid entwined by a dolphin functioned as a fountain at a villa in Pompeii.

This brilliant 'all'antica' adaptation of Venus and Cupid with a dolphin was given prominence in his collection by Cardinal Scipione Borghese because he imagined it to be a genuine antiquity: in fact, it was carved in Florence by Francesco Mosca probably only fifty years or so earlier.

Giambologna's charming little terracotta sketch of Venus and a dolphin, c. 1560, was lovingly preserved since the 18th century by a number of distinguished English collectors (who thought it was by Michelangelo), including the sculptor Nollekens and the painter Sir Thomas Lawrence, before coming via an ancestor into the hands of Sir Brinsley Ford.

Although many statues of Venus were produced during the Renaissance and later in all media and on every scale, from monumental to miniature, the addition of Cupid on a dolphin did not find much favour. However, an interesting variant of the classical composition is to be seen in a marble relief by an antiquarian-minded sculptor called Francesco Mosca that Cardinal Scipione Borghese mounted over the fireplace in the same room in his Casino in Rome, begun in 1613, as Bernini's famous statue of *David*. It shows Venus from behind (almost in the ancient pose where she is shown flirtatiously admiring her posterior, the *Venus Callipygus*). She is about to robe herself, with the help of Cupid, who is caught up under the hem of her garment as he rises off his squirming, diminutive dolphin. A terracotta plaque made by Giambologna in Florence shows Venus also robing herself, but accompanied only by the dolphin: the two figures are set on an indented plinth that defines them as a sculptural representation rather than a narrative group.

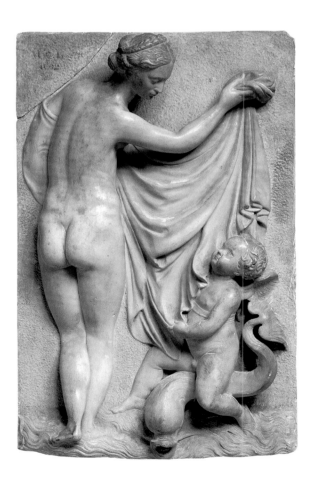

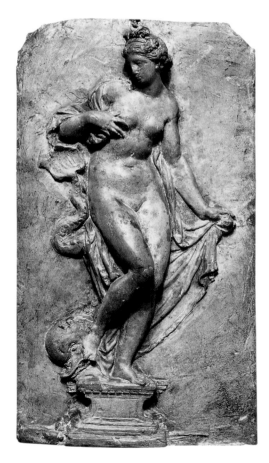

The elegant, elongated proportions of Venus were retained by Giambologna's best follower, a fellow Fleming, known in Florence as Pietro Francavilla, in a colossal marble statue of Venus that he signed and dated in 1600. It was the focal figure, larger than the other dozen statues involved, in an elaborate scheme of decoration for the garden of a *villa suburbana* at Rovezzano outside Florence belonging to Abbot Bracci. Indeed, it is not impossible that Giambologna's terracotta (p. 59) was a sketch for this very important joint commission. Francavilla's Venus faces in the same direction and holds her arms in a similar position, though her drapery is not extended sideways. The dolphin has been duplicated symmetrically, however, and two unprecedented new 'riders' have been added. This must have been in order to relate the statue better both visually and intellectually to the rest of the series of mythological figures, who were concerned with horticulture and pastoral poetry. Both smaller figures seem to seek Venus's attention like pestering children: to her left, a sea nymph holds her hand, tugging at her wrist plaintively; while to her right, the figure towards whom she turns is a non-marine monster, a youthful satyr, who is playfully pulling away the robe that Venus attempts to clasp to her waist with her other hand. Both are half-perched on the heads of the dolphins that spout water from their twin (completely inaccurate) nostrils. The inference is that – like the Royal Marines – Venus is powerful *Terra marique* – by land (the satyr) and by sea (the nymph, possibly a Nereid, for which see below).

The general appearance of the female nude figure with subsidiary ones clinging to and looking up at her for sympathy and even sustenance would have reminded any observer of the period of the Christian virtue of Charity, who was normally shown with infants, one of which is often being suckled. The doubled twin sprays of water from the dolphins below might in Florence also have recalled the statue of Abundance at the centre of Ammanati's marble Fountain of Juno, then in the Boboli Gardens, who is shown expressing water (i.e. milk) from both her breasts simultaneously. At the Villa Bracci, the water was channelled purposefully round the garden beds to irrigate the fruit trees, shrubs and flowers of the orchard, a veritable paradise in microcosm.

This monumental fountain centrepiece carved by Francavilla in 1600 was the focal point of a group of statues in the grand garden of the Villa Bracci at Rovezzano. The S-shape of the dolphin unifies and animates the group when seen from the side.

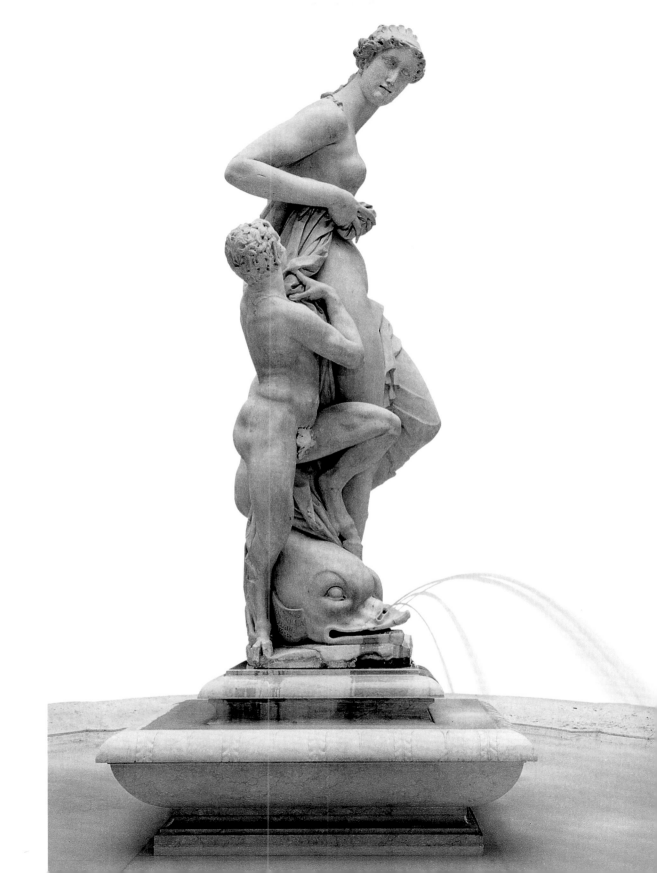

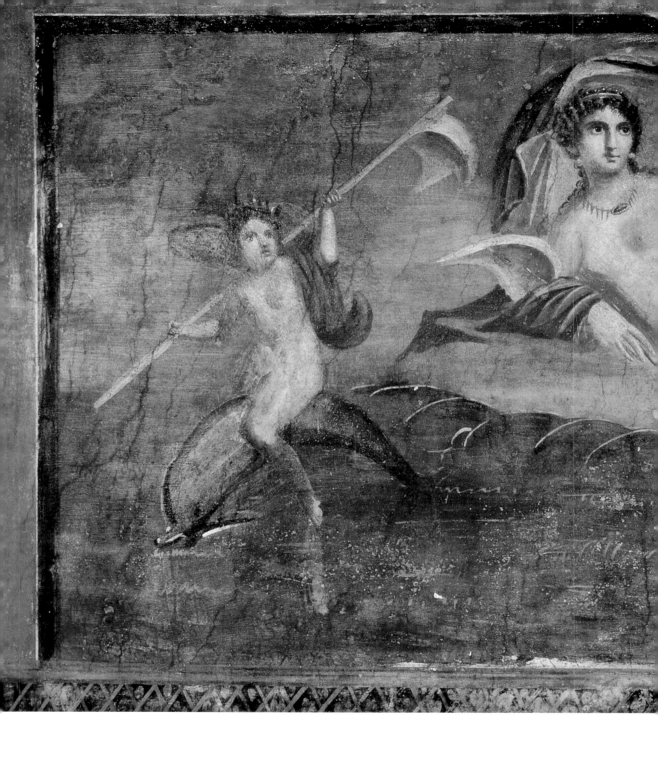

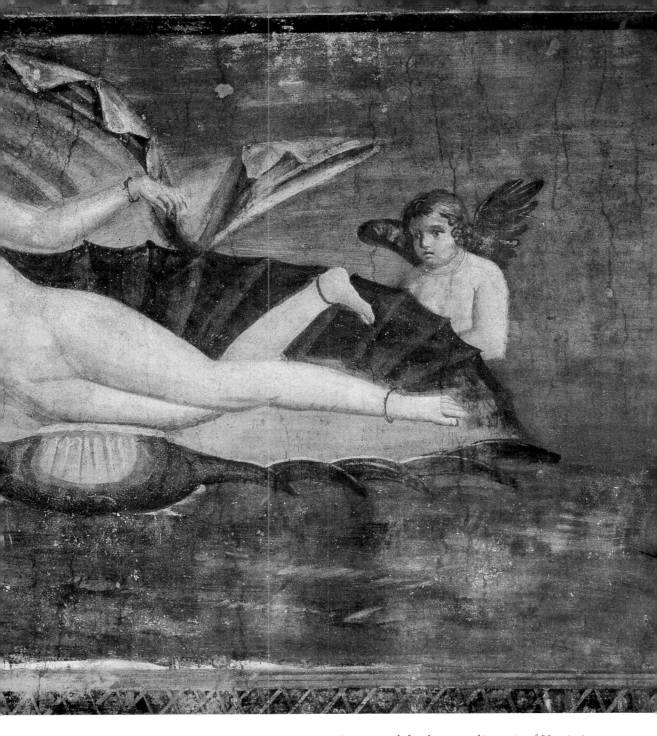

At some point before the catastrophic eruption of Vesuvius in AD 79, some ancient Velázquez painted this over-life-size fresco in the courtyard of a middle-class Roman villa (now known as the Casa di Venere) in the seaside resort of Pompeii.

To revert from sculpted to painted and graphic images of dolphins, we need to start once again with Antiquity, indeed with one of the best-preserved and most famous images of all. This is a panoramic fresco of the *Marine Venus and Cupid* in a house in Pompeii that has now been named after it (pp. 62-63). It is all the more important for being – perhaps – a copy of a celebrated portrait of Campaspe, the oriental lady-love of Alexander the Great. The painting was of course not visible during the Italian Renaissance and so cannot have had a direct influence on a painter such as Raphael when he designed a picture that we know now only from an engraving, *Venus Reclining on a Dolphin*. Probably Raphael had read some description of the Hellenistic painting of Campaspe by his famous predecessor, Apelles, and tried to re-imagine it; as Papal Surveyor of Antiquities, he would also have had access to all the paintings, relief carvings and miniature images on gems and coins that had survived from ancient Rome, and so may have had something concrete to go on. We have already had cause to note how Raphael, genteel and courtly painter that he was, favoured delphinic imagery (pp. 51-52).

Only through this sharply delineated but smallish engraving can we guess at the ravishing beauty of Raphael's idea of Venus being brought to shore on the back of a hard-working dolphin, by the light of a torch brandished by Cupid, while a butterfly – symbol of the human soul – flutters towards some clouds on the horizon of the calm sea. Her recumbent pose and the veil swept into a loop by a sea breeze recall the Pompeian fresco overleaf.

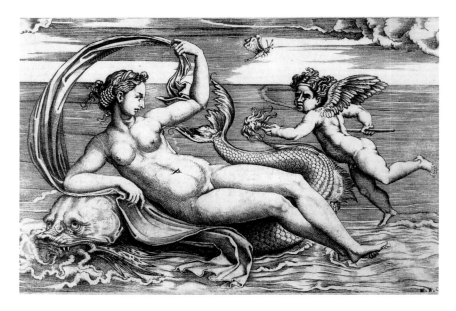

This rendering of Venus by Albrecht Dürer shows a stylized, dragon-like dolphin, like that ridden by Arion in Dürer's watercolour some ten years later.

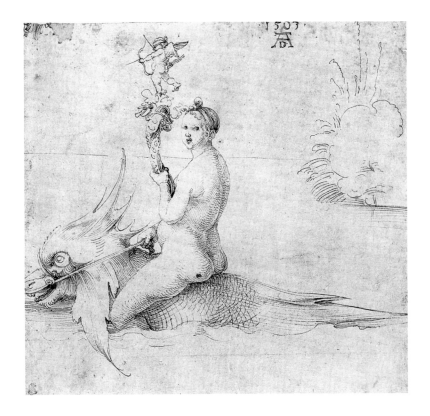

In northern Europe, meanwhile, and even earlier than Raphael, Albrecht Dürer addressed the theme of Venus on a dolphin in a pen drawing which he proudly monogrammed and dated 1503 in the sky: classical though the subject is, as in the case of his rendering of *Arion on the Dolphin* (pp. 32-33) – to which it would make a good pair – Dürer gives an imaginative twist to his interpretation, by making his Venus into a plump, naïve-looking girl from his native Nuremberg, who looks rather surprised – though perhaps not displeased – at being observed. She steers the dolphin with a tight rein and holds up with great aplomb a cornucopia, as though she were a beauty queen performing a difficult role on the float of some civic procession. This cornucopia is crowned with a representation of Cupid blindfolded about to ping off an arrow at some unwary target beyond the picture's edge. This in fact closely resembles little statuettes that were used to crown the bronze table-fountains being manufactured in the same city by Dürer's sculptor-contemporaries Peter Flötner (cf. p. 104) and Peter Visscher. Scholars, noting the change in the goddess, suggest that she represents earthly, rather than heavenly, love and is therefore a *Venus Voluptas*.

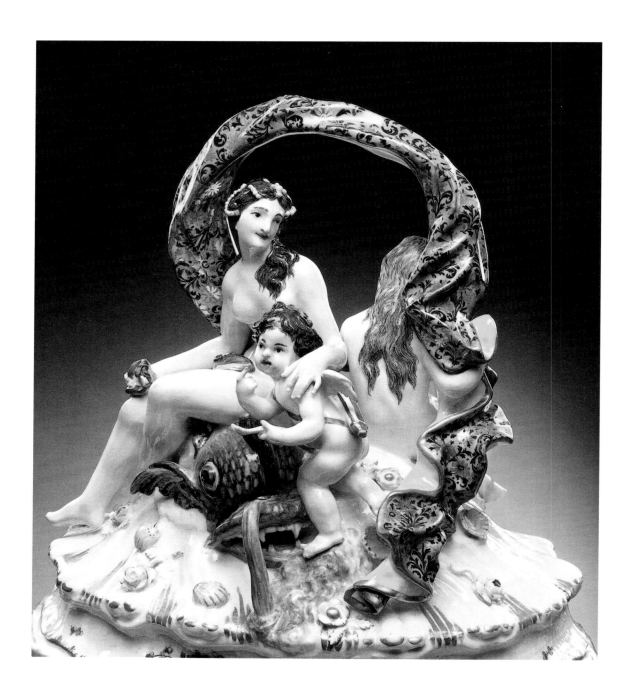

In that great repository of Rococo ceramic ware, the
Zwinger in Dresden, one of the favourites is this charming
late 18th-century Meissen group of Venus and Cupid,
with an exhausted dolphin beached amidst seashells on
what looks like a mighty, upturned cockle-shell.

Two and a half centuries later, a German artist, one who worked in the medium of ceramics, which came into vogue in the Rococo period, invented a daintily modelled and prettily coloured group in Meissen porcelain showing Venus with her dolphin safely beached, accompanied by a pert little Cupid in front and a nymph behind, framed amidst her windswept veil: in that age of collecting antiquities, could he have somehow been aware of a prototype, such as this Hellenistic earthenware group, with its traces of pastel colouring, so reminiscent of Tanagra figurines? The contrast between the naturalistic dolphin, well known in real life to the ancient potter from the Mediterranean Sea, and the cartoon-like creature dreamt up by the land-locked ceramicist in Meissen reflects their totally diverse cultures and clientèle and provides a fitting conclusion to the saga of this particular theme in dolphin imagery, revered over millennia.

This terracotta cult statuette of Hellenistic date found in Tunis makes a neat comparison with the elaborate group in Meissen porcelain shown opposite.

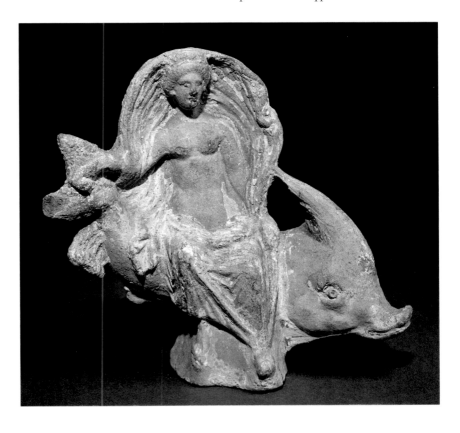

Neptune & the Dolphin

Poseidon, better-known today under his Latin name, Neptune – brother of Zeus, or Jupiter – ruled the sea and is the ancient god with whom, not surprisingly, the dolphin is most often associated in the realm of visual art. According to Aelian, Aesop and Aristotle the dolphin is king of the sea-beasts, rather as the lion is of the animals and the eagle of the birds. As a symbol of the very sea that it inhabits, the dolphin becomes Poseidon's personal emblem, along with the golden trident, with which he drives it and rules the waves (see pp. 108-13). Lysippus invented a type of statue for the sanctuary of Poseidon on the Isthmus of Greece where the god stands with one foot resting on the back of a dolphin and the corresponding forearm leaning upon his raised thigh. A statue in the Lateran in Rome introduces a variant, where Poseidon's foot rests on the prow of a ship, while the dolphin, head down, raises its tail behind him. The Greek historian and traveller Pausanias mentions that there was one such statue at Corinth.

In the Renaissance, Michelangelo's rival Baccio Bandinelli responded to a decree of the Genoese Senate declaring Andrea Doria as 'Pater Patriae' in 1528 by proposing an honorific statue in the expensive material of bronze, and produced a presentation drawing based on the type of ancient statues recorded by Greek gravestones, where the god holds out a miniature, symbolic dolphin with its tail curling around his forearm. In the hand of Genoa's great hero the dolphin would have looked like a very handsome pet.

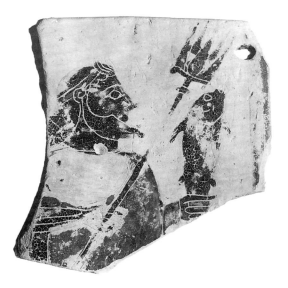

This fragment of a Greek black-figure vase of the 5th century BC shows Poseidon posed stiffly like a statue demonstrating his identity by holding up his standard attributes: a trident (with two additional intercalated prongs) and a small dolphin – most improbably in a top-heavy, vertical and immobile position!

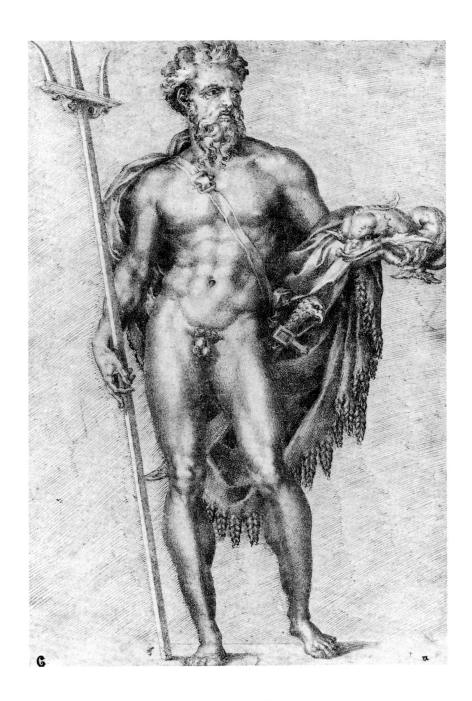

*Baccio Bandinelli's superb presentation pen drawing for his
statue of Andrea Doria in the guise of Neptune repeats the
type of an ancient Greek statue, probably in bronze, where
the god holds a miniature dolphin, perhaps to emphasize his
own super-human stature, as well as a trident.*

Bandinelli might have been aware of this composition from an ancient bronze statuette, or from the back view of such a statue that Mantegna learnedly included in the background of his engraving showing a *Battle of the Sea Gods*. Alas for the sculptor, by the date of a contract drawn up in 1529, the material was changed to marble (much cheaper in Carrara), and this predicated not only a reduced global fee, but also a change to the design, for the handsome free-standing figure with arm outstretched that he had proposed could only have been produced in metal. This may be the reason why he could not bring himself to finish the ill-starred statue.

Detail showing a classical statue of Neptune holding a dolphin, from Mantegna's engraving of a 'Battle of the Sea Gods', c. 1481-90.

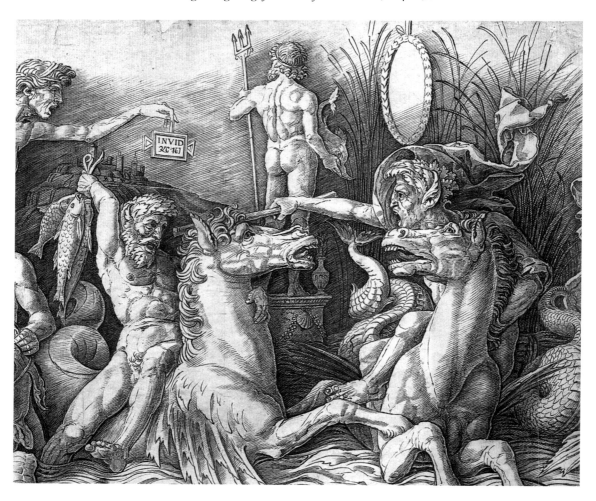

A well-modelled, lithe dolphin – which does not spout water – supports the leg of a statue of Neptune on an impressive fountain in Messina, the work in 1553-57 of Fra Giovanni Montorsoli, an associate of Michelangelo, whom he had helped with carving the statues of Sts Cosmas and Damian in the New Sacristy of San Lorenzo in Florence. The fountain (see p. 111) overlooks the Straits of Messina, a treacherous stretch of water between Sicily and the 'toe' of Italy: the turbulent currents running in conflicting directions from north and south were characterized in ancient mythology by malign mermaid-like monsters called Scylla and Charybdis. Statues personifying them writhe below the pedestal on which Neptune presides, grimacing resentfully as he stretches out his arm to calm them. The angles of the basin are carved with particularly curvaceous pairs of dolphins entwined round a vertical trident.

The commanding gesture of Neptune's right hand in the Messina fountain was in turn to inspire Giambologna, a sculptor of a later generation, when he was commissioned by the Senate of Bologna in 1563 to produce for the main square a magnificent Fountain of Neptune: his project for the crowning figure, in which he gave an added twist and a swing to Montorsoli's rather static composition by raising the right leg up to rest at 45 degrees behind, on the dolphin's back, is recorded in a bronze cast that he had to make to gain papal approval. As we shall see in the discussion of fountains, Giambologna was a great fan of the dolphin on account of its smooth curves and gave his renderings great élan (pp. 177-80). During the latter years of the 16th century and over the turn of the 17th, bronze statuettes of Neptune with a writhing dolphin proliferated north of the Alps.

A more realistic dolphin, with smaller eyes and a proper beak, provides a similar support to a statue by Giambologna's follower Pietro Francavilla, he of the group of Venus from the Villa Bracci (p. 61). It represents Grand Duke Cosimo I de' Medici as the founding Knight Commander of the Order of Knights of Santo Stefano and stands outside their splendid headquarters in Pisa (overleaf). (The Knights of Santo Stefano share with the far older Order of the Knights of St John of Jerusalem the 'Maltese' shape of cross, but instead of being coloured red, their cross is black.) Cosimo is shown in full battle-armour, as though he were commanding one of the Order's famously speedy galleys: dolphins must often have gambolled beside their prows as they sped across the Mediterranean under slave manpower to assail Barbary pirates or the fleets of Turkey.

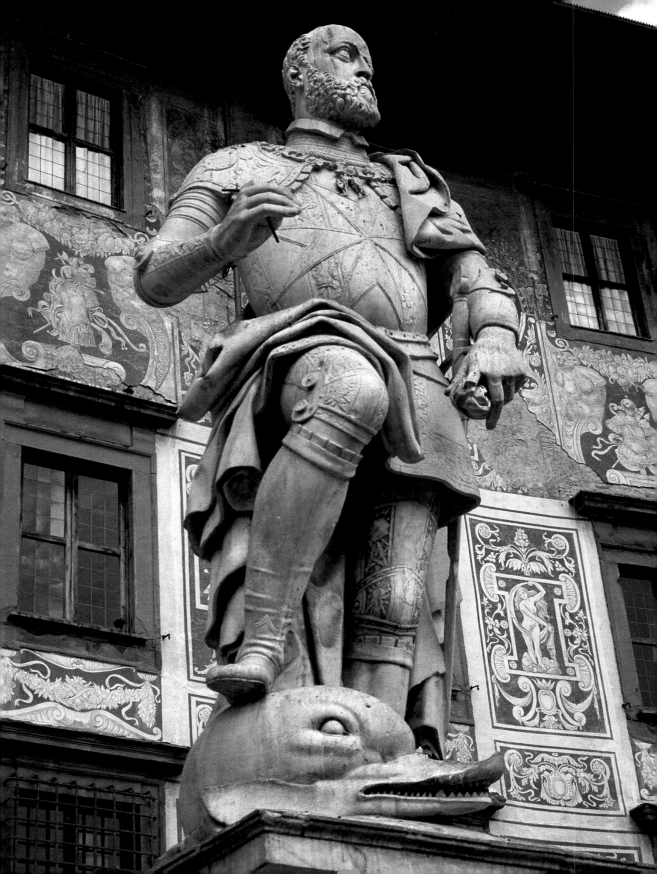

Meanwhile, in Italy, the standard small-scale version in bronze of the celebrated marble *Neptune and Triton* by Gianlorenzo Bernini substitutes a writhing dolphin, beached and gasping for breath, for the subsidiary figure of Triton: this may record a distinct alternative designed by the master, perhaps in a terracotta model that was then replicated for commercial ends, or an invention by a bronze founder, in order to satisfy contemporary collectors. Bernini, as a witty conceit and *tour-de-force* of carving, did include a dolphin's head in his marble group as a ghostly image, formed by the tail of Neptune's wind-tossed cloak spiralling out to the right.

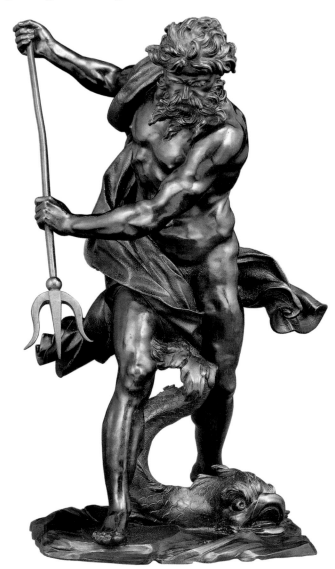

Cosimo I de' Medici, depicted by Francavilla as a Knight of Santo Stefano, outside the Knights' headquarters in Pisa. The more natural than usual dolphin inserted under his foot may be due to the propinquity of Pisa to the Tyrrhenian Sea, as well as to the sculptor's professional interest in biology and thus perhaps also zoology, for he was Professor of Anatomy at the University of Pisa, near where this statue stands.

'Neptune and a Dolphin', a small bronze based on Bernini's marble 'Neptune and Triton', of 1623, which crowned a fountain in the garden of the villa of Cardinal Montalto in Rome.

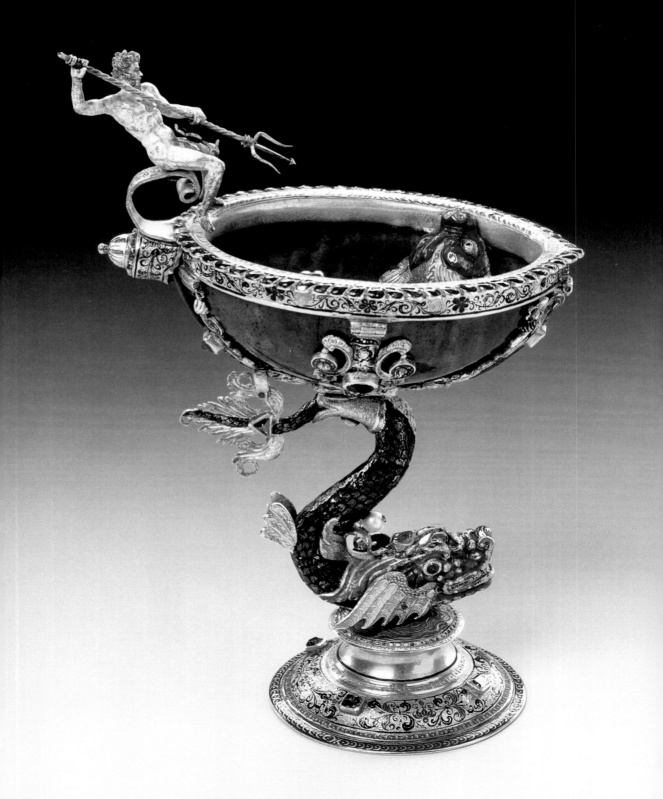

The dolphin plays a more central and a more colourful role in some other, highly original, artefacts fashioned out of precious materials to adorn the buffets or tables of the nobility. A classic example is one that was made in Milan towards the end of the 16th century. Neptune is seated on the handle, leaning back in preparation for hurling his trident at a naughty dolphin lurking within the sea-green jasper bowl. Framed in elaborately enamelled and bejewelled gold mounts, this is balanced on the tail and lower spine of a dolphin curled into an S-shape, which is magnificently enamelled in turquoise, with gold fins and rubies for its eyes. The fashion for such striking ornamental vessels continued well into the Baroque period, especially in Germany. One such was hammered by a goldsmith in Salzburg around 1590 into the curvaceous shape of a plump, joyously writhing dolphin. The creature functions as a ewer, with its tail forming a kind of handle, while a spout extends from between its serried rows of teeth.

Not only does this late 16th-century table ornament have a dolphin for its support, but another lurks within the bowl, a target for Neptune's trident. Made in Milan, it was owned before 1623 by Crown Prince Christian of Denmark, and later, through dynastic descent, by Augustus the Strong, Elector of Saxony.

This eye-catching silver-gilt ewer, made c. 1590, was first listed in an inventory of the 'Silberkammer' in Salzburg in 1612. By descent it reached the Museo degli Argenti in Florence as late as 1814.

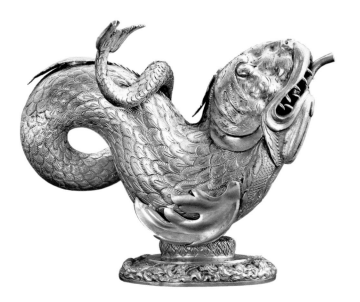

Neptune's Marine Family: Amphitrite & Triton

In his invaluable *Classical Dictionary*, John Lemprière obligingly describes
Neptune's mythological family: 'Amphitrite, daughter of Oceanus and
Tethys, married Neptune, though she had made a vow of perpetual celibacy.
She had by him Triton, one of the sea deities. She has a statue at Corinth in
the temple of Neptune. She is sometimes called Salatia, and is often taken for
the sea itself.' Triton was thus a unique being, but his name was later used
generically (with a small 't') to apply to all dolphin- or fish-tailed creatures —
mermen to us, just as our mermaids were called sirens by the ancients.
In ancient art Triton was frequently shown accompanied by dolphins to
reinforce his aquatic character and habitat (cf. p. 92).

*Triton, grandson of Oceanus, is usually shown as a mistiform creature, half-human and
half-dolphin. In this lively 2nd-century AD mosaic from the Sanctuary of Artemis at
Ephesus he is also accompanied by a proper dolphin, which dutifully bears in its mouth —
like a dog with a bone — the trident of Neptune, Triton's father.*

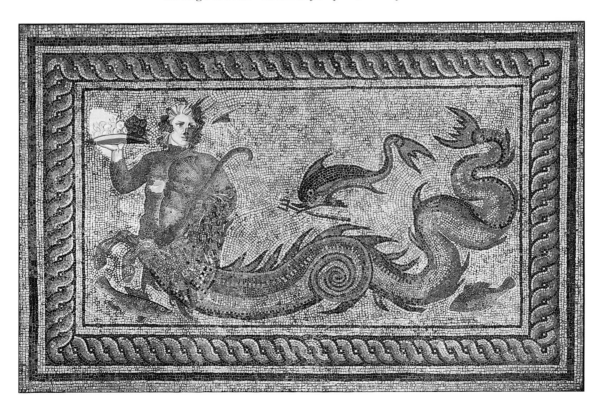

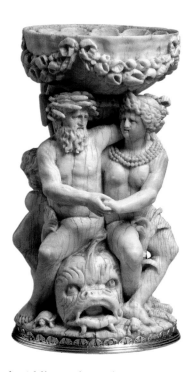

*Ivory salt cellar with Neptune and Amphitrite
borne by a dolphin, probably made by a
Nuremberg carver, c. 1650.*

Neptune and Amphitrite feature as a contented middle-aged couple on an
imaginatively conceived salt cellar in the tradition of Rubens: carved out of
a tusk of ivory from an elephant, the biggest animal on land, its cup contained
the fruit of the sea, so necessary for sustaining life and flavouring food. It was
made around 1650 by a craftsman who probably hailed from the land-locked
city of Nuremberg. The figures are seated cosily side by side on the back of
a large dolphin, whose grotesquely stylized face with open mouth peers out
from below. Crowned with bulrushes, Neptune clasps his bride's left hand,
while embracing her firmly with his other arm round her shoulders, his fingers
enmeshed in her necklace of pearls – a luminous product of the sea, precious
then as now for its rarity. Behind them, the dolphin's sinuous body and
thrashing tail rear up to form a sort of throne; Cupid brandishes the trident
that he is holding on behalf of Neptune whose hands are otherwise engaged,
and Triton, the couple's son, blows upon his traditional wind-instrument, a
great conch shell, calling the unruly waves to order. The precious salt was
contained within a bowl balanced precariously on the dolphin's tail above the
heads of the happy couple. Fluted within, to guide the fingers when taking a
pinch, the bowl is decorated on its exterior with pretty beribboned swags of
seashells. Minute terrapins, crabs and frogs decorate the base, which is meant
as the seabed and adjacent shore, with the denizens of its rock-pools.

Oceanus

Oceanus, father of Neptune, not surprisingly has a similar watery appearance. Typical is a late Roman image on a large silver dish: this huge head with staring eyes, radiating locks of wave-like hair, and a beard of seaweed, the forequarters of four dolphins poking out from the wavy strands, represents the god of the ocean, which was believed to surround the landmass of the earth like a disc. A similarly impressive head but on a colossal scale and in marble, enframed in a cockle-shell and flanked by inward-facing dolphins, survives in Rome. It still serves its original purpose as a fountain ornament, having come from one of 1593 by Giacomo della Porta in the Campo Vaccino.

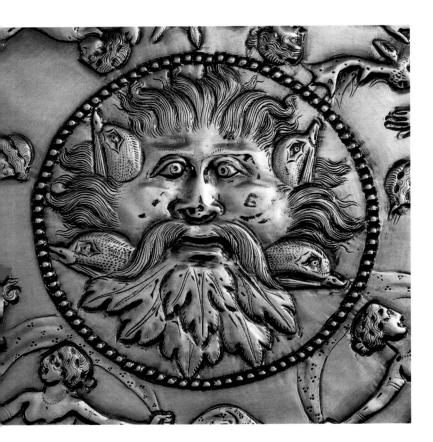

Oceanus on a silver dish, probably beaten out of sheet silver at Rome in the mid-4th century AD, found with a hoard of similar treasure at Mildenhall in England.

This ogrish mask of Oceanus by Giacomo della Porta now feeds water into an ancient granite container forming a drinking fountain outside Santa Sabina, on the Aventine Hill in Rome.

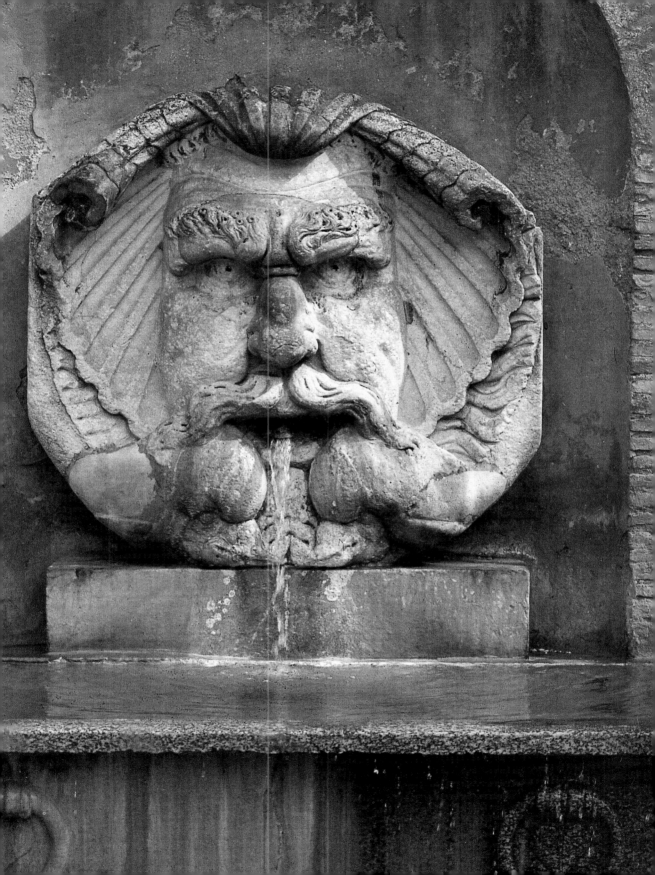

Thetis

In ancient Greece, Thetis, daughter of Nereus and once loved equally by
Zeus and Poseidon (Jupiter and Neptune to the Romans), was an attractive
sea-goddess who could metamorphose into many sea-creatures. A painter
of vases from the circle of the famous Euphronios (perhaps Euthymides or
Oltos) depicted Thetis running, like some feisty Attic maiden, with her
limbs in the time-honoured swastika-shape used to denote rapid movement,
apparently whirling about her in either hand a dolphin, while two more
plunge downwards beside her, so filling the blank spaces. It is as though she
were juggling with them. Her name is written, not very neatly, at the left.
Set within its wide border of chequer pattern, this image demonstrates the
economy of means that makes Archaic Greek vases so appealing today.

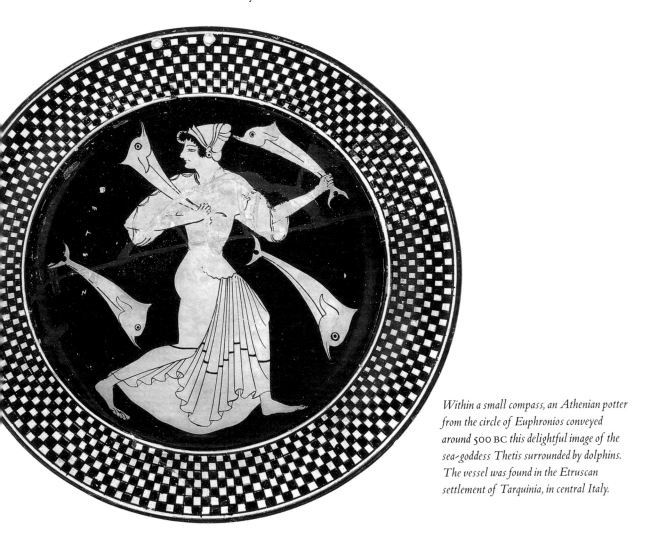

*Within a small compass, an Athenian potter
from the circle of Euphronios conveyed
around 500 BC this delightful image of the
sea-goddess Thetis surrounded by dolphins.
The vessel was found in the Etruscan
settlement of Tarquinia, in central Italy.*

The Nereids

The fifty daughters of Nereus, like Thetis, were collectively known as Nereids and dwelt with their father in a cave beneath the Aegean Sea. They were goddesses who represented various aspects of the sea – rocky or sandy shores, sea-salt, foam, waves and currents, and so forth. Patrons of all who sailed or fished, they would come to the aid of any in distress. They were worshipped in some cities and were widely sung by the poets of the ancient world. Greek painters of pottery have also bequeathed to posterity many impressions of how the Nereids looked, as – dolphin-borne – they went about their tasks. Rather as maenads and satyrs used to follow Dionysus/ Bacchus in a drunken procession celebrating the uplifting effect of wine, the Nereids were often accompanied by tritons in the retinue of Poseidon/ Neptune.

Ladylike Nereids, some borne on speedy dolphins, are delivering the arms of the Greek hero Achilles. They are painted on a red-figure pelike of around 425-401 BC from Apulia in southern Italy.

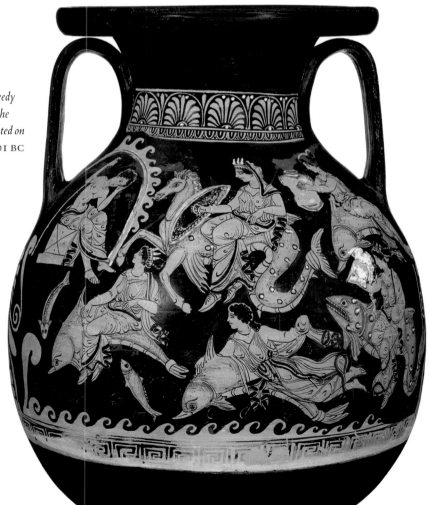

Galatea

The Nereid Galatea accompanied by Triton is the theme of one of Raphael's most delightful and accomplished frescoes, which provided him with an excuse to depict dolphins leaping happily over a serenely calm sea, in Agostino Chigi's Villa Farnesina (cf. pp. 50-51). Its theme, developed by the classical authors Theocritus and Ovid, was probably taken for this commission from a more recent, Florentine, source, Poliziano's *La Giostra*. Just like Venus, Galatea – named after the milky-white foam of the sea – is being drawn along in a great cockle-shell (endowed with paddle-wheels) by some energetic dolphins. The nearer one is chewing up a tasty octopus as it speeds along. Cupid is in the foreground and Triton behind, trumpeting Galatea's approach, while a sea-centaur in the background seems to be poling himself urgently in the opposite direction, with a comely passenger on his back, a blonde nymph with windswept hair. This is arguably the most sublime representation of the dolphin in post-classical painting.

A detail from Raphael's fresco of 'The Triumph of Galatea', painted in 1511, which decorates the wall of the main room of the Villa Farnesina on the bank of the Tiber in Rome, a pleasure-palace designed for Agostino Chigi, a rich banker and great patron of art.

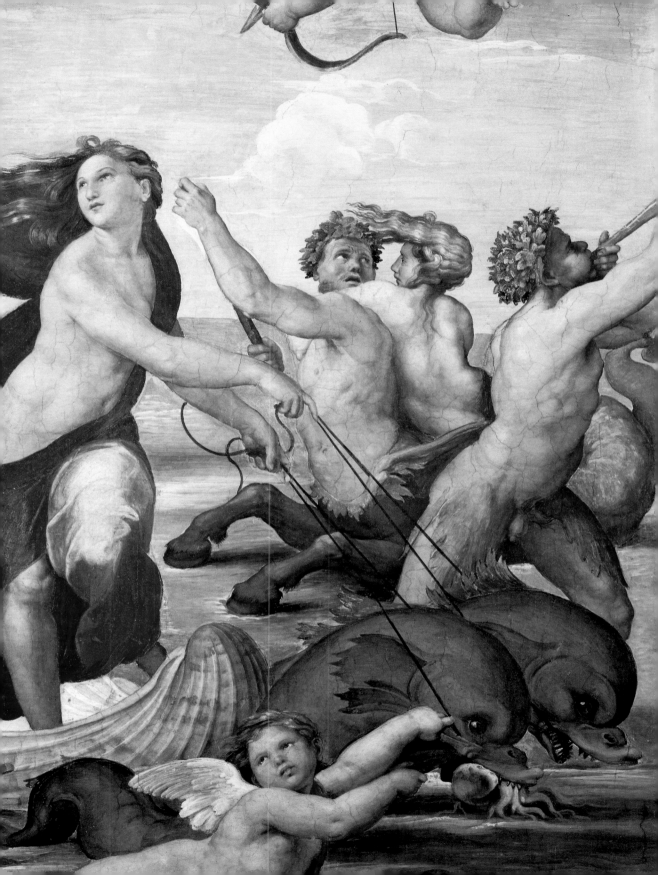

Fortune

The poet Horace in one of his *Odes* addresses a favourite goddess of the
Romans, Fortuna, as being 'mistress of the waters'. She was held to be a
daughter of Jupiter, who ruled human affairs. In Renaissance imagery she
is usually represented as balancing on one foot on a globe (the most unstable
form of support imaginable) in mid-ocean, with her veil flying out above her
like a sail, to symbolize the inconstancy of luck, which is as changeable and
unpredictable as a sea-breeze. Sometimes, however, combining her character
with that of love (equally inconstant), she is allowed like Venus to ride on a
dolphin. Colourful depictions of this iconography are to be found on a series
of maiolica *albarelli* or drug-jars made in Pesaro. On one pair the well-
endowed, golden-haired nude figures are made to face each other, but the
dolphins still swim in the same direction; on the left-hand jar Fortune rests
both feet on the creature, to steady herself, with a following wind billowing
out her sail, while on the other she teeters on one foot and faces backward.

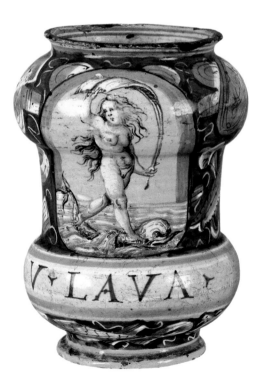 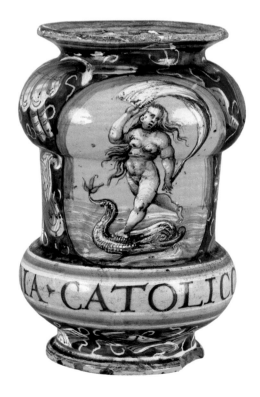

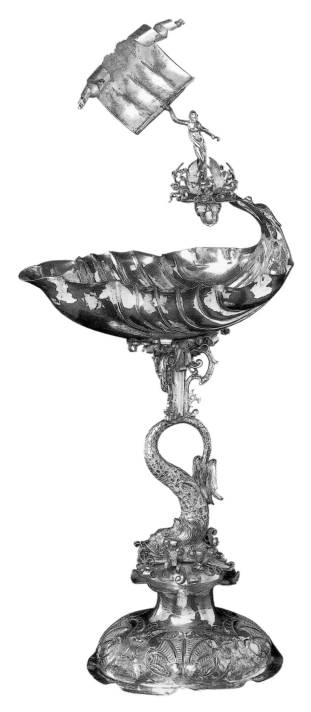

These ornamental maiolica drug-jars displaying the goddess Fortune riding on a dolphin were made for a pharmacy in Pesaro called 'At the Sign of Fortune', known to have been in business by 1565, by a local pottery run by Girolamo Lanfranco delle Gabicce.

The dolphin supporting this shell-shaped cup crowned by Fortune has lashed its tail fin right round against its own back, forming a taut bow on which gingerly to rest the shell. The cup was made by Hans Ludwig Baur of Ulm around 1660.

Fortune also held sway in northern Europe, witness an ornamental silver-gilt cup that she surmounts which is further animated by a dolphin serving as its stem, made at Ulm *c.* 1660 by the expert silversmith Hans Ludwig Baur.

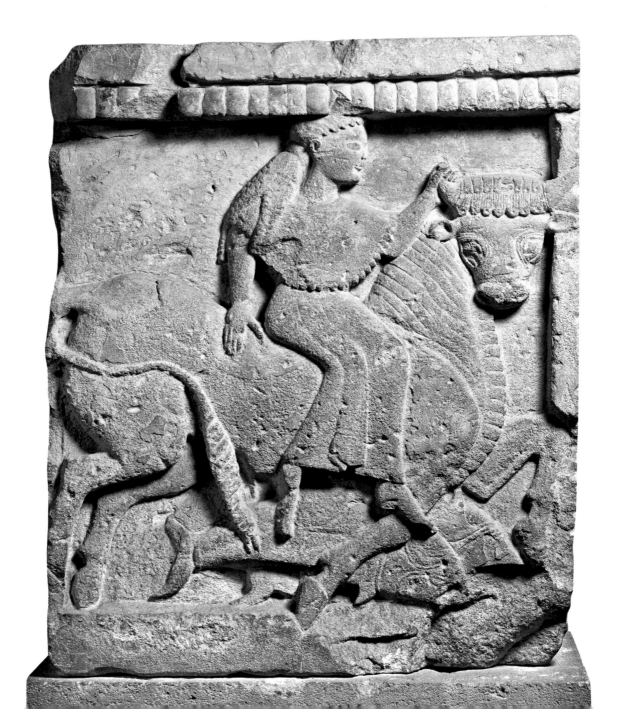

A stone metope from the frieze of Temple C at Selinunte in Sicily, mid-6th century BC. In this, the earliest known depiction of the myth of Europa and the Bull, the Greek sculptor has filled the space between the galloping hooves of Zeus with two purposefully swimming dolphins.

Europa

Since very ancient days dolphins, as a benign symbol of the sea, may be found accompanying a variety of other personages. Such a tradition was followed, for instance, in some images of the Abduction of Europa by Zeus/Jupiter, who in the guise of a handsome bull carries her across the sea. The dolphins perhaps serve an artistic purpose in animating the otherwise neutral area beneath the bull's hooves. In an Archaic Greek metope from Temple C at Selinunte in Sicily, a pair of dolphins proceed calmly beneath the excited quadruped. Two others cavort in front of and behind the bull on the side of an Archaic Greek black-figure amphora. And a single, rather self-conscious, one rides over the surface of the waters beside the rearing white bull in a Renaissance *cassone* panel painted some two millennia later by Liberale da Verona (overleaf). Europa reclines elegantly on the bull's back as if on a chaise-longue; she is depicted as a splendidly attired blonde maiden of the painter's own day, wearing a pair of fashionably pointed bright red shoes, like some supermodel of our times.

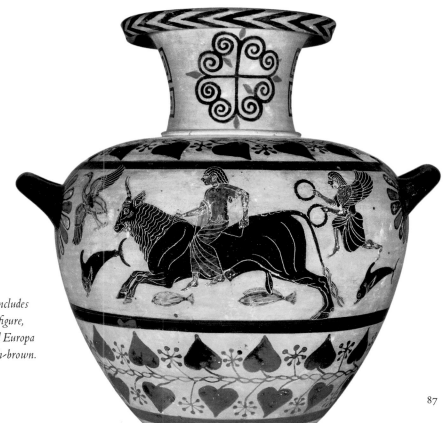

An Archaic Greek amphora includes two dolphin outriders in black-figure, like the bull, while two fish and Europa herself are picked out in reddish-brown.

*Europa and the Bull made a suitably erudite and romantic
subject for a painting on the front of a Renaissance 'cassone' or
wedding-chest, by Liberale da Verona, of 1500. At the right,
the bull – the god Jupiter in disguise – charms the girls, and
Europa climbs on his back. He then carries her across the
foaming sea to Crete, accompanied by a dolphin. When they
reach land, he assumes human shape and embraces Europa –
and the picture on the wedding coffer comes to an end.*

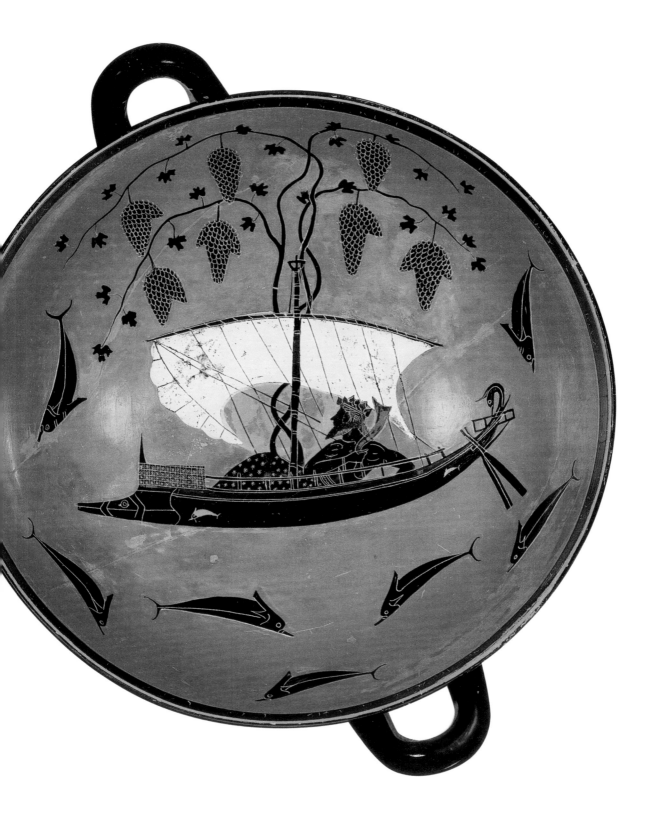

Dionysus & the Pirates

'Diviner than the dolphins is nothing yet created, for indeed they were aforetime men, and lived in cities along with mortals; but by the devising of Dionysos they exchanged the land for the sea and put on the form of fishes.'

Oppian

While the connection of the dolphin with Venus, Cupid and Neptune is easy to explain and quite well known, its association with Dionysus (Bacchus) and Apollo, the sun, two others of the Olympian gods, is more obscure and complicated, though evidently no less important. The Homeric Hymn to Dionysus relates how some Tyrrhenian pirates managed to kidnap the god as he was standing on the seashore. Once on board they were made to rue their folly by various miracles that he performed: the sail of their ship became covered with grapevines and its mast with ivy. The pirates became so terrified that they jumped overboard, whereupon they were turned, somewhat beneficently one might think, into dolphins. This story is beautifully illustrated in the bowl of an Athenian *kylix* (a shallow drinking cup like an Italian *tazza*) by the great ceramic painter Exekias. A gigantic figure of Dionysus reclining on one elbow occupies the whole skiff-like vessel, whose sail is bellied out by a strong wind. The mast is dwarfed by a pair of grapevines twisting around it and reaching into the sky, their leafy branches laden with great bunches of ripe grapes. Two dolphins (metamorphosed pirates) flanking the yard-arm appear to be hurtling in mid-air, as though jumping over the sail, just as Herodotus claimed that dolphins could. The hull of the vessel is streamlined like a dolphin, has a beak and eyes on its prow (typical of Greek ships), two tiny dolphins painted on its side, and a loop to its stern-post that also looks like a dolphin's head. The twin steering oars are unmanned, the god's willpower presumably being sufficient to guide the craft. Below dart five more dolphins in an imagined sea, for the shallow bowl provides a neutral continuum of sea and sky, which would be still more illusory viewed through some wine.

On this black-figure drinking cup the painter Exekias captured with crystalline economy of means the triumphant majesty of Dionysus after he has routed the pirates who had attempted to kidnap him, and turned them into better-behaved dolphins. Painted in Athens c. 530 BC, the cup was found at Vulci, an Etruscan site in Italy.

A slightly later hydria or water-jar made in Etruria, in central Italy (where the cup by Exekias was found) depicts the metamorphosis of the pirates into dolphins taking place in mid-air, just after they have leapt overboard: one on the left still has a human head and torso, while the remainder have dolphin heads but human lower halves. In an upper register, on the shoulder of the jar, a writhing figure of Triton brandishes a fish and a dolphin in either hand. Both scenes take place above a stylized pattern of breaking waves.

The Greeks told stories of the Great Flood (also recorded of course in the Old Testament with the story of Noah and his ark), which today is thought perhaps to have been the catastrophic flooding of the area of the Black Sea, when the waters of the Mediterranean broke through a land barrier near the Bosphorus. In the 3rd-century BC Greek writer Lycophron's *Alexandra* and in Ovid's *Metamorphoses* (completed in Rome in AD 8), a dolphin was said to have fed upon submerged trees and to have come face to face with a wild boar floating on the surface. The dolphin also rescued mankind from the flood, and brought back Dionysus in springtime, after he had seemingly died and disappeared into the waters during winter. The story of Dionysus' capture and escape from the Tyrrhenian pirates related above is by way of a gloss on this more general myth explaining the annual regeneration of plant and animal life.

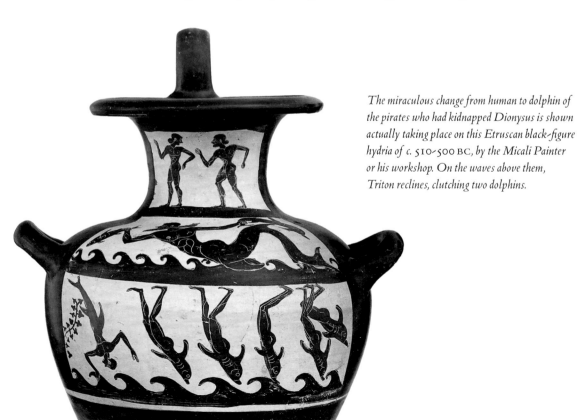

The miraculous change from human to dolphin of the pirates who had kidnapped Dionysus is shown actually taking place on this Etruscan black-figure hydria of c. 510-500 BC, by the Micali Painter or his workshop. On the waves above them, Triton reclines, clutching two dolphins.

Dolphins bear a never-ending procession of warriors' souls — one of which has a whirl of four dolphins on his shield — gracefully and charitably to the Elysian Fields. This frieze decorates a Greek red-figure wine-cooler used at symposia *or drinking-parties, by the painter Oltos, of c. 520-510 BC.*

The Dolphin 'Psychopompos'

In various other myths, the dolphin is associated with Apollo in conveying or accompanying the souls of the deceased across the waters of death, and thus assumes the role known in Greek as *psychopompos* – a guider of souls. It eventually became a standard decorative motif on Roman sarcophagi. Later on, this connotation encouraged Christians to identify the animal with Christ and the Resurrection, and then with the Virgin Mary, thus guaranteeing its use long after the classical period (see pp. 123-32).

A classic early illustration of this role is to be seen on a psykter or wine-cooler. Without a knowledge of Greek belief, one might have thought that the painter was depicting an idealized amphibious force; but instead the warriors or hoplites represent the souls of the heroic dead being ceremonially transported to the Elysian Fields, over the River Styx – rather than paying one *obol* to Charon, the ferryman, who rendered this service to ordinary mortals.

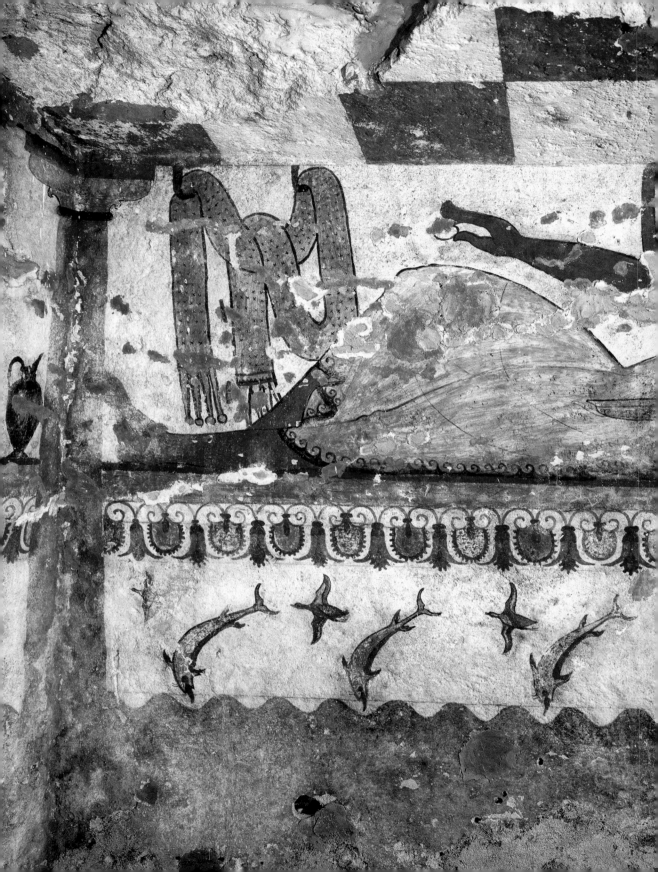

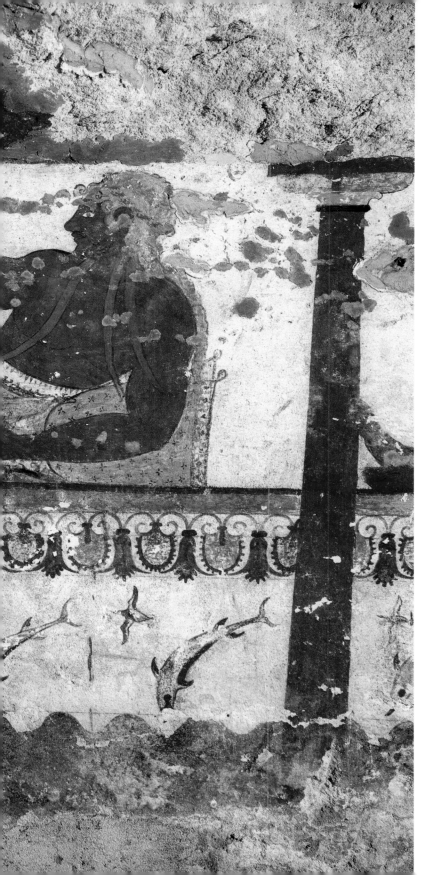

In this spectacular fresco in the
Tomb of the Lionesses at Tarquinia,
c. 520-510 BC, the frieze of leaping
dolphins below the reclining Etruscan
reflects their role as accompanying
special souls into the afterlife.

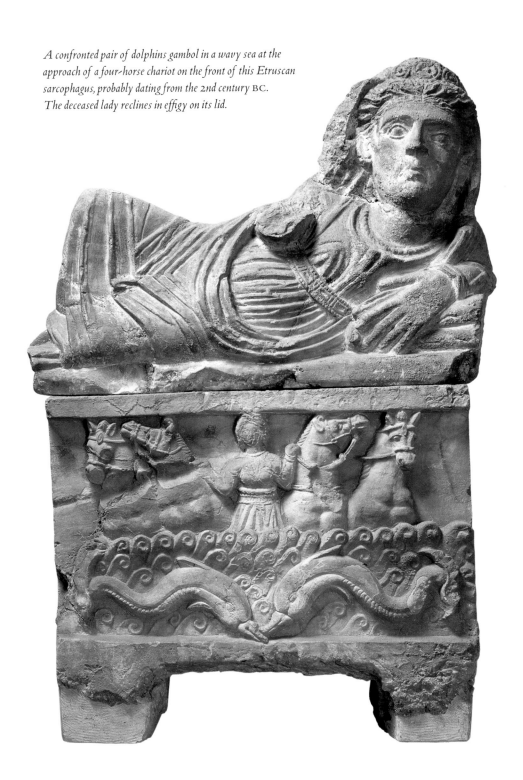

A confronted pair of dolphins gambol in a wavy sea at the approach of a four-horse chariot on the front of this Etruscan sarcophagus, probably dating from the 2nd century BC. *The deceased lady reclines in effigy on its lid.*

As so often, the Etruscans followed the Greeks in their beliefs and so dolphins are associated with their burial chambers and tombs. The most splendid representation of them is in the so-called Tomb of the Lionesses at Tarquinia (pp. 94-95). The deceased is shown life-size, lying – after death, as in life – at a banquet (*symposium*); below is a frieze of anthemions and palmettes, and below that a delightful row of dolphins performing in time an elegant leap into a wavy, blue sea, accompanied by as many flying ducks.

Other, fairly rare, images prove the survival of this belief in Roman religion. And as is so often the case with time-honoured symbols, it was retained in the imagery of the Early Christian Church, in an attempt to suggest some continuity, within radical change.

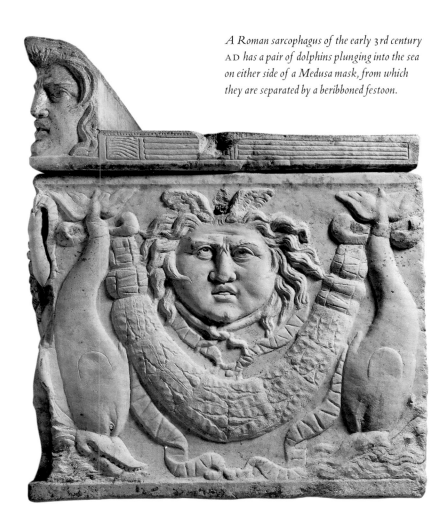

A Roman sarcophagus of the early 3rd century AD *has a pair of dolphins plunging into the sea on either side of a Medusa mask, from which they are separated by a beribboned festoon.*

The most prominent examples of dolphins in Christian art are to be found in the mid-6th-century mosaics on the chancel arch of the church of San Vitale in Ravenna. At the apex of the arch, Christ as Pantocrator stares out earnestly from within a circle whose changing colours and tesserae recall – perhaps – the classical symbol for Eternity, a snake biting its own tail, while outside this on either side, the Saviour is accompanied protectively by two pairs of dolphins linked by their tails. Down the sides of the arch, Peter and Paul and other Apostles look out from a series of parti-coloured roundels which are upheld from below by similar pairs of beneficent dolphins, rather as though they were swivelling circular mirrors in a U-shaped support.

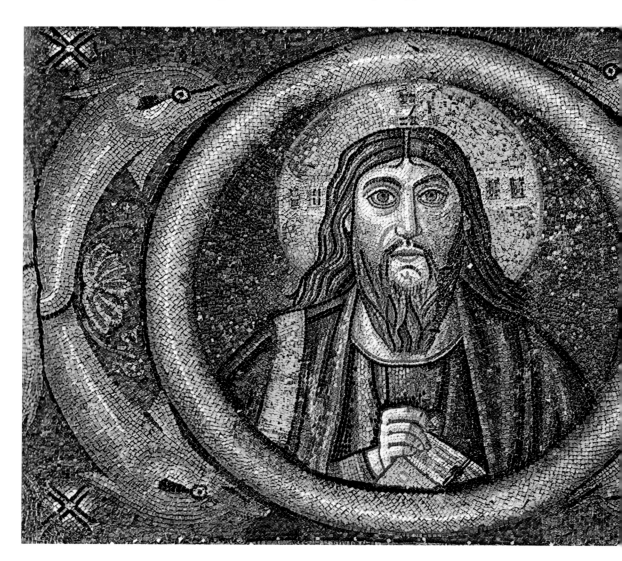

On the inner face of the arch separating the nave
from the chancel of San Vitale in Ravenna, roundels
of Christ and his Apostles (depicted rather as on
the coinage of Byzantine emperors) are framed by
prominent images of dolphins.

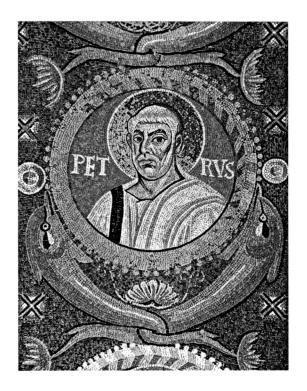

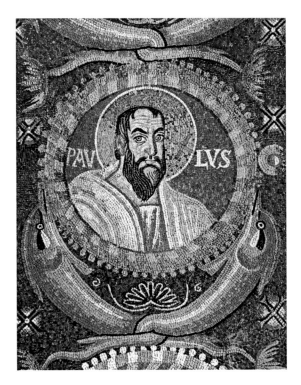

The classical idea was revisited – amazingly as it might seem – by that complex late medieval northern painter Hieronymus Bosch, in the background of the central panel of his triptych, *The Garden of Earthly Delights*. Wilhelm Fraenger describes it thus: 'From the left two dense processional throngs of dolphin-knights come swimming, all identical in appearance, their faces hidden under lowered visors. Their heraldic emblem, the dolphin sacred to Apollo, occurs several times: they carry it in the fork of a divining-rod held aloft at the head of the procession, and it plays around them in the water too.' He continues with a learned explanation: 'in the Pythagorean doctrine of metempsychosis the dolphin embodied a transitional stage that the soul passed through on its journey towards a higher re-birth. In other words, the masked identical dolphin-knights are the "greater army" of those who have died, the universal brotherhood of the dead, travelling out of earthly into eternal life.'

The association of the dolphin with death and the journey to the afterlife was well understood by literate society at the time, as can be seen by its appearance in a contemporary emblem book, where a pair of dolphins flank a Medusa head to decorate a classicizing tomb, as on the Roman sarcophagus (p. 97).

In the upper realm of the central panel of 'The Garden of Earthly Delights' by Hieronymus Bosch, of 1500-1505, two processions of dolphin knights sail across, led by a figure holding up a dolphin in a forked stick, while another such knight flirts with a mermaid nearby. This complex scene is but a detail of an immense, encyclopaedic, disquisition upon Christian morality.

Dolphins frame a Medusa head on a tomb: emblem no. 156, 'Appropriate to Death', from an edition of Andrea Alciati's 'Emblemata' published in Padua in 1618.

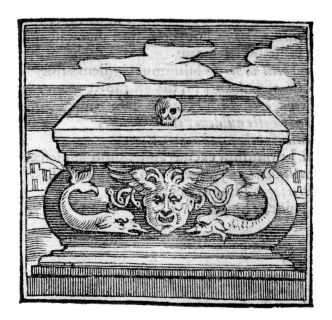

Apollo, God of the Sun

The god associated with the dolphin as guider of the soul is Apollo: in one manifestation he was worshipped specifically as 'Apollo Delphinius', in a cult that was widespread. One of Apollo's principal shrines was at Delphi in mainland Greece, near the Gulf of Corinth, a spot that received its very name from a dolphin, which was said to have led some mariners from Crete by swimming in front of their boat or even leaping into it, to the harbour of Cressa at the foot of the crags down the side of Mount Parnassus, on which the whole sanctuary was eventually laid out. In fact Apollo may have been linked with an earlier deity actually called Delphinius: there was a month during the spring with that name in the calendars of Crete, Aegina, Chios and Thera. In Aegina, an island off the coast near to Athens, a festival of Apollo celebrated in this month was devoted to the cult of the dead, involving the ceremonial carrying of water and therefore called the 'Hydrophoria'. A sanctuary to Apollo Delphinius in Athens was supposed to have been founded also by sailors from Crete, who, after being caught in a storm, were led to safety in Attica by Apollo himself, disguised as a dolphin (this smacks of a derivation from the foundation myth of the oracle of Apollo at Delphi).

In Rome, Apollo was worshipped in the shape of a dolphin during the ceremony of the 'Quindecimviri' or 'Fifteen Men'. As Servius relates, 'today the dolphin is placed on top of the cauldrons of the *quindecimviri*, and the day before they offer sacrifice the dolphin is carried around as a symbol, for this reason, that the *quindecimviri* are warders of the Sybilline Books, moreover the Sibyl is the prophetess of Apollo and the dolphin is sacred to Apollo.'

Apollo seated on the tripod sacred to him in Delphi, with leaping dolphins in attendance, is celebrated on this red-figure hydria by the Berlin Painter, c. 500 BC.

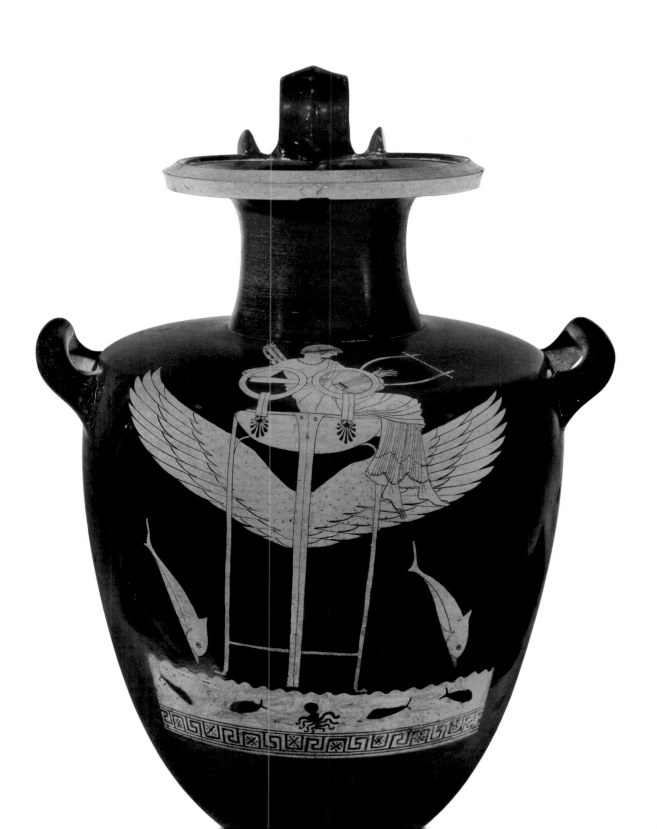

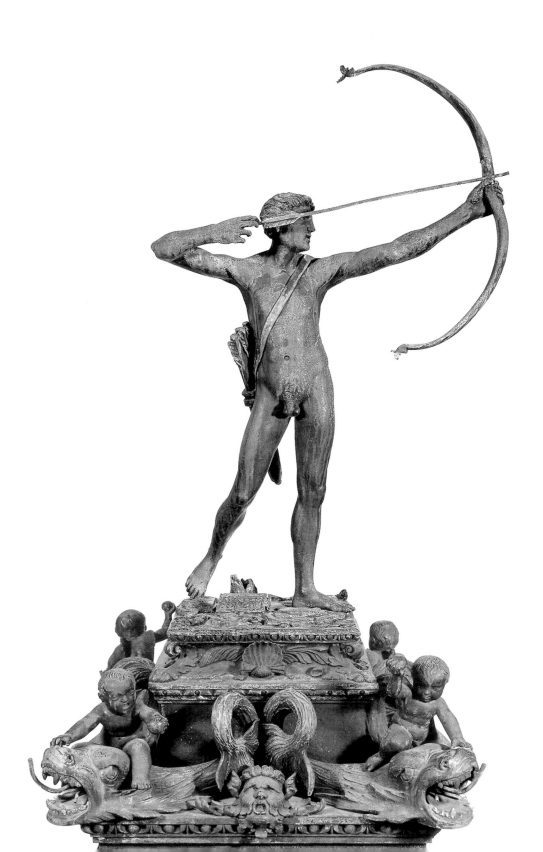

Also in Roman times, presumably on account of the dolphin's reputation for speed, a bronze image of one, counterbalanced by an eagle, was used as a starting signal for races in the Hippodrome at Olympia: this was activated by the release of a spring which, as on a seesaw, made the eagle rise just as the dolphin dived downwards. In a similar sporting context, seven dolphins were mounted as signs at either end of the central division (the *spina*) of Roman circuses, one being turned down to mark the completion of each lap of a race (they can be seen on a particular class of sarcophagus in which Cupids drive chariots round a circus). The practice is said to have started under Agrippa, which may account for the fact that a dolphin support (like that of Venus, p. 56) features on one statue of him. It also explains the combination of dolphins with tridents and cockle-shells on the Corinthian friezes of the Baths of Agrippa in Rome. A couple of writers of the later Roman period, Cassiodorus and Tertullian, state that the lap-signal dolphins also spouted water into the middle of the arena: perhaps this was a later hydraulic mechanism and function, but it signals their frequent use thereafter in the appropriate and handy role of fountain-figures.

The dolphin eventually became a favourite feature of Roman domestic fountains, famously those in bronze that have come down to us complete, owing to the earthquake that engulfed Pompeii and Herculaneum – themselves seaside resorts, where the real creature could no doubt be seen sporting in the waves of the Bay of Naples. That bay is the scene of one of the later versions of the story of the boy on a dolphin: the Roman scholar Pliny – who actually died in the eruption of Vesuvius in 79 AD – relates in his *Natural History*: 'In the reign of the late lamented Emperor Augustus a dolphin that had been brought into the Lucrine Lake fell marvellously in love with a certain boy, a poor man's son, who used to go from the Baiae district to school at Pozzuoli, because fairly often the lad when loitering about the place at noon called it by the name of Snub-nose and coaxed it with bits of bread he had

The association of Apollo and the dolphin is reflected in the classical Fountain of Apollo designed in 1531 by the Nuremberg sculptor Peter Flötner, who had just returned from a visit to Italy: the god is accompanied perfectly appropriately by four dolphins ridden by little boys to serve as spouts. The bronze cast by Pankraz Labenwolf was completed a year later.

with him for the journey, . . . and when the boy called to it at whatever time of day, although concealed in hiding, it used to fly to him out of the depth, eat out of his hand, and let him mount on its back, sheathing as it were the prickles of its fin, and used to carry him when mounted right across the bay to Pozzuoli to school, bringing him back in a similar manner, for several years, until the boy died of disease, and then it used to keep coming sorrowfully and like a mourner to the customary place, and itself expired, quite undoubtedly from longing.'

All in all, a far wider range of associations – all of them positive – sprang into the minds of the ancients, and to a lesser extent of their heirs during the Renaissance, when they spotted a school of dolphins than they do in the case of today's observer: reminders of four of the Olympian gods (a third of the total of a dozen!); ideas of rescue; of the rebirth of the seasons, or of the resurrection of the soul after death; ideas of love, music and poetry. Not surprisingly among peoples dwelling around the shores of the Mediterranean and Aegean Seas and their islands, the dolphin occupied a bigger and more important place in the imagination than, stripped of its mythological associations, it ever can today, when it is seen merely as a harmless mammal to admire, albeit a particularly charming, intelligent and intriguing one.

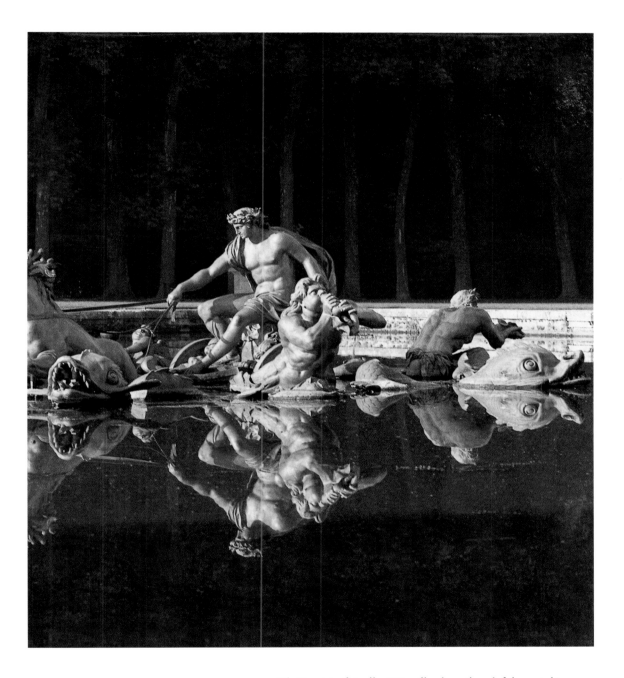

The Fountain of Apollo at Versailles shows the god of the sun in his chariot, with tritons and dolphins as outriders, about to begin his daily journey through the sky. Made by Jean-Baptiste Tuby and installed in 1671, the sculpture's importance mirrors the fact that King Louis XIV had taken — in common with various distinguished predecessors — the radiant sun as a symbol of his person, hence his sobriquet 'The Sun King'.

III THE SYMBOLIC DOLPHIN: EMBLEMS, HERALDRY, & ATTRIBUTES

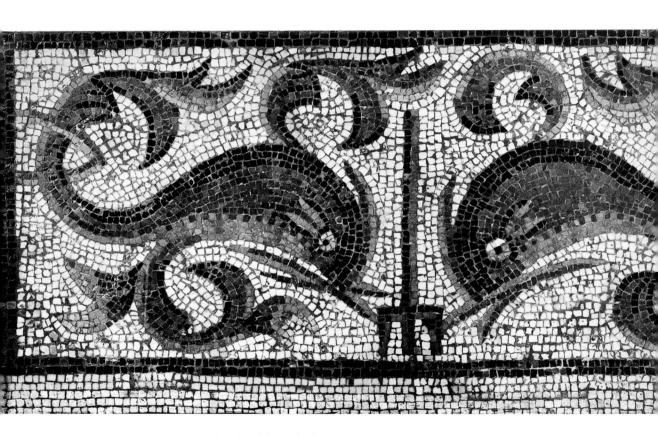

*This delightful pair of dolphins sporting with a trident on
a 2nd-century AD Roman mosaic is arranged symmetrically,
but – to avoid monotony and enhance the sense of movement –
their fins, stylized quite unnaturally into acanthus-leaf
shapes, are not identical: visually they double up as waves
and seaweed being thrashed into a turmoil.*

Our Elders, when their meaning was to shew
A native-speedinesse (in Emblem wise)
The picture of a Dolphin-Fish they drew;
Which, through the waters, with great swiftnesse, flies,
An Anchor, they did figure, to declare
Hope, stayednesse, or a grave-deliberation.

George Wither, *A Collection of Emblemes*, London, 1635

The Trident

The trident wielded by Poseidon/ Neptune is an effective form of harpoon, such as was – and still is – used in the Greek world for spearing all kinds of fish. Over time, the dolphin's form was found to entwine harmoniously round it, as also round an anchor. The hard, metallic, man-made lines of these pieces of nautical apparatus contrast pleasingly with the sinuous outlines and implicit rapid movement of the creature.

A characteristic example is provided by a Roman mosaic from the 2nd century AD: a pair of dolphins confront each other on either side of a trident, tines down, that plunges vertically between their snouts. Their beady eyes give a look of concentration, as though they were aiding its passage.

An ancient Roman sculptor when carving the frieze of the Basilica of Neptune to the south of the Pantheon in Rome (overleaf) approached the same topic quite differently: he set the trident upright (behind a displayed shell), adding reinforcement to its tines in the form of volute-brackets, which serve also to soften its rigid mechanical contours and echo the counter-curves of the neighbouring dolphins' tails, a clever piece of design. The trident's cross-bar is also continued visually on either side into the shape of an inverted bow by their adjacent tail fins. Dolphins, trident and shell are grouped again on what may be an ancient Roman fragment that supports a holy-water basin in St Mark's, Venice (p. 149).

A millennium or more later, the Florentine High Renaissance sculptor Fra Giovanni Montorsoli, one of the pioneers of public fountains in the 16th century, revisited the theme of the ancient Roman frieze when he came to carve some fountains for Sicily, notably in the exciting figural plaques that punctuate the plain mouldings of the rim of a fountain dedicated to Neptune in Messina (for a discussion of the fountain as a whole, see p. 71).

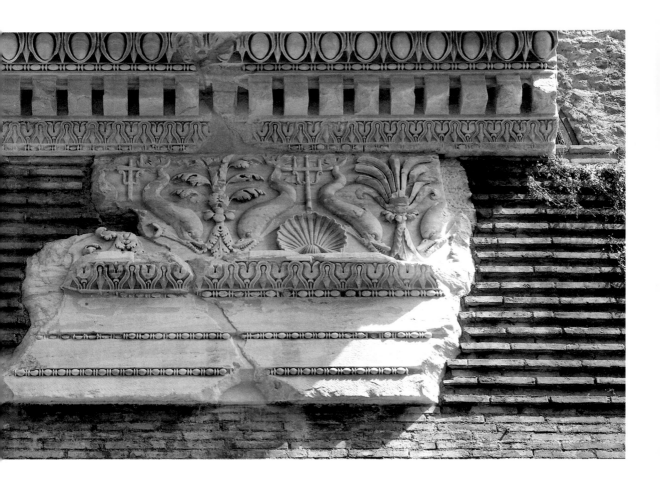

The richly carved frieze of the Basilica of Neptune in Rome, rebuilt by the Emperor Hadrian c. 118–125 AD, integrates the standard motif of dolphins flanking the god's symbolic trident with foliate ornament, alternately an acanthus (left) and an anthemion or stylized honeysuckle.

On the Neptune Fountain at Messina, of 1553–57, the god overcomes Scylla and Charybdis; around the basin, Fra Giovanni Montorsoli cleverly squeezed the marine elements of the frieze of the Temple of Neptune, overlapping the dolphins and entwining their tails with one another round the shaft of the trident, to fit neatly into a rectangular field.

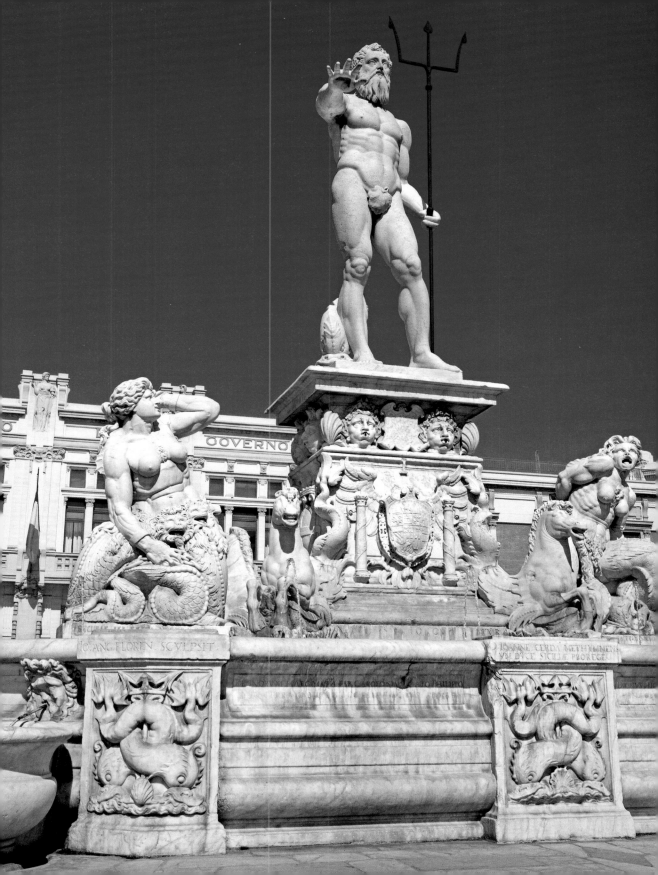

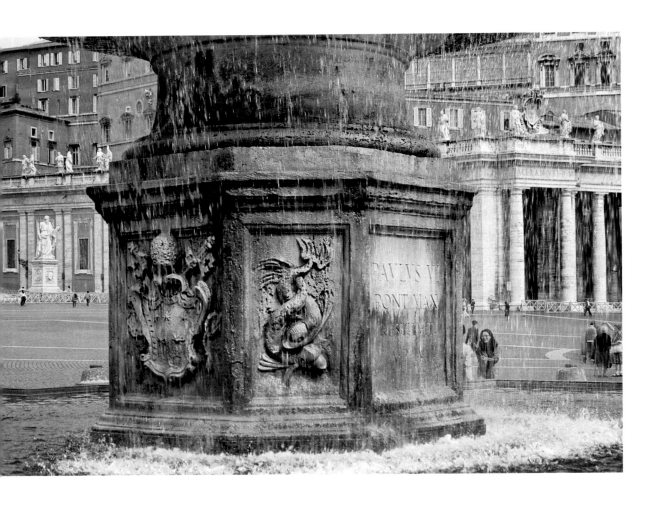

The papal coat-of-arms of Clement X (Altieri) alternates with panels of cavorting dolphins round the base of a fountain by Bernini in the Piazza of St Peter's in Rome. Poised above the basin and seen behind a curtain of falling water, they seem to be in their natural element.

The design of the Parisian 'wallace' drinking fountain, by Charles-Auguste Lebourg, in an eclectic, neo-Renaissance style, includes on its lower flanks the ancient attributes of Neptune: a dolphin and trident. (This cast was installed in the garden of Hertford House, Sir Richard Wallace's London residence – now the Wallace Collection – after his death.)

A century later, in 1677, Bernini appropriated the device for a pair of fountains in the Piazza of St Peter's, Rome. But, Baroque designer that he was, he omitted the rectilinear trident from his pattern of sinuously – almost sensuously – entwined dolphins, whose fleshy curves and counter-curves echo those of the elaborate frame round the coat-of-arms on the adjacent panels. The motif of dolphin and trident had a long life, becoming secularized by degrees, so that it simply denoted 'water', as is probably the case with its appearance on the fifty cast-iron public drinking fountains designed by Charles-Auguste Lebourg that were presented to the City of Paris in 1872 by Sir Richard Wallace, which have ever since been known to the French as *les wallaces*.

One ancient example of the motif has been reserved until now, as standing outside the normal tradition of representations; for a freer, more painterly, approach was permitted – indeed necessitated – by the medium of fresco to a Roman artist who decorated the wall of a tomb, deep underground, in a catacomb dedicated to Jewish burials. Its appearance in this funereal context suggests some knowledge of the pagan concept of the dolphin as a conveyor of the soul into the afterlife or *psychopompos* (see p. 93), despite the different faith of the deceased. It has the same sense of energy and movement, here engendered by the whiplash of its imaginary tail, as the fresco from Pompeii with Cupid in his dolphin-chariot (p. 43; cf. also p. 76).

Dolphin swimming with a trident, frescoed on the wall of a
Jewish tomb beneath the estate of the Villa Torlonia in Rome.

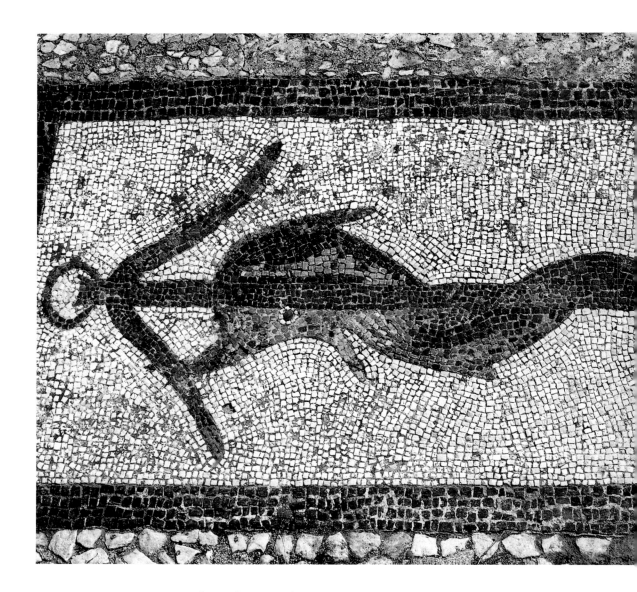

Hellenistic floor mosaic of a dolphin and anchor
in the House of Dionysus on Delos.

The Anchor

To turn now to designs of a dolphin with an alternative man-made piece of nautical equipment, the anchor, there is also on the island of Delos, but in the House of Dionysus, a Hellenistic mosaic floor that employs the device of the dolphin and anchor to good effect, though in different ways, sometimes with the shaft of the anchor running parallel with the long side of a rectangle, and sometimes with it on the diagonal of a square field. Some centuries later, the cross-bar and shaft of the anchor were reinterpreted by Christians as the cross of Christ and the dolphin as a symbol of the Saviour.

Before the new faith was accepted by the Roman Empire under Constantine, this initially may have served as a secret sign, for as Douglas Keister explains, 'The fish is one of the most common Christian symbols. It can be seen everywhere from tombstones to bumper stickers. The symbols of sacramental fish, with wine and a basket of bread, represent the Eucharist and the Last Supper in Christian art. The fish symbol developed as a Christian icon for a number of reasons. It was often used as a part of a secret code during times of persecution by the Roman government.' More pertinently for us, the dolphin could easily be confused with a fish, and thus, as the same author continues, 'Besides the generic Christian fish symbol, the dolphin is the most frequently portrayed marine animal in Christian art and symbolism. On funerary monuments, dolphins are often intertwined with an anchor, which was an early disguise for a cross. Dolphins symbolize salvation (in mythology they are often portrayed as rescuing sailors), transformation (Bacchus was said to have turned drunken sailors into dolphins), and love (they are widely thought of as friendly and playful marine mammals).'

In 1499 Francesco Colonna published in Venice his erudite novel, *Hypnerotomachia Polifili*, an account of a dreamlike quest for love by the young hero, Poliphilus. At one point he comes across 'an antique marble bridge', which had panels of porphyry and serpentine let into its parapet. They were incised, like some ancient Egyptian obelisk, with hieroglyphs (thought up by the author Colonna and illustrated). Poliphilus writes of one panel, 'I saw this elegant carving: a circle, and an anchor around whose shaft a dolphin was entwined. I could best interpret this as ΑΕΙ ΣΠΕΥΔΕ ΒΡΑΔΕΣ: Always hasten slowly.' Or in Latin, as we know the tag best, 'Festina lente'. Surprisingly, Colonna, who was a Dominican monk, and his hero are thus discounting any messages of death and resurrection, whether pagan, Jewish, or Christian. This secular interpretation was followed in 1635 by an Englishman, George Wither, as cited in the epigraph to this chapter (p. 109). Wither enlarged upon his motto at some length, adding, however, to the symbolism of the anchor, the Christian virtue of which it is the standard attribute, Hope, summing up: 'By *speedinesse*, our works are timely wrought; By *staydnesse*, they, to passe are, safely, brought.'

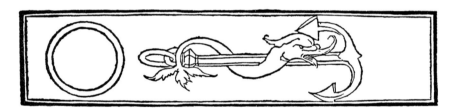

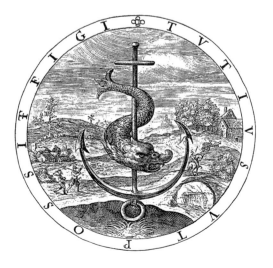

This horizontal panel incised with a dolphin entwined round an anchor follows closely in the ancient Greek tradition of design, conveyed down the centuries to Francesco Colonna. This woodcut from his 'Hypnerotomachia Polifili', published in Venice in 1499 by Aldus Manutius, shows what the hero describes as a hieroglyph. He interpreted its meaning as 'Hasten slowly'.

George Wither in his 'Collection of Emblemes', published in London in 1635, uses the time-honoured device to proclaim the same sentiment as Colonna ('as the Dolphin putteth us in mind'): 'If Safely, thou desire to goe, Bee not too swift, nor overflow.'

The Venetian printer Aldus Manutius adopted Colonna's design for his mark, and his heirs continued to use it after his death in 1515. In this edition of Castiglione's 'Il libro del Cortegiano', published in 1528, it melds in perfectly with the print of the text, so as to give a harmonious and pleasing appearance to the page.

IL LIBRO DEL CORTEGIANO
DEL CONTE BALDESAR
CASTIGLIONE.

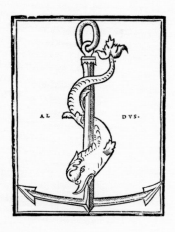

Haffi nel priuilegio,& nella gratia ottenuta dalla Illeftriffima
Signoria che in quefta,ne in niun'altra Citta del fuo
dominio fi poffa imprimere, ne altroue
impreffo uendere quefto libro
del Cortegiano per·x· anni
fotto le pene in effo
contenute ·

Meanwhile the attractive and meaningful device had been pressed into service as an elegant printer's mark by the famous early publisher Aldus Manutius, working in Venice between 1491 and his death in 1515. It was Aldus who printed the *Hypnerotomachia Polifili*. At least five (slightly variant) renderings of his mark are known, of which one graced the title-page of another crucial book of the High Renaissance, Baldassare Castiglione's *Il libro del Cortegiano*.

(Also in the realm of books, *The Dolphin* was a journal devoted to all aspects of fine book production, published in New York between 1933 and 1941; its device was a lively diving dolphin, without the steadying anchor. The employment of the dolphin in such roles may have had some – at least subliminal – influence on the choice of the dolphin by the founders of Thames & Hudson in 1949 to symbolize the ethos of their new publishing house.)

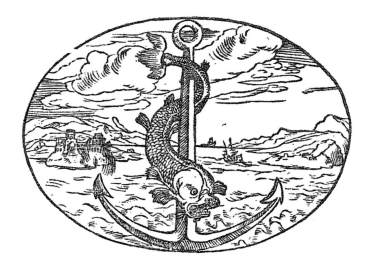

Paolo Giovio noted that the Roman Emperor Titus used the device of dolphin and anchor on his coins. In the French edition of his book, 'Dialogue des devises d'armes et d'amours', published in Lyon in 1561, this is illustrated anachronistically with a charming seascape as a setting.

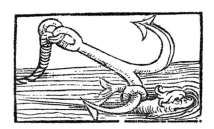

A woodcut in Andrea Alciati's 'Emblemata' (here the Padua edition of 1618) shows a beneficent dolphin towing an anchor, to save a ship full of storm-tossed sailors – demonstrating the protective attitude with which, in Alciati's view, a ruler should treat his subjects.

This minute engraving from an edition of Alciati's 'Emblemata' published in Antwerp in 1584 illustrates another proverb: a dolphin writhing in its death throes on a beach is a lesson in the effect of over-confidence.

In the generation following Aldus Manutius, Paolo Giovio in a book on heraldry noted how the Emperor Titus had used the device of dolphin and anchor on his coinage; in the French edition, *Dialogue des devises d'armes et d'amours* (Lyon, 1561), this is illustrated not with a dry, medallic miniature, but with the device set amidst a romantic seascape, with distant shorelines, cities, mountains and ships. This may have been known to the illustrator of Wither's emblem book (p. 116). An active version of the subject was also used by Andrea Alciati in his *Emblemata*, first published in 1531, to illustrate the concept of 'A ruler ensuring the safety of his subjects'. He writes: 'Whenever the Titan brothers stir up the waters, a cast anchor helps the unhappy seamen. Then the dolphin, which is well-disposed towards mankind, takes it in its coils and tows it through the waves as safely as possible. Similarly, it behoves Kings, bearing this in mind, to behave as though they were using the anchor to save the sailors and as if the people were their own.' (A distinctly less happy dolphin, beached and about to expire, was used by Alciati to illustrate his emblem no. 116, 'On he who perishes on account of the over-confidence of his crew'.)

Dolphins also feature as benign denizens of the deep on printed maps of the oceans, on globes, and on navigational instruments, their designs usually being derived from sources such as have just been described.

The draughtsmen of maps and globes used the dolphin to symbolize the sea: here a detail of one of Willem Blaeu's early 17th-century globes.

The Dolphin in Early Christian & Renaissance Art

We have tried to consider some of the main contexts in which artists of the Renaissance (and later still) drew on ancient, pagan sources under the appropriate classical deities or symbols. Inevitably, this has not included every manifestation from the 15th and 16th centuries.

The most extraordinary, indeed the most enchanting, such omission, albeit of a probably classical subject, a Muse, is by Cosmè Tura. In terms of learned identifications this good lady has been – and remains – all things to all men, from Venus to Spring to an 'Enthroned Goddess', and from 'the Muse Erato' to 'the Muse Calliope'; the current catalogue of the National Gallery, London, that houses it, opts for 'A Muse (Calliope?)'. The dolphins have defied explanation, unless the goddess is considered to be Venus or Erato, Muse of Erotic Poetry; or unless they were a private device of Borso d'Este, for they appear more than once in the court art of Ferrara. The painting was probably part of the decoration of the *studiolo* of Lionello d'Este, a set of the Nine Muses, which was commissioned initially in 1457. Tura's involvement in completing the series is not certain, but this picture and another (now in Milan) depicting possibly the Muse of Dance, Terpsichore, are held to be part of – or at least to reflect – his contribution. Tura certainly excelled himself here with the vivid imagination and sure hand that created this audacious image. The Muse – if such she be – is sitting in an active, and therefore at the time a rather provocatively masculine, pose (like that for example of Michelangelo's Medici Captain in the New Sacristy of San Lorenzo in Florence). But the simple marble components of her throne are ornamented – indeed in respect of the shell-niche above held together – by no fewer than six bizarrely stylized, if not downright threatening, dolphins. Seemingly made of gold or gilt bronze with ruby eyes, all have razor-sharp fins with pointed tips that are perhaps meant to form a protective barrier round the heroine like thorns round a rose (a common metaphor for the pain that comes with the pleasure of love). They may also be intended to reflect oriental bronzes, for their stylization and exaggerated extremities do not look like anything in the Graeco-Roman tradition of dolphin representation.

An unheard-of type of throne ornamented with stylized metal dolphins supports a richly clad allegorical figure in this picture by Cosmè Tura, in the bizarre style of his native Ferrara, c. 1455-60.

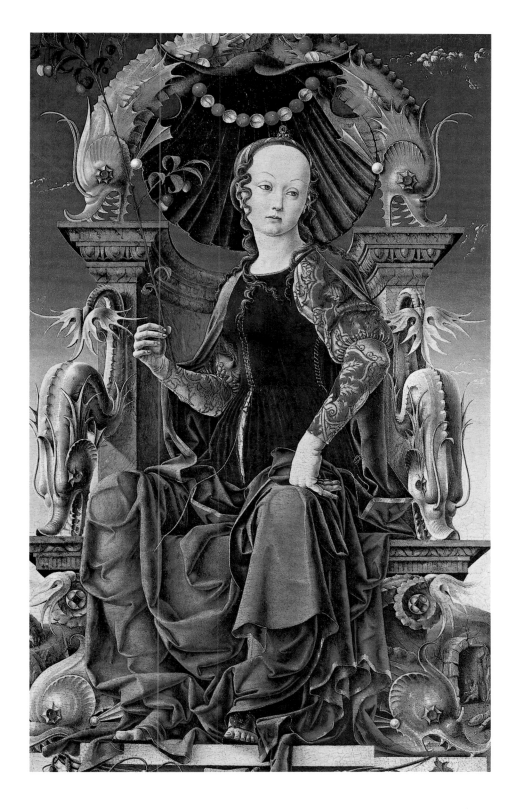

It is interesting to note how at much the same time and place Renaissance artists could imbue the dolphin with such diverse meanings. The art historians Michael Jacobsen and Vivian Jean Rogers Price explain: 'Dolphins appear in conjunction with episodes from the life of Christ, in particular those episodes that especially emphasize His role as Saviour, such as the Nativity, but also the Annunciation. But even more frequently dolphins decorate images that are non-narrative, or rather, are fixed "ideal moments" such as images of the Madonna and Child, the Man of Sorrows or the Dead or Risen Christ. Such images often emphasize Christ as the source of salvation. In both narrative and symbolic representations, the dolphin usually decorates the throne, tabernacle, triumphal arch, or other framing device within or around the central image.'

They cite as a classic example an illuminated initial enclosing a diversely populated scene of the Adoration of the Magi, above and below which two dolphins disport themselves, as though diving in opposite directions through a ring: both are gilded, which makes them look more like bronze statues than live animals. Their tails, stylized into leafy finials, interrupt the notes of the musical score, while they coyly hold strings of three pearls – like sprigs of red-currants – in their beaks: could these be marine symbols of the Virgin Mary or of the Trinity?

In a page from a choral book, illuminated c. 1470-80 by Girolamo da Cremona and Liberale da Verona, two incongruous dolphins play with the initial framing the Adoration of the Magi.

A Renaissance architect known as Il Cronaca happily for posterity
recorded the appearance around 1480 of the 'Fountain of Life' that stood
in the forecourt of Old St Peter's in Rome sheltering the ancient Roman
pine-cone. Its gargoyles were ancient bronze dolphins of about natural size,
hence very impressive – now, alas, lost.

Antonio Pollaiuolo, a Florentine of the same generation as Il Cronaca,
when inventing a novel tomb for Pope Sixtus IV (of Sistine Chapel fame)
was perhaps inspired by the dolphin spouts with acanthus-leaf mounts of
the 'Fountain of Life' for the four corner 'legs' of the bier, whose profile can
be seen as that of a stylized dolphin, though the 'beak' is actually a lion's
paw. Sixtus died in 1484; the tomb was completed in 1493.

Possibly the artists had at the back of their minds an early Christian re-use of some classical remains to form a 'Fountain of Life', which stood in the forecourt of Old St Peter's in Rome until it was demolished to clear the site for the new Basilica. Round a colossal bronze pine-cone, a symbol of generation and resurrection for the ancient Romans (the pine being the Tree of Life), which was adopted by the Christians, stood a neat little structure decorated with paired peacocks (still to be seen flanking the pine-cone in the Belvedere Courtyard in the Vatican). Four enormous bronze dolphins (springing from acanthus leaves) functioned as gargoyles at the corners, and were thereby converted from paganism to serve the new religion.

It has never before been remarked that this ancient set of dolphins, seeming to swoop downwards and outwards from a rectangular structure, may have been the source for Antonio Pollaiuolo's witty adaptation to serve as 'legs' for an ornamental bier on which he presented an effigy of Pope Sixtus IV in his unprecedented bronze tomb in St Peter's. The intervening six lesser 'legs' have been interpreted as echoing the dolphin motif, diminuendo, with scrolled, leathery volutes – instead of lion's paws – indicating eyes, snout and tongue amidst curling waves. It is interesting to see how influential were some great antiquities of the past, which, owing to their subsequent total loss, are virtually unknown, even to specialists, today. The learned clerics of the Vatican would also doubtless have informed Pollaiuolo of the classical concept that the dolphin served as *psychopompos*, accompanying the heroic dead into the Elysian Fields (see p. 93), so the Pope's strange bier could also be seen as a funeral barge, drawn and guarded by the ten docile symbolic creatures.

Stefano Bolognini added a double dose of 'psychopompic' dolphins to the architectural surround of a chapel in Santa Maria dei Miracoli in Brescia, to aid the passage of the deceased into the afterlife, while reminding the living of the omnipresence of death by the worm-ridden skull resting on a fiery furnace. The supporting child-caryatids are no benign sprites, but turn out to be threateningly diabolic too, for they have the hideous lower bodies of the classical harpies, monsters who were ready to swoop and snatch away souls.

A relief of the Madonna and Child by Andrea della Robbia in glazed ceramic, from the Badia in Florence, c. 1500, has dolphins flanking its 'foot' – not by a happy chance of design, but to enhance its message of salvation to passers-by.

Such knowledge must also have been available to a stonecarver at the opposite end of Italy, at Brescia in the far north, near the sub-Alpine quarries: for four aggressive-looking specimens of dolphins, duly decorated with acanthus-leaf fins, are incorporated around the bases of engaged columns in a chapel in Santa Maria dei Miracoli. There are many examples of dolphins meaningfully inserted into the architectural settings of Renaissance altarpieces: friezes carved with dolphins feature near the Madonna, for instance, in Crivelli's *Demidoff Annunciation* of 1476 (National Gallery, London), in Filippino Lippi's *Altarpiece of the Otto di Pratica* of 1485-86 (Uffizi, Florence), and in Lorenzo da San Severino's *Madonna enthroned with Four Saints* of around 1490 (Cleveland Museum of Art). In the last example, an inscription specifically associates Mary with the sea, as 'Stella Maris' or 'Star of the Sea', one of her standard epithets, which was particularly beloved of seafarers, and so the association with dolphins was doubly appropriate and clearly deliberate.

Meanwhile, in Florence, Andrea della Robbia enjoyed using the reversed curves of a pair of dolphins (facing outwards with a rather aggressive look), glazed white against his customary blue background, instead of the usual cornucopiae or etiolated volutes, to form the contours of the console supporting one of his panels of the Madonna and Child.

The Virgin Mary's lectern in an *Annunciation* by Braccesco in the Louvre is carved with dolphins, and so is the overdoor that is given great prominence in the top centre of an *Annunciation* by Albertinelli. There, a roundel is supported by the dolphins' tails, which are transmogrified into foliate scrolls terminating in a rosette (the subject of the sculpture, the Sacrifice of Isaac, was held to prefigure the ultimate sacrifice that would be made for mankind by Christ). And the curls on the capitals of the elegant Renaissance pilasters that articulate Mary's chamber – like the volutes of an Ionic capital – on close inspection turn out also to be the tails of dolphins, attacking a central monster, with which they are enmeshed, as in the classical motif of their attacking an octopus, symbol of evil (cf. p. 57).

Mariotto Albertinelli painted this Annunciation in 1497. Prominent dolphins support the roundel over the doorway containing a depiction of the Sacrifice of Isaac, and further dolphins appear in the capitals.

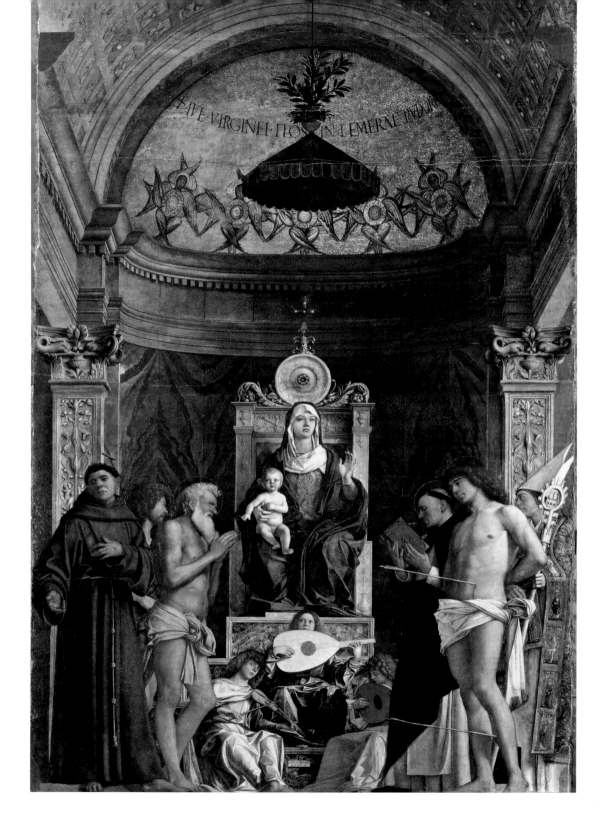

A similar motif – though without the added drama of this aggressive activity – animates the capitals of the apsidal hall within which the Virgin and Child are enthroned between six saints and hymned by cherub-musicians in Giovanni Bellini's sublime masterwork, the San Giobbe Altarpiece. Such capitals, of various designs, are not infrequent in real, domestic architecture of the period, for example in Bergamo on the Casa dell'Archiprete, and in Bologna, on the mid-16th-century Palazzo Bonasoni by Antonio Morandi – the latter also incorporating the classical motif of a trident and shell. Dolphins also surmount the arched giltwood frame of Bellini's painting of the Virgin and Child in Santa Maria Gloriosa dei Frari in Venice, of 1488; they are addorsed against a central flaming vase, and further small dolphins are attached to further flaming vases at either end of the entablature.

Giovanni Bellini transformed standard capitals of the Ionic order into dolphins in order to flank the Virgin Mary and to point to her salvation-bringing role, in his San Giobbe Altarpiece of c. 1480. A capital of the Casa dell'Arciprete in Bergamo, possibly by Pietro Isabello, of 1520, resembles Bellini's fanciful invention.

The friezes of dolphins that adorn so many Marian images are not however her exclusive preserve in the Renaissance. Originating from friezes of 'psychopompic' dolphins swimming nose to tail along the edges of Christian sarcophagi – almost in imitation of the ancient Greek wave-pattern – they were easily adapted to further symbolic purposes. They were particularly appropriate for fonts, or holy-water stoups at the entrances of churches, and a noteworthy example stands in St Mark's, Venice (p. 149). Three be-dolphined water-basins, all slightly different, were carved for Siena Cathedral around 1457-60 by the young Antonio Federighi, a local follower of Jacopo della Quercia and Donatello. One, known as the 'pozzetto da Sabato Santo' ('little well of Holy Saturday', i.e. the day between Christ's Crucifixion on Good Friday and his Resurrection on Easter Sunday), is octagonal and has a self-contained scene on each side, three of which incorporate little boys (sprites) riding on the dolphins' backs: on one side the infant riders use their tridents in kindly wise as goads to compel their dolphins to drink from the same central bowl (the eucharistic cup of salvation?); on another, two joust, stabbing vigorously with tridents at each other's mount; while on the third, a sprite urges his dolphin on, in an attempt to catch up with some friends borne along on the back of a triton. Federighi also carved a near-pair of holy-water stoups at the western entrance to Siena Cathedral with friezes of dolphins: one has pairs with entwined tails running along under the rim, projecting between cherubim, while the other has a more classical frieze of mini-dolphins diving down on either side of an upright shell (a classical motif made Christian here by the frequent use of such shells to pour baptismal water), interspersed with Greek anthemion motifs. In Florence at much the same date Antonio Rossellino carved on a large liturgical basin in Brunelleschi's Old Sacristy in San Lorenzo two rampant dolphins with their jaws open just above water level, so that they appear to be leaping out of the sea.

A dolphin carried for Renaissance man a weight of symbolism to us surprising, mostly derived from ancient sources: it came in useful for Francesco Colonna as one of his hieroglyphs in the *Hypnerotomachia* (p. 116); and it was also a symbol of Mars, god of war, used by Andrea Riccio in the decoration of the helmet of his *Shouting Horseman*. In the 1480s Verrocchio or a follower used a dolphin as the crest of an elaborate helmet for the Persian King Darius, the elderly opponent of the young Alexander the Great, in one of a pair of idealized and contrasting imaginary portraits in relief of those famed warriors. The more or less true to life rendering of the dolphin – save for its acanthus leaf of a tail – contrasts absolutely with the stylization manifested in a pair on a coat-of-arms picked out in polychrome glazes by the Della Robbia workshop (overleaf).

One of three oblong panels with putti riding dolphins in imitation of ancient examples, carved by Antonio Federighi on a basin in Siena Cathedral.

This striking portrait of the war-hardened King Darius is superbly modelled in the style of Verrocchio (whose 'nutcracker' type of face was picked up by Leonardo da Vinci), and then glazed in the technique of the Della Robbias. A dolphin, symbol of Mars, crowns his helmet.

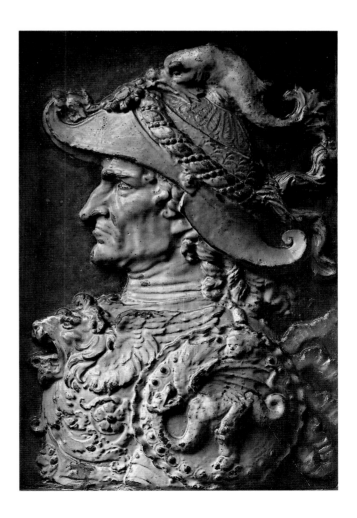

Heraldry, & the Dauphins of France

The standardized, symbolic usage of the dolphin in heraldry is different in kind from the imagery that we have been immersed in so far. In England, as early as the *Morte d'Arthur* of 1400, we meet a nobleman who has 'a derfe schelde . . . With dragone engowschede . . . Devorande a dolphyne' (a bold shield, with a stout dragon devouring a dolphin).

This gorgeous rendering of the coat-of-arms of the Pazzi family with its 'hauriant' — upright — dolphins, set within a circular scalloped 'shell', is bordered with a festoon of ripe fruit typical of the Della Robbia workshop.

The coat-of-arms of the Pazzi family, Florentine grandees like the Medici, with whom they were often at loggerheads, is described heraldically as follows: '*Azure*, two dolphins hauriant [i.e. erect, head upward], embowed, addorsed *or*, and five crosslets botonny, fitched, of the same.' While these arms are almost as well known to informed visitors to Florence as the golden balls on a red ground that denote the Medici, they are not the original distinguishing mark of the ancient crusader dynasty of the Pazzi, but were granted them by the Duc de Bar for heroic service rendered in the Holy Land during a crusade in 1388.

Of course the most celebrated claimant to the dolphin on his arms was the crown prince of France, known as the Dauphin: it is quartered there with the fleur-de-lys of France. The origins of this curious name, which is not preceded by a royal title (unlike the *Prince* of Wales) and hence does not refer to rank, are lost in the obscurity of the Middle Ages. He is by right sovereign of the province of the Dauphiné and the mysterious name sprang most probably from this connection, indeed from a nickname given to an earlier individual ruler there. The Dauphin's crown is of fleurs-de-lys closed with four outward and downward facing dolphins, their upturned, addorsed tails supporting above a three-dimensional fleur-de-lys. In the French edition of Paolo Giovio's book on heraldry, published at Lyon in 1561 (see pp. 118-19), a device is proposed for 'Le Roy Dauphin de France' – 'if he wished to have one made'!

The arms of the Dauphin, eldest son of the kings of France: Quartered, the first and third 'azure' with three fleurs-de-lys 'or', the two others 'or' with a dolphin 'azure'.

The device proposed for the Dauphin, son of Henri II, included in 'Dialogue des devises d'armes et d'amours', the 1561 French translation of Paolo Giovio's work on heraldry: 'a dolphin bearing on its back a globe of the Earth, formed by a diamond ring [a device of the house of Medici: the Dauphin's mother, Queen Catherine, was a Medici] from which grow two branches, one of palm for victory and the other of olive for peace to come'.

The most appealing rendering ever of the Dauphin's arms must be that penned in a single intricately scrolling line (as is proudly proclaimed in an inscription below) by Jean de Beaugrand. To the shield of arms the draughtsman adds for good measure a vigorous pair of supporters riding upon dolphins: on the left, the wings denote Cupid, launching a dove, symbol of his mother Venus; opposite, a figure with windswept hair almost like feathers (Triton?) is accompanied by a flying stork (a symbol of vigilance). The penmanship is amazing and the whimsical result is elegant and light-hearted.

The Dauphin's arms, designed by the calligrapher Jean de Beaugrand, from his 'Panchrestographie', an album of such tours-de-force, published in Paris in 1604. The entire design, including the two dolphin supporters, is drawn in one continuous line — faithfully reproduced by the engraver 'D. Firens' (perhaps a Florentine?).

D Beaugrand inuenit. P. Firens sculpsit

Toutes les figures cy defsus sont formées d'vn seul traict

Entree des sieurs de Vroncourt. Tyllon. et Marimond

C. allot fec.

In a revival of the classical entertainment of a 'naumachia', a mock sea-battle held on real water, the ancient myth of Arion was alluded to in a court masque of 1627 aimed to please the Dauphin of the day, later King Louis XIV. Jacques Callot drew the effect, as the large dolphin carried three well-known noblemen on its back and Arion rode a smaller dolphin alongside.

In court masques, as Jacques Callot graphically recorded, dolphin floats, with their particular symbolism for their French audience, abound: the most amazing must have been the monster one that in 1627 bore on its back three high noblemen, de Vroncourt, Tyllon and Marimond, accompanied by another, of more manageable size, ridden by Arion strumming a lute. A generation later, for the marriage of the son of King Louis XIV, known as the 'Grand Dauphin', in March 1680, a fan leaf decorated with an allegorical miniature of the diplomatic background to the affair was charmingly enlivened for a court lady, if not the princess herself (overleaf): six playful dolphins with gay pink snouts, fins and dorsal spines sport round the interlaced initials of the happy couple, A and L.

Some two centuries later, an anonymous designer/ embroiderer – probably French – worked a semicircular case for a fan in silk and brocade, imagining a brilliantly stylized pair of dolphins with seaweed-like acanthus fins, leaping towards and almost butting a central gilded urn of pretty pink and white flowers.

A fan celebrating the marriage of Louis, the
Grand Dauphin, son of Louis XIV of France, with
Maria Anna, daughter of the Elector of Bavaria,
in 1680. It is ornamented with no fewer than six
symbolic dolphins swimming round the interlaced
initials A and L. (The central segment and top
corners were added to make up a rectangle for
framing.)

A fan case, embroidered in the mid-19th century.
Long after the last Dauphin of France had died,
the dolphins live on as embodiments of joie-de vivre.

Dolphins were naturally *de rigueur* in the decorative arts of the French Crown. They feature in architecture and furniture, some on a miniature scale, such as the handsome quartet in gilt bronze that support the pedestal and define the identity of an equestrian statuette of the Grand Dauphin. Opaque white glass was formed into sweetmeat dishes supported on dolphins by an Italo-French specialist, Bernard Perrot, while the Grand Dauphin himself owned a wonderful Milanese carving in precious rock-crystal of a plunging dolphin bearing a lobed cup. It was given to him by Mademoiselle de Lillebonne and is recorded in an inventory of his possessions by 1689. On a luxury table-top inlaid with *pietre dure* (semi-precious hardstones of varied hues), a splendid pair of dolphins, with lively highlights in their eyes, focusing on the beholder, writhe round and notionally support the French royal arms, which are surmounted by the grand-ducal crown of the Medici (pp. 142–43).

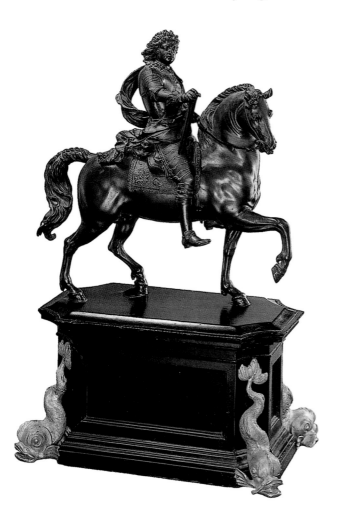

A late 17th-century bronze equestrian statuette of the Grand Dauphin in full armour (for he was a brave soldier), adorned by dolphin supporters in gilt bronze.

This rock-crystal dolphin, attributed to Giovanni Battista Metellino of Milan, was fashioned around 1676-85. By 1689 it belonged to the Grand Dauphin, from whom it passed by inheritance into the collection of his nephew, Philip V of Spain.

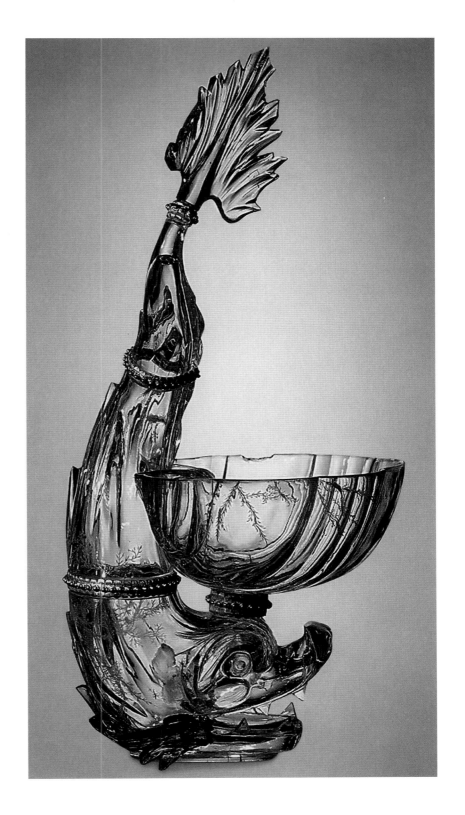

Dolphins supporting the arms of France and the grand-ducal crown of the Medici appear on a Florentine table top, made in the 17th century by a skilled craftsman in the Opificio delle Pietre Dure, a grand-ducal laboratory for working hardstones into inlaid patterns. The designer ingeniously gave the appearance of iridescence to the (completely imaginary!) scales of his ultra-Baroque creatures.

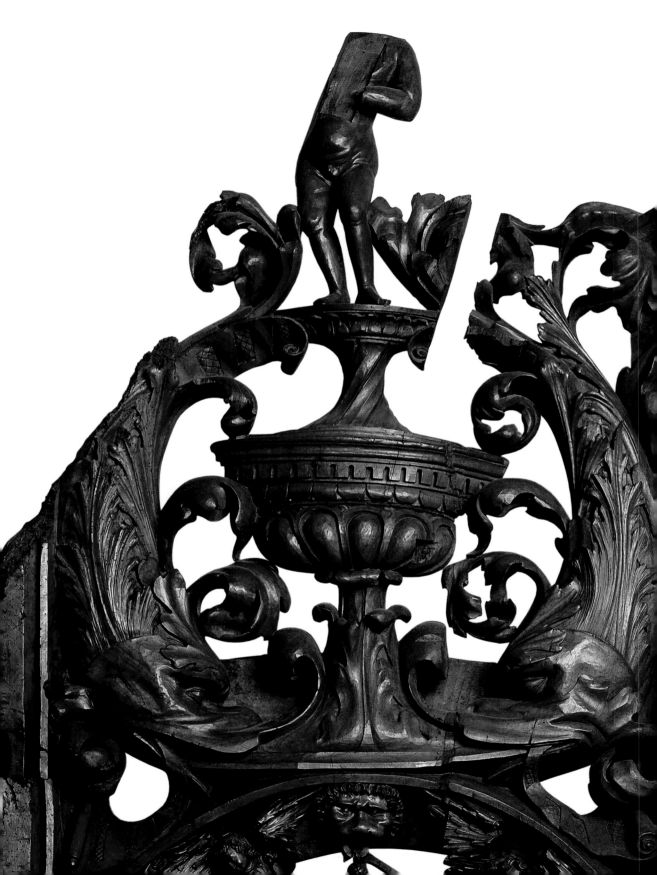

A curious byway of the obsession with dolphins of the French – and in particular of the Sun King – was noted by Diderot in 1754 in his famous *Encyclopédie*, where he explains that thirty-nine commentators on Latin writers who were employed by the King to publish them in Paris for his son's edification (poor soul!) were – owing to this connection – known as 'the Dauphins'.

A meeting between France and Italy occurred in the abbey church of Santa Maria di Staffarda in the Italian part of Savoy. This had rich furnishings made some time between 1510 and 1530 by a woodcarver who may have hailed from as far afield as Champagne in north-eastern France. The patron can only have been Giovanni Ludovico di Saluzzo (the son of Marchese Ludovico II and Marguerite de Foix, a Frenchwoman), who became abbot in 1510. At the ends of the choir stood openwork screens carved from walnut with ornaments resembling the stylized candelabra beloved of Renaissance Italy. Reading upwards, the decoration of one of them consists of St John the Baptist; the Virgin and Child, at the top of the main panel and above eye-level; and, at the very top (which is broken) possibly the Christ Child, standing on a chalice. This device is flanked by a huge pair of dolphins, head down, facing each other, following in the same tradition of Christian iconography as their Italian counterparts. Ribbons issue from their open mouths, while they hold the foot of the chalice: their tails are stylized as acanthus leaves.

Other examples of the dolphin used as an ornament in French furniture, sculpture and the decorative arts are so many and various as – alas – to preclude mention, let alone illustration, in an overview such as ours.

This fine element comes from a screen carved out of walnut, probably by a Frenchman, in the early 16th century for the abbey church of Santa Maria di Staffarda not far from Turin. It is animated by an especially fine pair of slim dolphins, diving down to confront each other.

Venice, from 'La Serenissima Repubblica' to 'Hello Venezia'

So long as the sea contains dolphins,
So long as clear skies contain stars,
So long as the moist ground yields her pleasant fruits,
So long as the human race survives on earth,
The splendour of the Venetians will be celebrated for all eternity.

Marin Sanudo il Giovane, *De origine, situ et magistratibus urbis venetae, ovvero La Città di Venetia*, Venice, 1493–1530

Jacopo de' Barbari's immense bird's-eye-view map of Venice was printed in 1500 from woodblocks on six sheets of paper. Neptune rides on a dolphin in the foreground in the Pool of St Mark's (the Bacino di San Marco), directly below the presiding deity Mercury, god of commerce, brandishing his caduceus in the sky, and below the adjacent place name and date in Latin. The view is accompanied by an inscription that reads: 'I, Neptune, reside here, watching over the seas at this port.'

The idea that the gods might prod the contours of an island with a trident into the shape of a dolphin is part of the myth of the birth of Venus. It was available in the Renaissance from a Greek manuscript, Nonnos' *Dionysiaca*, collected by Francesco Filelfo, a humanist adviser of Lorenzo the Magnificent (in whose famous library at San Lorenzo in Florence it still remains): 'Nereus had traced the boundaries of this Cypros (godwelcoming island of the feathered Loves) with the deep-sea prong, and shaped it like a dolphin.' The merchant-venturers of Venice were always eying enviously the two great islands strategically placed in the eastern Mediterranean, Crete and Cyprus, and came eventually by force of arms to rule over them, thus securing their trade routes to the Middle East, the Holy Land and Constantinople (modern Istanbul), by warfare or negotiation with their difficult neighbours, the Turks.

It has recently been claimed by Deborah Howard – in my view convincingly – that in 1500, when Jacopo de' Barbari produced his enormous and celebrated map of Venice (it spreads over nearly 4 square metres, some 40 square feet), despite its seeming minute accuracy, he managed to subtly manipulate the perspective of its street plan, and thus correspondingly the general contours of the two main islands, into the semblance of a schematic dolphin. In this respect he – or the city fathers – were nudging it into shape just as Nereus had supposedly done to the island of Cyprus ages before.

The distortions and the result are such that they cannot be accidental, especially at the western end (to the left), where the actual coastline was rounded out to the north in order to form a semblance of the dolphin's bulging forehead; and near the centre of the left-hand margin, where spits of land were altered to enhance the illusion of an open beak! The arguments, scientific and computer-driven, are too complex to rehearse here, but it emerges that maps of Venice were more accurate even by the 14th century, as they were needed for navigating one's way between the shoals and mud-flats of the lagoon on which Venice was built. Schemes for reclaiming (or actually adding) land round the western perimeter may have been aimed in the same, ideological direction: namely to enhance the similarity of the ground-plan of the city to the shape of a dolphin. The association of the city with the dolphin goes back at least a century earlier than Jacopo de' Barbari, when a sculptor carved a big medallion depicting an allegory of Venice as Justice on the façade of the Doge's Palace.

But why should the canny Venetians wish to make so much of this chance similarity, exaggerated for the sake presumably of their civic pride by Jacopo de' Barbari in his 'super-map', which was intended for world-wide commercial distribution, at the high price of three ducats? Well, they already identified their fair city, on account of the similarity of its name, with Venus – 'Venice, like Venus, was a quasi-supernatural image of beauty, born out of the waves', explains Deborah Howard, elaborating as follows: 'An imagery often confused with the "Venus marina" is the figure of Fortune astride a dolphin, but in this case the ambiguity would have been a potent one. Metamorphosed into a dolphin, Venice thus adopts the dual attributes of Venus and Fortune, the latter much needed by a trading nation involved in risky maritime voyages. The familiar association of the dolphin with speed would have underlined this encomiastic reference to Venice's trading supremacy.'

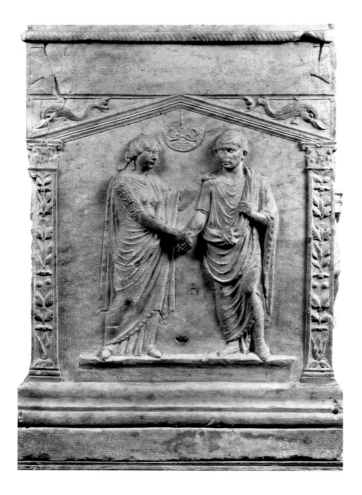

Psychopompic dolphins flank a pedimented tabernacle housing a double portrait of the deceased taking leave of his wife on this Roman funerary altar.

On the lower drum of the holy-water basin at the west end of the nave of St Mark's in Venice – perhaps a re-used ancient Roman element – pairs of dolphins dive into the sea on either side of a trident that supports a shell.

The dolphin's appearance in Christian iconography with the connotations of salvation and resurrection goes back to ancient, mythological prototypes, where dolphins served as companions of deceased souls into the after-life, or *psychopompos* (see pp. 93-97) – as seen on, for instance, a funerary altar from Imperial Rome. The continuous conflation of old and new, involving dolphin imagery, right in the heart of Venice, characterizes the holy-water basin – it is too magnificent to be called a stoup – in St Mark's. In many parts of the Basilica, trophies of ancient art purchased or pilfered from abroad, mostly from Constantinople, were combined with elements newly fashioned in local stone to create a useful complex such as this: the basin is thought to be Late Antique; it is supported on putto-caryatids that may be from a different source; and from another source too may be the lower drum. It is this that concerns us, for it is carved with pairs of twin dolphins diving into the sea around the stem of a vertical trident (on the prongs of which is balanced a shell), alternating with a trident supported at its base by a similar, but inverted, shell. Its prominent position would have meant that, in a church-going epoch, every Venetian child would have been familiar with these realistic and exciting creatures, for they were to be seen at its own eye-level between the legs of the adults. In the Renaissance some lineal descendants were not slow to emerge only a short distance away, as we shall see.

Deborah Howard also alerts us to the facts that 'Dolphin-like fish crowd the
waters in the celebrated early 13th-century mosaic of *The Creation of the Birds
and Fishes* in the atrium of San Marco' and that 'On the eighth capital from
the right on the 14th-century Bacino façade of the Doge's Palace appears the
figure of Arion, playing his violin and riding a dolphin. Ruskin remarks that
"The dolphin has a goodly row of teeth, and the waves beat upon his back."'
(It is not at all obvious in existing photographs, and a current campaign of
conservation has – alas – precluded the taking of new ones.) A trio of
dolphins also features on the arms of the prominent noble family variously
called Dolfin or Delfini. They are therefore to be seen all over Venice, carved
at various dates. Howard notes that 'In the wing of the Doge's Palace erected
after the fire of 1483, two fireplaces in the ducal private apartments, in rooms
on the first floor over the canal, are decorated with friezes of playful putti riding
dolphins flanking images of the Lion of St. Mark, as if to underline the
patriotic association of the imagery . . . these chimneypieces [are probably
identical] with those executed for the Sala dell'Udienza and its Anti-camera
by Tullio and Antonio Lombardo in 1500, the very year of the publication
of the Barbari map. Thus we know that at that precise moment, dolphins
were adopted to adorn the setting for ducal audiences. As we approach 1500,
interest in dolphins reveals itself across a wide cultural spectrum.'

It was at the same moment that the dolphin and anchor first appeared, in the imaginary hieroglyph illustrated in the *Hypnerotomachia Polifili*, printed by Aldus Manutius, while by 1501 he had adopted it as a printer's mark (pp. 116-17).

Within the decade, Antonio Lombardo went to Ferrara – where a generation earlier Cosmè Tura had painted his enigmatic Muse (p. 121) – for he had been commissioned to carve for Duke Alfonso d'Este a 'studio di marmo' in his palace: this must have been an extraordinary sight, with its walls clad with selected slabs of marble, some of them elaborately carved with figures and classicizing ornaments by Antonio and his team, from 1506 to 1508. Panels with stories from mythology capture the eye of the casual visitor, but it is one of a diptych of ornamental panels that catches our attention, for – as a recent cataloguer has written – it 'shows a mask surrounded by foliage in the centre presiding over a flat basin flanked by two dolphins composed of vegetation: their tails end in two leafy volutes which invade the remaining surface of the relief in exquisite symmetry, leaving space in the lower corners for two birds with outstretched wings pecking the acanthus blossoms.' Perhaps already here one can sense Antonio striving – and succeeding – to outdo the Antique rendering of dolphins on the holy-water basin in St Mark's (p. 149). What was observed in the case of Tura's dolphin throne for his *Muse*, that the dolphin may have been a device of the Este dukes, has seemingly not been taken into account by scholars in this later context.

This panel of ornament with handsome dolphins by Antonio Lombardo is one of several carved for Duke Alfonso d'Este's 'marble study' at Ferrara in 1506-8.

In the meantime, in Venice, Doge Leonardo Loredan commissioned an important native goldsmith-turned-mint-master and then bronze-foundryman, Alessandro Leopardi, to produce three matching flagpole stands to go in front of St Mark's. Leopardi, fresh from successfully bringing to completion the casting of Verrocchio's equestrian monument to Bartolomeo Colleoni in the 1490s, designed three splendid narrative reliefs to go round their drums at eye-level: these consist of variations on the classical theme of triumphal processions of sea-monsters and deities (a marine *thiasos*), in which

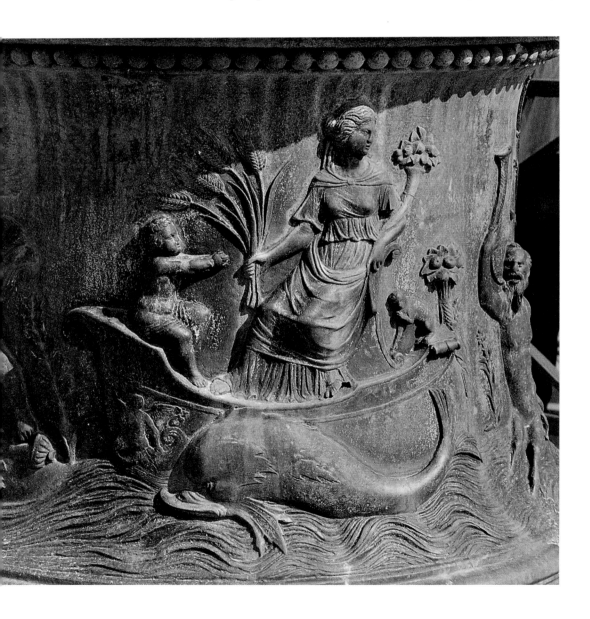

allegories of the civic virtues of Venice are embedded. The scene that concerns us shows a gracious, classical female figure of Abundance, complete with her symbolic cornucopia and sheaf of barley, enthroned – rather precariously – on board a disproportionately small barque. This is being gently nudged along by a dolphin, rather as a modern cruise-liner is attended by a tugboat as she passes through the relatively narrow channel between St Mark's Square and the island of Giudecca. The general demeanour of the creature is closely similar to those carved by Antonio Lombardo a year or two later for Ferrara (p. 151) and one at least of Leopardi's sources may also have been the dolphins round the drum of the holy-water basin in St Mark's (p. 149).

In 1503, Leopardi was chosen by the (very grand) Procurators de Citra of St Mark's, along with Antonio Lombardo, to create a magnificent chapel in the narthex of the Basilica, replete with imagery in marble and bronze, for the recently deceased Cardinal Giovanni Battista Zen. In it, apart from the usual effigy and attendant Madonna and carefully selected saints, to be rendered life-size and in bronze, there was to be a roundel with a life-like God the Father, surrounded by cherubim. This was to have a support 'in the form of a big fish in the guise of a dolphin, the head of which is to be fixed on the roundel of the corner, projecting strongly, its middle to be raised and its head lowered, as is typical of this fish. It is to have its tail against the wall of the vault and is to be well-wrought from nature, with scales [!] big enough to be seen from a distance. There shall be two of these fish, one on either side, and they are to be silvered or gilded according to the decision of the Procurators. These fish shall consist only of the part that can be seen from outside.'

This is a good example of the legalistic care that went into drawing up a contract in the Renaissance for a major work of art. Presumably the two sculptors had provided a drawing or a three-dimensional model, from which the city's lawyers derived their pedantic description. Alas, after protracted alterations to the scheme, these dolphins – which may have been based on those of the drum of the holy-water basin in the nave (p. 149), near this still-extant but usually closed chapel – were not cast.

Abundance, enthroned in a boat propelled by a docile dolphin, as depicted by Leopardi on one of the flagpole stands in front of St Mark's in Venice. The first of the three to be finished, it is signed and dated 1505.

Owing to threatening international wars on a European scale, there now followed a brief intermission in the rise of the dolphin in Venice. This came to an end when, following the Sack of Rome in 1527, there arrived in Venice a distinguished sculptor-architect from Tuscany and Rome, Jacopo Sansovino. His services were snapped up by La Serenissima Repubblica, which appointed him architect-in-chief of St Mark's, a post that made him virtually omnipotent. For painting – the art that is in the public imagination most closely associated with Venice – was at the time less highly regarded and far less expensive than its sister arts, which offered the ability to construct and decorate grand new buildings, adorned with carvings to emphasize the power of the city. Deborah Howard notes: 'Jacopo Sansovino's activities in Venice after his arrival in 1527 reflect a sensitive awareness of Barbari's legacy, both in iconographic and urbanistic terms. Venus, Neptune and Mercury appear in the Loggetta sculpture, together with Apollo, another deity with delphinic associations, while Neptune is represented with a dolphin in one of the two colossal statues at the head of the Scala dei Giganti.'

The latter is another excellent, but standard, example of the classical type discussed above. The Loggetta on the other hand requires a brief explanation: it stands serenely at the foot of the towering, separate, Campanile of St Mark's (itself a symbol today of Venice, just as Big Ben, the Eiffel Tower and the Statue of Liberty are of other major cities). Sansovino created a breathtakingly elegant loggia in the form of a triumphal arch (he had only just left Rome itself!) and an extra-colourful one at that. This was because he employed not only white marble, the ancient norm, but incorporated four ancient columns of rare oriental marble, adding for good measure elements in orangey-red 'rosso di Verona', Istrian limestone, and other striated stones. These housed – like some gorgeous picture frame or stage-set – the series of four life-size statues enumerated by Howard (which, being made of polished bronze, originally would themselves have had a golden hue). In its attic storey were set three huge and eye-catching panels carved in relief with sensuously nude allegorical figures. But what concerns us here is the fact that round the projecting pedestals of the columns that articulate its façade are to be found – now below eye-level and therefore often hidden from view by the crush of tourists' legs, but then, before the terrace in front of the Loggetta was added, at the eye-level of every passer-by – a series of lively marble panels filled with one marine figure after another, several being accompanied by rambunctious dolphins.

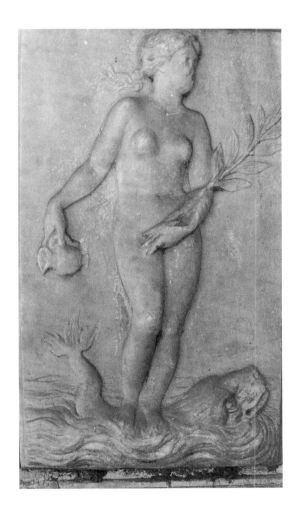

Two details from the bases of the columns of Sansovino's Loggetta of the Campanile of St Mark's, Venice. They were carved by his assistants around 1540. A Venus-like figure — or is she Amphitrite, or yet another deity, nymph or Nereid? — is being wafted to shore, teetering on the back of an anxious dolphin, as she extends a jug (for a libation to the sea perhaps) and an olive branch (indicative of land nearby and of peace, as in the story of Noah's Ark in the Old Testament). Neptune steps off the back of his squint-eyed dolphin-steed and monitors with his trident the behaviour of fishes rising from the waves nearby.

Reverting to the question of the shape of the bird's-eye view of Venice, Deborah Howard sums the matter up in magisterial fashion: 'since its site was almost entirely man-made by the laborious process of land reclamation and piling, its whole form could be artificially created, and adjusted through time. It is intriguing to remember that the major extension to the city in the 16th century along the northern fringes of the city served to enhance the stream-lined profile of the dolphin's back. The smoothing of the fish's belly was accomplished with the construction of the *riva* of the Zattere in 1519. It might be far-fetched to suggest that the recent reclamations at Santa Maria Maggiore had consciously provided the dolphin's upper and lower jaw, or that the extension at Sant'Antonio had formed a tail-fin. Once the imagery achieved graphic form in 1500, however, further developments could respond to the potency of this idealized vision. The Delphic allusion bestowed on Venice the protection of Neptune and Mercury, as well as the identity of her alter-ego, Venus. . . . it also endowed her with associations of speed, fortune, musical harmony and ultimately the Christian resurrection of the soul. Even the pedantic Scamozzi was beguiled by the imagery when he wrote of Venice in his *Idea della architettura universale* in 1615: "la sua forma s'assomiglia ad'un Delfino, col petto al Mare, e la schiena verso Terra."' Scamozzi's telling remark may be translated, 'her shape resembles a dolphin, with its breast towards the Sea and its back towards the Land.'

Moving from the sublime of the 16th to the ridiculous of the 21st century, the transport system of the city has recently adopted as its logo the five-hundred-year-old design of Venice-as-dolphin, with the vulgar, pigeon-English tag of 'Hello Venezia'.

The logo of the Venetian transport system, 'Hello Venezia', reverts — for all its seemingly trendy modernity — to the age-old idea that the city-plan resembles a profile view of a beneficent dolphin.

Venetian Decorative Arts

In the decorative arts of Venice the dolphin also appears in many slightly less serious, though still meaningful, contexts. The foundrymen and the designers associated with them, as we have seen, loved to avail themselves of the naturally sinuous shape of the creature, which lent itself easily to being bent so as to serve as a support, a foot, or a handle. We shall enjoy these creations from the delphinic viewpoint, without being drawn into questions of authorship, which are often complex.

A small bronze vase made in Venice c. 1500, covered in classical ornament and imitating ancient ceramic and goldsmith shapes, could be picked up by its dolphin handles.

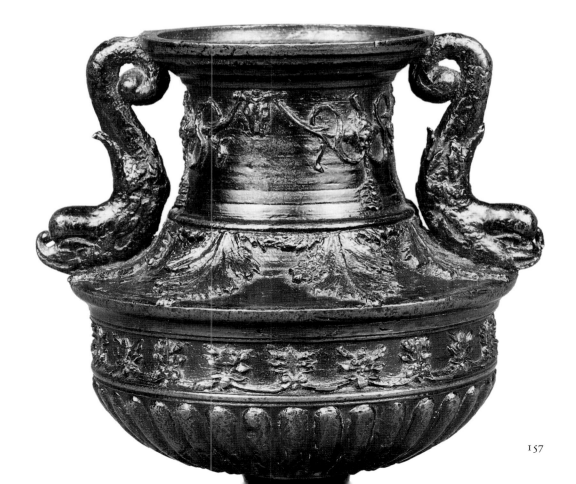

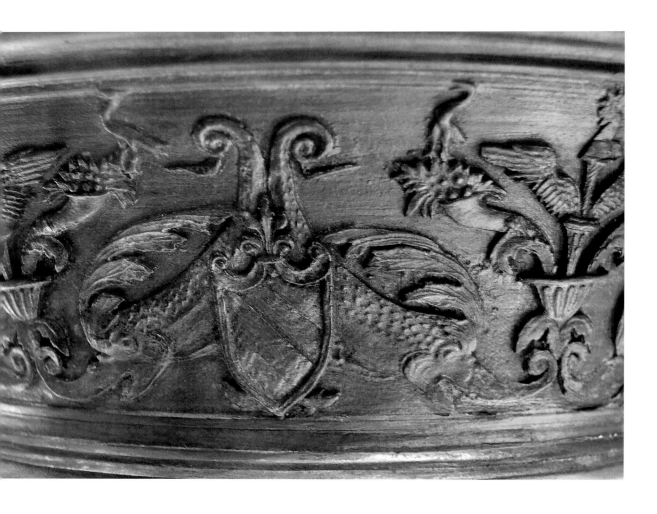

In the years around 1500 foundries in Venice and its dependency Padua commonly applied dolphins as delightful handles to everyday artefacts such as mortars and bowls. Of the former, examples are to be found in several of the collections of the great museums of the world, for instance in Paris and Berlin. A classicizing form of vase was also revived by some bronze-founder in Venice, who gave it handles that are unusual in having the dolphins inverted (p. 157): the creatures slip smoothly from its neck down a concave moulding at its shoulder, and their heads then project neatly at either side. In a series of footed bowls, some of which are signed by Alfonso Alberghetti and dated 1572, the dolphins are transferred from the handles to a frieze running round the body, adapting the 'all'antica' device in the same way as the Italian marble sculptors and French woodcarvers discussed previously (pp. 144, 151). Venetian woodcarvers resorted to the same motif from time to time too.

From the idea of dolphin as handle comes a secondary, technical, meaning of the word, as is tersely noted in the *Oxford English Dictionary*: 'In early artillery, each of two handles cast solid on a cannon nearly over the trunnions, commonly made in the conventional form of a dolphin.' For this special usage the earliest source it cites is of 1704: *'Maniglions* or *Dolphins* . . . are the Handles placed on the back of the Piece near the Trunnions, and near the Centre of Gravity, to mount and dismount it the more easily.' But this attractive shape had been in use long before then in Venice – and elsewhere, too. Two fascinating drawings of 1646 signed by 'Michel Winholdt' – Michael Weinholdt, gun-founder to the Elector of Saxony – depict cannon of different calibres seen from above; and the real appearance from this angle is distorted, in order that the dolphin handles may be clearly seen in a profile view.

Diving dolphins are the major components of the ornamental frieze of this bronze bowl by Alfonso Alberghetti, of 1572.

Scale drawings for a 48-pounder and a 24-pounder cannon by Michael Weinholdt, gun-founder to the Elector of Saxony, 1646.

Another, especially Venetian, use of dolphins as handles is on the grand, lyre-shaped, bronze door-knockers which the city's foundries turned out in large numbers and over many decades. They come in an eye-catching medley of forms – animal, vegetable, human, or monstrous. We have already seen one, with a statuette of Venus flanked by twin cupids on dolphins, which may have been influenced by the form of some ancient Roman vase-handles (p. 57). Others, by different hands, with more monstrous renderings of the flanking dolphins, are centred with a variety of figures, now a Neptune, now a Cupid, now an allegory of Hope. Below these, the dolphins hold, like their evil octopus prey of old, masks, sometimes of Medusa and sometimes of grotesque old men: these had an apotropaic function, to repel enemies and evil spirits from the portals on which they hung.

Other ornamental artefacts manufactured in the bronze-foundries on the Lagoon also have dolphins woven into their complex, eclectic and additive designs: the monumental bronze well-head by the De Conti, for instance, at the southern end of the courtyard of the Ducal Palace, has some entwined near ground-level at the angles. Huge ornate firedogs were much in vogue, and a splendid pair now in the 'Doge's Suite' of Hearst Castle at San Simeon, California, is supported on massive, ferocious, dolphins, with their heads down on the ground (as though skimming across the deep) and tails curled in mid-air.

In other areas of Venetian domestic design the suave forms of the dolphin can often be remarked. These range from small jewel-boxes for ladies (made of alder-wood and covered with designs in relief, formed out of paste pressed into moulds, like gingerbread) to great door- or wall-panels, carved in wood and lavishly painted and gilded.

The indefatigable, but naïve, English traveller Thomas Coryate, in his book of 'Crudities' (ideas he had picked up on his travels), published in London in 1611, described the metal prow of the Venetian gondola (the *ferro*, or iron) as 'a crooked thing made in the form of a Dolphin's tayle, with the fins very artificially represented, and it seemeth to be tinned over'. Clearly the dolphin was much on his mind in this maritime city, but the likeness that he noticed is so vague as to be nonexistent: if anything, this traditional, abstract form resembles rather the head of a horse (as stylized in the knight of a chess-set), and hence perhaps of a hippocamp, the classical hybrid seahorse that has the front legs of a real horse, but with the hooves replaced by fins. Even the gondoliers tell contradictory stories of the meaning of this highly symbolic but enigmatic figure-head, today one of the 'logos' of Venice.

Our next special case is another maritime city at the heart of an empire, but one that was far more extensive than that of Venice.

A knocker of c. 1580, formerly on the door of the Palazzo Grimani in Venice. This is typical of many variants that have now been disseminated all over the world as 'collectors' items'. Very few, alas, still adorn the doors of palaces in their city of origin, and of these most are relatively modern copies, replacing originals that have been sold.

The Dolphin

and

Guild Gazette

THE JOURNAL OF
THE IMPERIAL MERCHANT SERVICE GUILD

·PERGITE·

MSG

The Imperial Merchant Service Guild

THEY THAT GO DOWN TO THE SEA IN SHIPS

Vol. I., No. 2. APRIL, 1920. ONE SHILLING.

'Rule Britannia!'

We have seen when considering Venice that a secondary meaning of the word 'dolphin' was the lifting-handle of cannon, but in English nautical parlance, the *Oxford English Dictionary* lists the following further uses: '(*a*) A spar or block of wood with a ring bolt at each end for vessels to ride by; a mooring-buoy. (*b*) A mooring-post or bollard placed at the entrance of a dock or along a quay, wharf or beach, to make hawsers fast to. (*c*) A wreath of plaited cordage fastened about a mast or yard, to prevent the latter from falling in case of the ropes or chains which support it being shot away in action.' It also gives an interesting, generally forgotten, composite noun: 'dolphin-striker: a short gaff spar fixed perpendicularly under the cap of the bowsprit for guying down the jib-hook', citing its appearance in 1841 in Captain Marryat's *Poacher*: 'The . . . collision carried away our . . . dolphin-striker.'

Such a wide range of expressions indicates how familiar our brave mariners of yesteryear were with the dolphin and its habits. The creature is omnipresent in the imagery of the British Navy as well as of the merchant fleet. It was also pressed into service by the Watermen's Company of London to support their coat-of-arms.

'The Dolphin', journal of the Imperial Merchant Service Guild, displayed a logo of a dolphin carrying a Union Jack.

Coat-of-arms of the Watermen's Company of London, with dolphin supporters.

Beyond any doubt the most splendid rendering of dolphins in London, indeed in Great Britain, is the pair that frame the star of the Order of the Garter on the stern of the Royal Barge. The Barge was first noted in *The Country Journal or Craftsman* on Saturday 1 January 1731/32: 'The Prince of Wales being to have twelve Watermen and a Coxswain, the said Watermen are all to have their new Cloaths ready to appear on the 19th of next Month, being his royal Highness's Birth-day. And a fine new Barge, that is building for His Royal Highness at Mr. John Hall's on the other Side of the Water, facing Whitehall, is to be launched by that Time.'

Two drawings for the vessel by William Kent survive, the first with its elevation and plan, and the second with his design for the stern and the front of the State House, the royal cabin. A series of vouchers for payment in the Prince's archive detail the expenditure on the various components. Those that concern us were made to 'James Richards, Master Sculptor and Carver in Wood' to the Crown, an expert who had succeeded the better-known Grinling Gibbons in 1721. For his carvings on the stern of the Star and Garter, the trio of ostrich feathers in the crest of the Prince of Wales, the festoons, the pair of mermaids holding up their tails, and the gorgeous pair of dolphins Richards received the princely sum of £13.

The splendid craft cost (including its lavish leaf-gilding) over £1,000 and it was launched into the waters of the River Thames in July 1732 – well after the Prince's birthday. It remained in use until 1849. Geoffrey Beard ended his article on the Royal Barge: 'It may rank, along with the long lost costumes for the Prince's masquerade of December 1731, as one of Kent's happiest inventions'.

The British Royal Barge, designed by William Kent and carved by James Richards in 1732 for Frederick, Prince of Wales. Its stern makes dramatic use of the dolphin motif.

While Beard did not investigate the sources for the real Barge, he hit the nail on the head in this summing up, for its prototypes are to be found among the ephemeral vessels and floats designed for *naumachia* and other festivities in the Florence of the Medici grand-dukes. The earliest of these, for the festivities occasioned by the second wedding of Francesco I in 1579, had been in the very form of an enormous dolphin, which was ridden by suitably arrayed figures representing the Adriatic and Tyrrhenian Seas, with outriders in the form of hippocamps and tritons. It was one of an extraordinary sequence of displays that took place in the courtyard of the Pitti Palace.

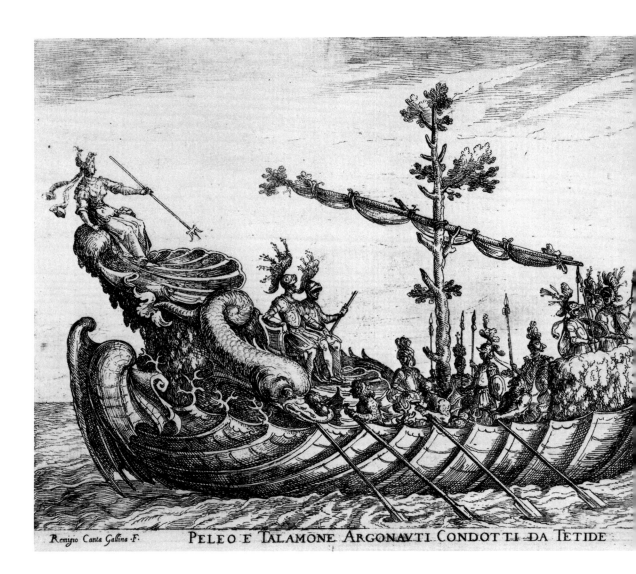

Remigio Canta Gallina ·F· PELEO E TALAMONE ARGONAVTI CONDOTTI DA TETIDE

Also in Florence, in 1608 – four hundred years ago at the time of writing – there was staged on the River Arno itself a mock naval battle to celebrate the wedding of Francesco's grandson (who would become Francesco II). This time there was a real ship, designed by Giulio Parigi, which is surely the inspiration for William Kent's Royal Barge, with prominent dolphins scrolling down its poop and its beak formed as a ferocious fish.

Such events were recorded in engravings, which were part of the stock-in-trade of artisans and designers, or would be shown to them by their patrons in bound volumes in their libraries. William Kent would inevitably have picked up for future use many such records of recent Italian festivities during his long stay in Rome, between 1709 and 1719. He had actually been elected to 'the Great Duke of Tuscany's Academy of Artists which is an honor to his native county of Yorke', according to Ralph Thoresby, a contemporary English collector, and so he must have been shown, been given or have acquired all such highlights of designs for court festivities in Florence.

We must now skip a century and a half – in which dolphins were certainly much utilized as furniture decoration, as we shall see in the next chapter – into the high days of the reign of Queen Victoria, when London was the capital of a huge maritime empire generating enormous power and wealth. Its great waterway, the Thames, was an open sewer breeding cholera, until the efforts of an eminent Victorian engineer, Sir Joseph Bazalgette. As the Latin inscription on his memorial puts it, *Flumini vincula posuit*: 'He placed chains round the river.' Chief Engineer of the Metropolitan Board of Works from 1856, Bazalgette was charged with improving London's inadequate sewage system. Particularly urgent and strenuous efforts were demanded by Parliament after 30,000 Londoners had died of cholera between 1848 and 1854, and the 'Great Stink' had been caused by raw effluent flowing into the Thames in hot weather in 1858. Bazalgette ran 82 miles (130 km) of new sewers alongside the Thames in the continuous Victoria, Albert and Chelsea Embankments, built out over the riverbank, channelling – and enhancing – the river, as well as providing valuable new throughways above its water-level.

An engraving shows the ship of Peleus and Telamon as it sailed into a Medici wedding celebration on the River Arno called the 'Argonautica' in 1608. The mast was an oak tree. Splendid dolphins secured the shell-shaped poop, where the guiding Thetis sat enthroned, to the hull, formed like a pair of dragon's wings.

The cast-iron standards bearing globular lights set on the granite parapet of the Embankments are bravely upheld by the entwined tails of pairs of plump, scaly dolphins, which peer at passers-by from eye-level, as though in an aquarium. Furthermore, the lamp-posts along the pavement illuminating the broad new carriageway – reminiscent of Baron Haussman's *boulevards* in Paris – are decorated with gilded dolphins, as well as the gaily painted arms of the Cities of London and Westminster and some Tudor roses in the style of William Morris. It is interesting thus to find dolphins at the very 'Heart of Empire', lining in ceremonial fashion the fine, upstanding new banks of Old Father Thames, extending Britannia's rule of the waves well up the tideway, past the government offices of Whitehall, and past Westminster Abbey, and beyond the 'Mother of Parliaments', towards newly fashionable Chelsea, setting of painters' studios and the cloistered studies of Victorian men of letters, such as Thomas Carlyle.

One of the dolphin lamp-standards on the parapet of the Embankments along the Thames, designed by George Vulliamy and modelled by C. H. Mabey, 1870. Originally for gas, they were converted to the new-fangled electricity in 1878.

A handsome dolphin-decorated lamp-post on the pavement of the Victoria Embankment, by Walter MacFarlane & Co. of Glasgow, 1900.

The last of our examples of the dolphin under the present rubric are those on fountains under the shadow of Nelson's Column in London, commemorating Admiral Jellicoe and Vice-Admiral Beatty, two naval heroes of the First World War – by an irony conceived before, but finished only after, the *Second* World War. The distinguished author of one, later to be President of the Royal Academy, (Sir) Charles Wheeler, tells the story wrily in his autobiography, *High Relief*: 'The last large job before the war was the Jellicoe Memorial Fountain in Trafalgar Square. William McMillan did the Beatty fountain there, both of us working sympathetically together with Edwin Lutyens as architect. Parliament commissioned us. The Commission of

William McMillan's Art Deco mermaid, with her own sinuous fishtails, is mounted on a dolphin and is trying to catch two baby ones as they sport round her in Trafalgar Square in a fountain celebrating Vice-Admiral Beatty. The form is daringly cantilevered out from a tight cylindrical stand in the pool below, enhancing the sense of movement. This and the other bronzes were completed in 1939, but the fountains were not unveiled until 1948.

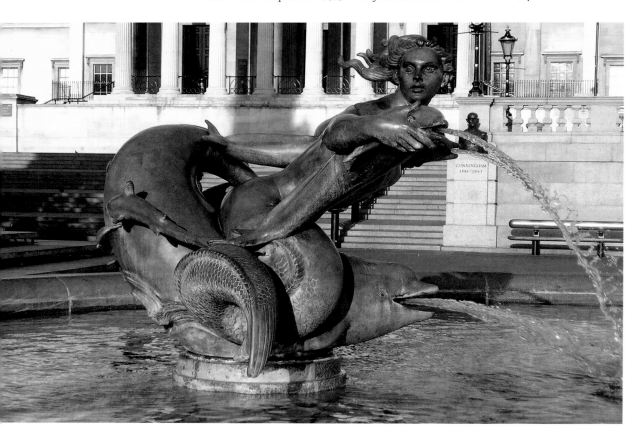

Works, which dealt with such matters before the Ministry of Works was instituted, was presided over by Sir Philip Sassoon and he was a patron after my own heart, for he avoided bureaucracy as much as possible and made decisions whenever he could in the Medici manner of a benevolent dictator; and that works in matters of Art better than do democratic committees. He was obliged to show a model of the scheme in the tea room of the House of Commons, but, fearing delaying criticisms, he arranged for it to be placed there at 4 o'clock on the very day that the House rose for the summer recess and when Members were eager to get away. Having carried out at least the letter of the regulations and received no adverse opinion Sassoon told us to go ahead and by the time Parliament reassembled the matter was *un fait accompli*.' Wheeler concluded: 'although it was planned to unveil them in 1939, the war came and the bronze groups were buried in the vaults of the British Museum for the duration. When the war ended the sculptures were resurrected, placed in the already completed basins and a grand unveiling by the Duke of Gloucester was arranged.'

Broadly speaking in the Art Deco style of the 1920s and 1930s, and inspired by similar bronze fountains in the United States by the Swedish sculptor Carl Milles, these energetic groups of tritons and mermaids sporting with dolphins celebrate the steamlining of the creatures, which was inspiring so many designs for speedy vehicles on land, sea and air at the time. William McMillan's twin fountains in the pool to the east (or right, looking towards the National Gallery) are very effective, especially the one with the female form to portray, on account of its voluptuous curves and the long hair that he could make fly out behind in a tousled mane. A distant cousin of the *Little Mermaid* who sits demurely on the shore by Copenhagen harbour, this supermodel of a girl really seems to be hurtling through the air, as she strives to catch first one water-slippery dolphin and then another. When McMillan was designing her, the Olympic Games of 1936 (notorious because hosted by Hitler and the Nazis) had only just taken place in Berlin, and so perhaps he was inspired by a real athlete, seen live, or on one of the propaganda films. One is also reminded of John Betjeman's paean of male praise for the athleticism of Joan Hunter Dunn! It is from these splendid bronzes that David Wynne was in turn to take his inspiration several decades later (pp. 27, 197).

IV

FOUNTAINS & FURNITURE: THE DOLPHIN IN A SUPPORTING ROLE

Fountains

The modern fountains in Trafalgar Square in London (p. 170) are heirs to a long tradition. The association of a marine creature such as a dolphin with a source of water (albeit fresh, not salty), one of the staples of life, and with or without a presiding deity such as Neptune, Venus or Cupid, is perfectly natural.

As we have noted, the dolphin became a favourite feature of Roman domestic fountains. One type shows Cupid seated sideways on a dolphin, whose mouth is pierced to emit water: they appear to be beached on the seashore, for Cupid's feet rest firmly on the sand, while the dolphin is shown more or less out of the water. This, combined with Cupid's nostalgic look, puts one in mind of the ancient stories where the dolphin dies in such circumstances.

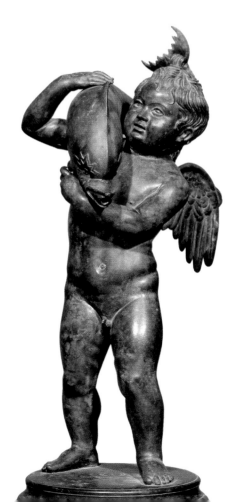

'Cupid supporting a Dolphin', a Roman bronze fountain figure from the House of the Great Fountain in Pompeii, 1st century AD.

This Renaissance statuette from a wall-fountain suggests that Donatello, before making it c. 1435-46, must have seen a Roman statue similar to the one from Pompeii.

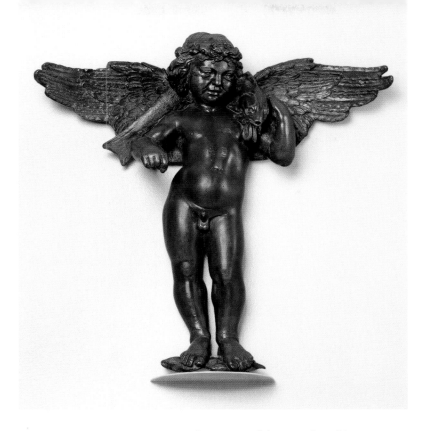

The most famous Roman statue (because widely reproduced in more recent times by Neapolitan foundries) is the *Cupid supporting a Dolphin* from the House of the Great Fountain in Pompeii. The original forms the centrepiece on an island in the pool, backed by a fabulous polychrome mosaic niche with a water stairway, flanked by tragic and comic masks. It is of exquisite workmanship, though its surface is now corroded by the play of water over it and its subsequent burial in the earthquake of AD 79. This particular statuette was not excavated until the 18th century, and so could not have been known to artists of the Renaissance.

Nevertheless, Donatello must have known a similar ancient bronze, for his *Cupid supporting a Fish* is so similar in its motif and its functioning as a fountain. It is not fully finished behind, and has a hole in its back to receive a water-pipe to supply the jets in the mouth of the fish and in Cupid's erect penis, so it must have stood against a wall, perhaps in a niche. Cupid is also gingerly balanced on a tortoise, which – if only the fish were a proper dolphin! – would neatly define the meaning as *Festina lente* – or, in English, 'more haste, less speed'. Possibly Donatello was not, at the stage when he modelled the group, aware of the bulging forehead that is characteristic of the dolphin.

The reason for this special pleading over the identity of the creature is that Donatello's close follower, Verrocchio, seemingly influenced both by this small domestic fountain figure and by the Antique, produced a statue, almost of life size, where a Cupid does indeed hold a dolphin (though it is shown struggling to free itself from the tight grip of his two hands, rather than passively draped over his shoulder). This group is crucial in the evolution of Renaissance sculpture, for it was carefully composed by Verrocchio so as to be enjoyable from all angles, owing to its continually spiralling design, of which the curves of the dolphin's body are a vital component. Its meaning would have been learnedly noted and discussed by the humanists of the Platonic Academy founded by Cosimo il Vecchio, whose seat was in the Medici Villa at Careggi, where it originally crowned a fountain in the garden.

A century later, the charm of this seemingly light-hearted image captivated Tribolo, a follower of Michelangelo, who specialized in garden statuary. Wishing to carve it out of marble, however, he was constrained to omit the protruding wings and to insert another figure under what is in Verrocchio's bronze a free-hanging leg. Several such groups of paired children are known, but their dolphins are not especially impressive. Similar single figures also abound in the gardens of Florence, for instance a pair in the Grotta di Madama in the Boboli Gardens. Others have been removed to museums or private collections.

The taste for fountains involving dolphins was by no means restricted to Florence: at the far north of Italy, in Trento, an up-and-coming local sculptor called Alessandro Vittoria, working for the Prince-Bishop, included a fine pair with entwined tails as supporters for the upper basin of a Neptune Fountain that he designed around 1550. The tradition culminated in Rome with a pair of exquisite marble groups of putti astride vivacious, caricatured dolphins in the courtyard of the Casino of Pope Pius IV in the grounds of the Vatican.

By the mid-century dolphins on their own had become part of the standard repertory of the Mannerist 'fountaineer' (*fontaniere* in Italian). Examples include a fountain of 1583 in the Piazza Vittorio Emanuele at Cesena, one by the aptly named architect Domenico Fontana outside St John Lateran in Rome, and another with four dolphins rearing up and spouting outwards from round the base of an obelisk at the Villa Medici in Rome.

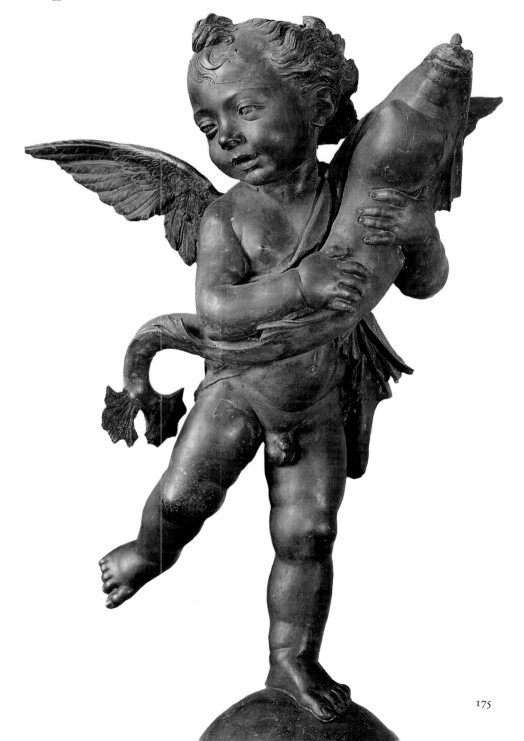

Around 1470 Andrea del Verrocchio produced this more sophisticated and bigger variant on the ancient theme of Cupid and dolphin as the bronze finial of a marble fountain in the gardens of the Medici Villa at Careggi.

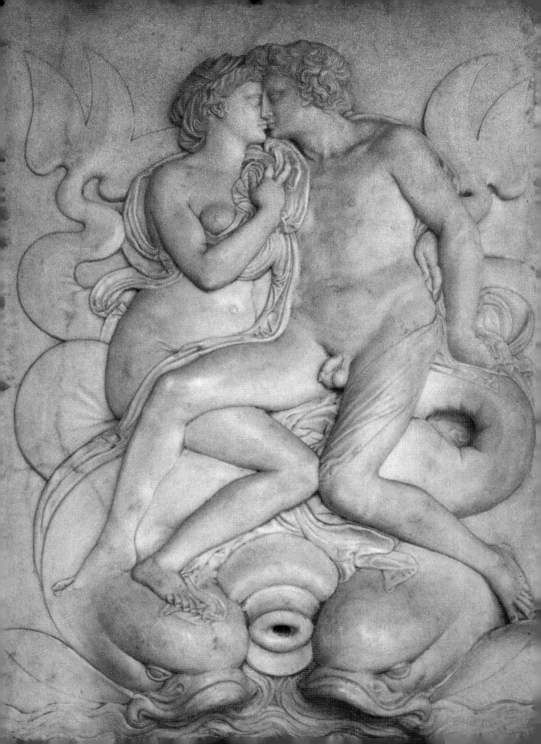

In relief sculpture too the dolphin appears as a motif to ornament the spouts of fountains. One such is now walled into the balcony of the Bargello Museum in Florence, as dry as a bone, but it must once have looked marvellous with water gushing from the central overturned urn between the paired dolphins' heads, below the reclining figures of Peleus and Thetis. Another relief that gives more prominence than average to its dolphins is set in a shallow niche, within an elegant aedicule, on the outside of the Sacchetti Palace on Vicolo del Cefalo in Rome. It is a variant – with redoubled dolphins – of the earlier, better preserved, one by Raffaello da Montelupo (p. 53).

Elsewhere in Italy, the dolphin scene had been flourishing also. In 1563 the architect-designer Tommaso Laureti began to purvey alternative designs to the city council of Bologna for a prestigious fountain to embellish the central piazza of their city: in most, dolphins naturally feature, amongst other marine creatures, monsters and deities, either seeming to swim in the pool below (their open mouths perhaps functioning as drains) or spouting water from one level to another. In the event, he and the patrons hit upon a Flemish sculptor, who went in Italy by the name of Giambologna and who had recently been worsted in a competition to design a Fountain of Neptune in the centre of Florence, to provide sculpture in bronze for installation on a marble structure designed by Laureti. The result – unveiled in 1567 – was a triumph, owing to Giambologna's innate skills as a designer of suave figures in the classical and Michelangelesque traditions (overleaf). Never did a fountain rely on more dolphins. The crowning deity, Neptune, rests his relaxed right foot on the back of one; four putti seated at his feet on the corners of the pedestal hold up one each to spout water; and four sirens below them straddle some still bigger ones that seem to swim into the pool below.

A Mannerist wall-fountain showing the marriage of Peleus and Thetis features an engaging pair of dolphins forming a sort of marine couch, almost a water-bed, for the amorous couple.

For his bronze sculptures on the Fountain of
Neptune in the Piazza di San Petronio, Bologna,
of 1563-67, Giambologna devised sirens expressing
water, instead of milk, from their full breasts, as they
ride great dolphins into the surrounding pool, and
higher up, just below Neptune's feet, reverted to the
Roman and Renaissance idea of a boy draining a
dolphin of water.

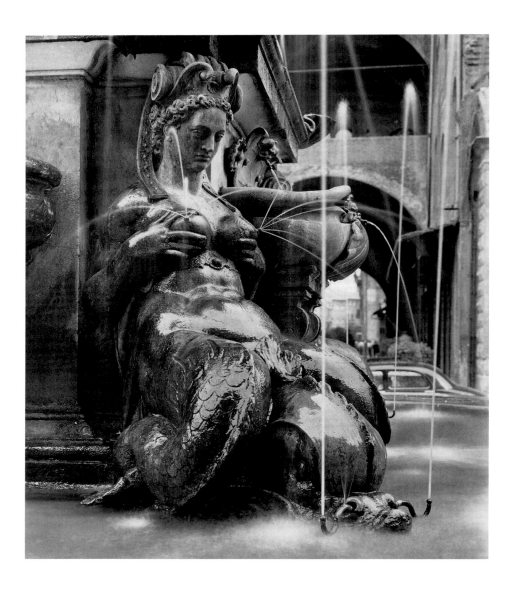

Much later in life, Giambologna created a marvellous bronze fountain-group of Triton trumpeting: he is supported in unlikely fashion – but anything is feasible in mythology – on the upraised and entwined tails of three dolphins, slithering outwards over an upturned cockle-shell. The brilliance of the composition may partly be explained by the fact that Giambologna had the benefit of an earlier Florentine treatment of the same theme in a marble group carved by Battista Lorenzi at some date before 1574; in that, Triton's horn is an oversize sea-snail shell, which tends visually to weigh the group down. Noticing this defect, Giambologna changed the instrument on which Triton trumpets his warning to the rebellious waves into a long, wavy, non-marine horn.

In the same vein, in Rome, Taddeo Landini modelled as supports for the tazza of a fountain in the Piazza Mattei four lithe youths resting their feet rather heavily on some dolphins, seeming to make them spout water. The dolphins' heavy, arched eyebrows, big protruding eyes and leaf-like fins – all quite unnatural – became part of the standard, slightly caricatured and therefore rather endearing, image of the dolphin for centuries to come, a foundation that was to be built upon most prominently by Bernini.

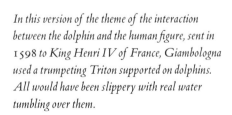

In this version of the theme of the interaction between the dolphin and the human figure, sent in 1598 to King Henri IV of France, Giambologna used a trumpeting Triton supported on dolphins. All would have been slippery with real water tumbling over them.

Landini's dolphins on the fountain in Piazza Mattei, Rome, c. 1581-84, have a harassed look as their sprightly captors tweak them unceremoniously by the tail and tread on their heads, as though to expel liquid from a wineskin. (The fountain is known as the Fountain of the Tortoises, because such creatures were later interpolated far above.)

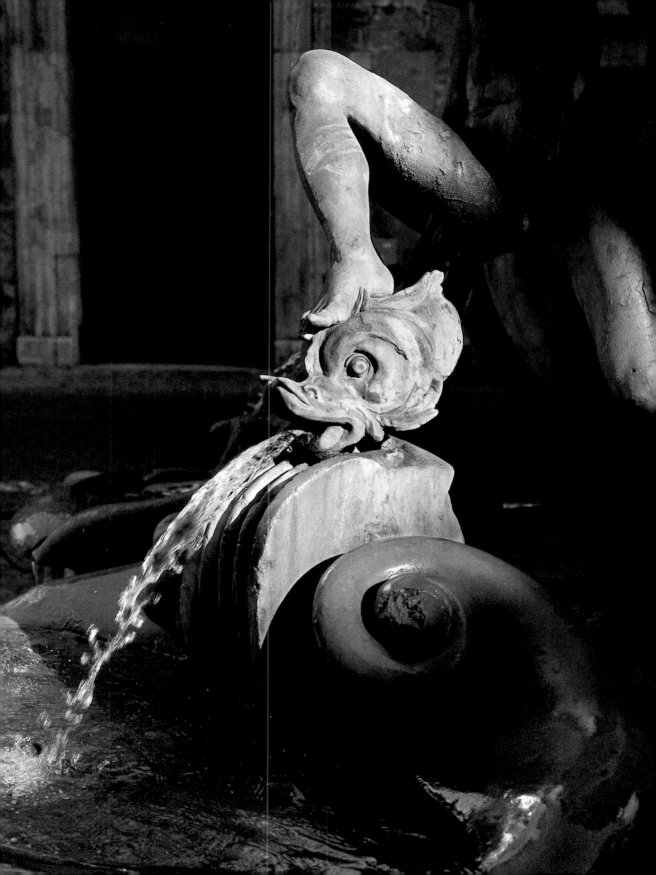

Pairs of dolphins flanking grotesque masks on the fountain at the southern end of the Piazza Navona formed part of a design by Giacomo della Porta, of 1573, which was later adapted into Bernini's Fountain of the Moor, on the same site.

A fountain in the garden of the Quirinal Palace in Rome incorporates four aquatic creatures, dolphins and also turtles, that once supported two heavy sarcophagi which used to act as cisterns in the Vatican. They stood below some ancient statues installed there in 1511 by Antonio da Sangallo.

This is not to say that more lifelike representations disappeared: far from it. Several such feature in fountains by Giacomo della Porta. The most notable are four pairs that sidle up against huge grotesque masks whose mouths are open to spout water. They – now replaced by copies – are among the principal ornaments of the southern fountain in the Piazza Navona, surrounding Bernini's monumental statue of the Moor (see pp. 188-89). Similar groups, with a Borghese dragon behind, supporting the dolphins' backs with its spread wings, decorated Giacomo della Porta's fountain in front of the Pantheon (itself later modified: see p. 190).

Della Porta was perhaps inspired by a pair of natural, unadorned dolphins in marble that had been carved a generation or two earlier in the Vatican workshop to support a Roman sarcophagus that received water spouting from below a famous statue of Ariadne (formerly called *Cleopatra*). This was set in a niche in the octagonal Court of Statues in the newly constructed Belvedere. The statue was acquired in 1511 and was installed under the auspices of Antonio da Sangallo the Younger, who may have designed the dolphins. They were accompanied under a neighbouring sarcophagus, which stood similarly beneath an ancient statue of the River Tigris, by a pair of turtles. This was of course the very moment when Raphael began also to include dolphins in his paintings (see pp. 51-52, 82-83).

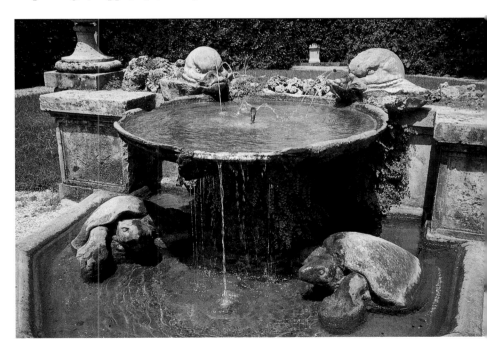

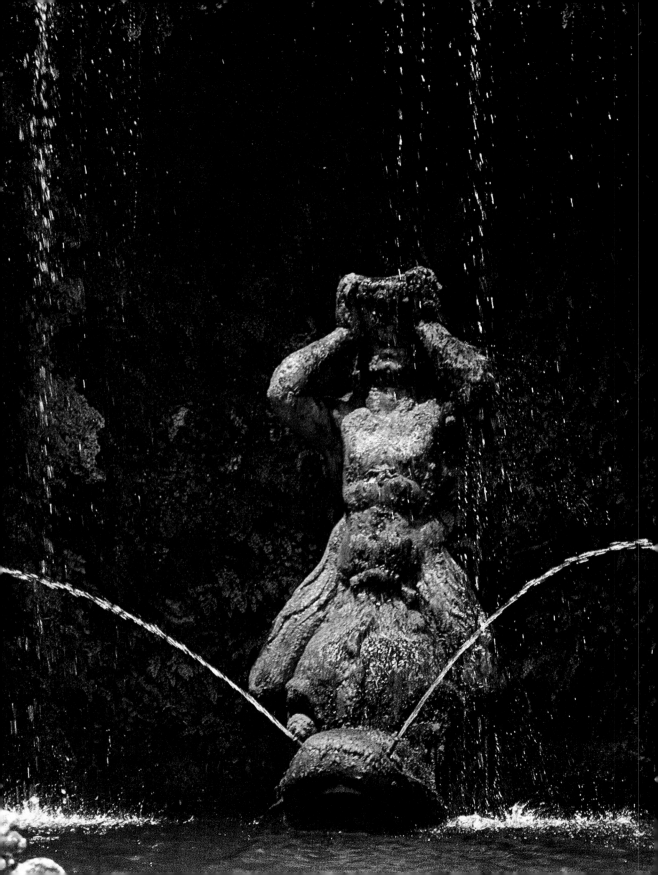

One of the biggest dolphins ever carved is one surmounted by Triton blowing his conch-shell which seems to issue forth from a rustic cave in the gardens of the Vatican. They form the focal point of a fountain that is, rather perversely, called after another creature set far above them, the Fontana dell'Aquila (or dell'Aquilone) – 'of the (big) eagle'. Carved by Stefano Maderno in 1612, this is important not only on its own account, but as a precedent for a sculptor then in his teens, who was to become the *maestro* of the art within a few years, Gianlorenzo Bernini. Bernini adored the sinuous, squashy shape of the dolphin – albeit the playfully stylized sort – and frequently introduced it into his fountains, which are such a prominent and delightful feature of the Eternal City.

The Triton and dolphin of the Fontana dell'Aquila or Eagle Fountain in the gardens of the Vatican were carved by Stefano Maderno out of travertine in 1612.

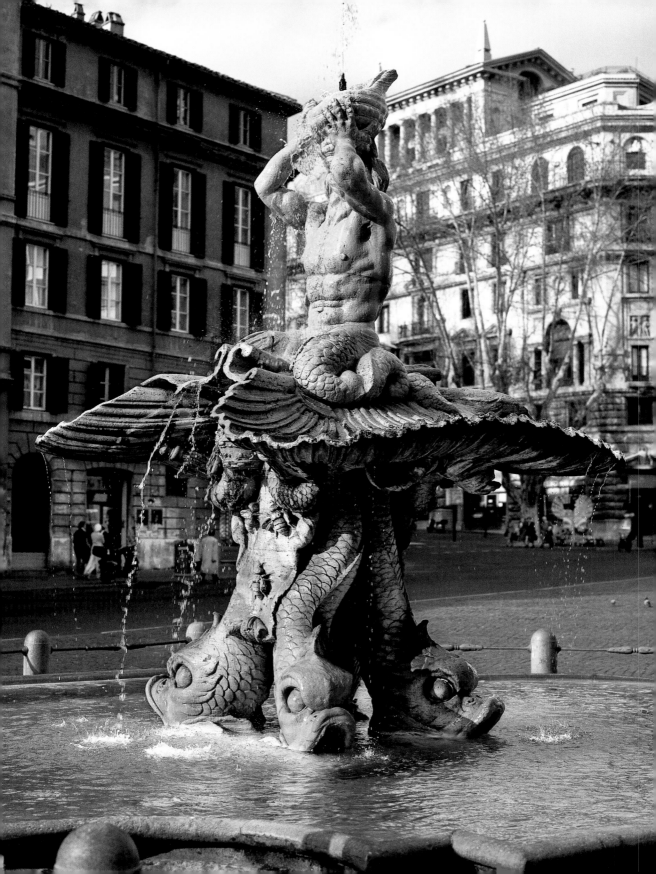

Bernini's Triton Fountain still presides over one of the main squares in Rome, Piazza Barberini, named after the family palace nearby of Bernini's patron, Pope Urban VIII. We know from a drawing that he intended to separate the *dramatis personae* of Maderno's Eagle Fountain by a wide basin in the form of an open shell: this rests on the upturned tails of four dolphins, from which hangs the shield of arms of the patron, while Triton is seated astride it. Save for the shape of the shell, which became a bivalve with a corrugated edge, this design is what was finally executed between 1642 and 1643. These photogenic dolphins, with their completely unnatural large eyes (reminding one of Walt Disney cartoon creatures) and open mouths, are everybody's favourites.

Five years later, under the next papacy, Bernini managed to win off a rival a highly desirable commission for a fountain in the centre of the Piazza Navona. In a preliminary drawing for what was to become the famous Fountain of the Four Rivers, the four pylons of carved rock are each inhabited by a river-god, and the gods are seated over huge shells as receptacles for water, under the corrugated edges of which lurk in the shadows huge dolphins spouting water lustily. Alas, these did not survive into the final design, but dolphins do still feature on the fountain, albeit on a diminutive scale and high above eye-level: they help to affix the papal tiara and crossed keys (of St Peter) firmly to the coat-of-arms of Bernini's patron, Innocent X, a member of the Pamphili family.

Four large dolphins support Bernini's Triton Fountain in the Piazza Barberini in Rome, hewn out of travertine in 1642-43. It once dominated a more countrified environment, as we know from old engravings. Instead of spouting water, as dolphins do on so many fountains, they are sucking it in, for they function as drains for the pool.

A pair of docile little dolphins nudge into place a shell (in combination, a motif with strong Christian connotations) between the arms of Pope Innocent X and the papal tiara and keys on Bernini's Fountain of the Four Rivers in the Piazza Navona in Rome, of 1648-51.

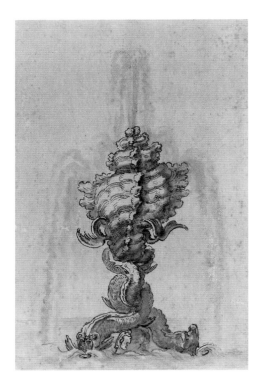
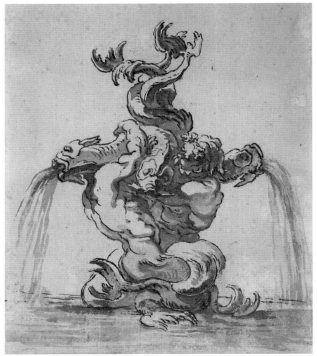

However, the dolphin was now definitely on Bernini's mind whenever he thought of fountains. When asked to re-do the smaller fountain at the southern end of the Piazza Navona, whose scheme by Giacomo della Porta already embodied pairs of dolphins flanking masks round the periphery (p. 182) but lacked a centrepiece, Bernini immediately came up with an idea for one: it consisted of three up-ended dolphins, like those of the Triton Fountain, but with their entwined tails supporting the shell of a sea-snail. The arrangement of the dolphins Bernini may have borrowed from an album of engraved designs for fountains that had been published at Rome in 1618, but his variation on the theme is brilliant and was carved and installed straight away. However, for once, he had slightly miscalculated, and his patron demanded something more impressive. The attractive central motif of dolphins with raised and entwined tails was re-used as a support for the basin in later fountains elsewhere, not by Bernini, for instance in the courtyard of Santo Spirito, Rome, and as far afield as the Certosa of Pavia.

The sculptor was quick to react to this setback, drafting a variant in which the trio of squirming dolphins was hoisted aloft by a pair of muscular tritons facing each other and with their fishtail-legs entwined to give them extra purchase. Surprisingly, this did not find favour either, and so Bernini had to return to the drawing board. This time – perhaps at the patron's behest – he designed an unidentified but giant human figure, wielding a dolphin almost as though it were a scythe: no drawing for this is known, but a brilliantly executed model has recently come to light. The shell of a sea-snail has re-surfaced in this design, canted horizontally, as an unlikely vessel for the muscular figure to balance on. His Moorish facial features recall those of the River Plate on the Fountain of the Four Rivers a few yards away, but the reason for this choice is not known. The endearing dolphin has scales, as so often, and its head, apart from a bulging forehead and projecting beak, bears little relation to the real creature, but is a figment of Bernini's ever-vivid imagination: could he have seen a Pekinese dog at this early date?

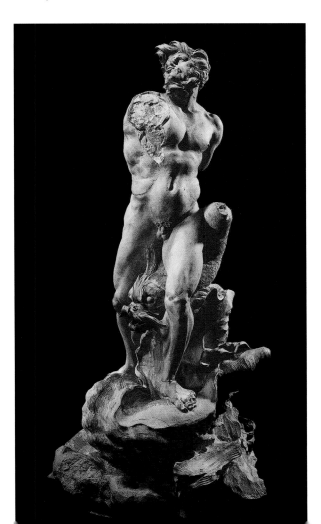

Bernini's first idea, of 1651, for the centrepiece of the southern fountain in the Piazza Navona (which became the Fountain of the Moor) involved a trio of performing dolphins juggling with a giant, coruscated seashell balanced on their tails.

Bernini's second idea for the fountain, with the dolphins lifted up by tritons, 1652.

A model for Bernini's final version of the Fountain of the Moor, 1653. The be-whiskered face of the dolphin between the man's knees is even more characterful here than in the final marble statue, which was carved by an assistant.

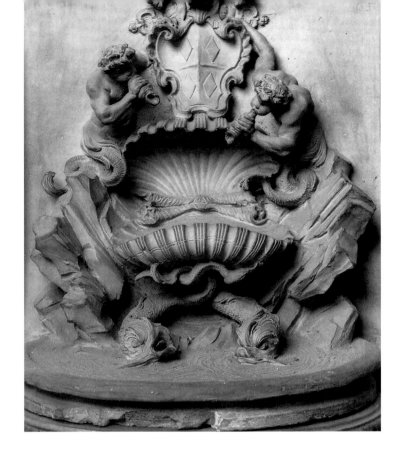

This typically Baroque model for a fountain in the garden of Paolo Strada, of 1668, shows Bernini late in life reprising several of the motifs that he had explored or used before, in particular the pair of frowning dolphins that swim in the pool and support on their tails a bivalve shell as a basin for the fountain.

Nicolas Poussin liked dolphins as much as Bernini, in the mid-1630s drawing two handsome ones on the same sheet as a study for Venus sitting in a shell, with Cupid bearing a torch standing behind her.

Also best seen in a surviving presentation model are the dolphins on a fantastic wall-fountain that Bernini designed in 1668 for Pope Clement IX, which was destined for the garden of a palace belonging to his steward and butler, Paolo Strada. The arms are therefore those of the Rospigliosi. Bernini's exciting composition inspired later designers of wall fountains.

The notion that Bernini and his friend the French painter Nicolas Poussin were comparing ideas gains some credence from the latter's drawing of two large dolphins on the same sheet as his sketch of Venus sitting in a shell. The tempting repertory of variations on the theme that Bernini's work proffered could not fail to influence all his successors: one has only to walk a few hundred yards from the Piazza Navona to the Piazza della Rotonda, the square in front of the Pantheon, to see a quartet of dolphins that was added to the pre-existing fountain by Giacomo della Porta in 1711 (overleaf), when Pope Clement XI also replaced its centrepiece with a rocky pedestal bearing an Egyptian obelisk, deliberately to resemble the Fountain of the Four Rivers.

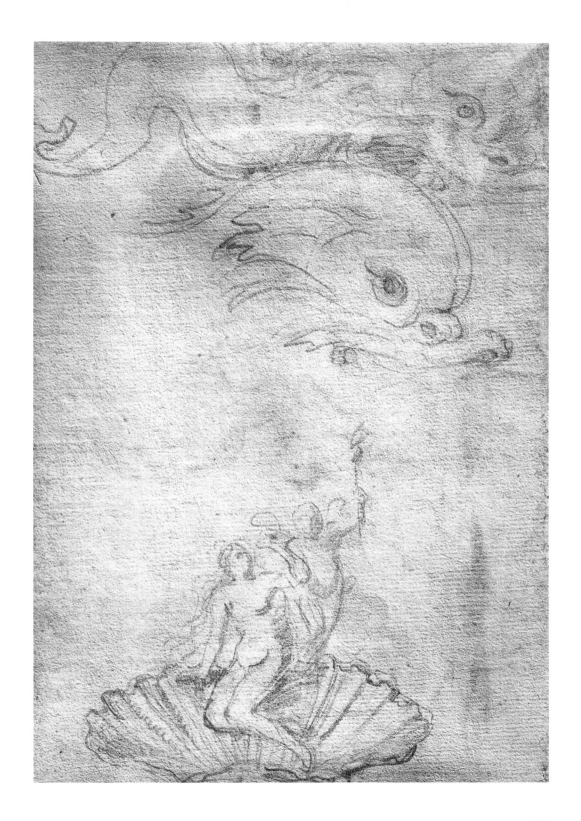

This close-up view of the fountain in front of the
Pantheon (whose façade is in the background) concentrates
on one of the dolphins by an unknown sculptor, though
clearly derived from Bernini, that were carved at the
corners of a new central pedestal in 1711.

This pair of dolphins with tails up and entwined, for once
supporting nothing, is one of four flanking the lateral fountains
(of Rome and of Neptune) that adorn the Neoclassical
retaining walls of 1823 round the Piazza del Popolo.
They were carved to Giuseppe Valadier's design by
Giovanni Ceccarini.

The idea of a quartet of dolphins supporting an obelisk spread far and wide, to Aix-en-Provence in France, and to Spain, where in the courtyard of the monastery of Las Huelgas at Burgos stands a similar fountain, though with more highly decorated dolphins hoisted aloft on a pillar.

Back in Rome, other sculptors working in the newly fashionable style of Neoclassicism helped to decorate every corner of the revamped ancient city, and dolphins, dissociated from any but aquatic imagery, pop up all over the place. For instance, in 1823 Giuseppe Valadier introduced four pairs of dolphins carved to his design into the hard white marble surrounding of the Piazza del Popolo.

*The Perseus and Andromeda fountain
at Witley Court in England is animated
by multiple jets of different heights and
directions that encase it in a kinetic, linear
cage of white water, and a haze of spray.
It was created by James Forsyth c. 1860.*

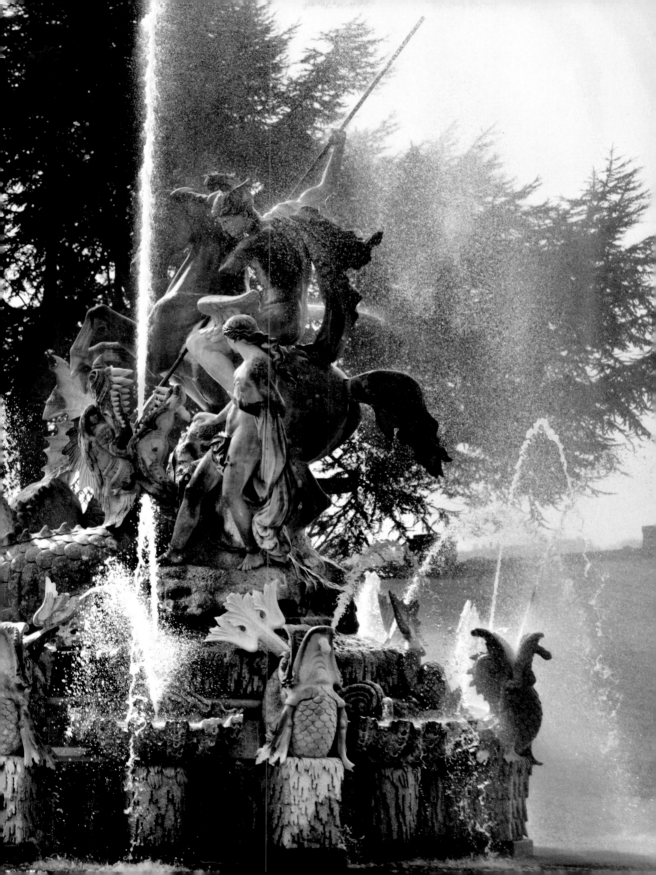

The drinking fountain on the Common in Boston, Massachusetts, with its entwined dolphins, was one of a number erected in American cities in the later 19th century by Dr Henry Cogswell (a promoter of temperance); another with a similar design survives in Washington, D.C.

David Wynne's bronze fountain of 'A Girl with a Dolphin', a commission of 1973, near Tower Bridge in London.

From Rome in the later years of the Grand Tour and during the Age of Steam, the habit of decorating fountains with dolphins spread worldwide, to England, in the splendid gardens of Witley Court in Worcestershire (pp. 194-95), where a performing team spout jets of water under pressure created by steam-driven pumps into mid-air around a Romantic sculpture of Perseus and Andromeda, and to the United States, where in Lake Forest, Illinois, a pair spout downwards into a fountain against a retaining wall beneath the Villa Turicum, the country estate of Mrs Rockefeller McCormick, and entwined pairs in bronze in elegant classical tempiettos formed drinking fountains in various cities, including Boston, Massachusetts, and Washington, D.C.

Finally, in London, a striking modern fountain on the banks of the Thames near Tower Bridge of *A Girl with a Dolphin* is another delightful take by David Wynne on the age-old theme of a dolphin disporting itself with a young human being. Exploiting the tensile strength of metal, the sculptor has managed to balance the two spiralling creatures in mid-air on one tip of the dolphin's tail fin, near the single fountain jet, while barely touching one another. They look as though they are swimming underwater, or as if the girl has just been hurled off the dolphin's back as they play and leap about. This and David Wynne's aerial acrobatic group of a boy with a dolphin (p. 27) could scarcely have been executed without the help of a modern aid, photography, to capture the complex, momentary, swirling movement.

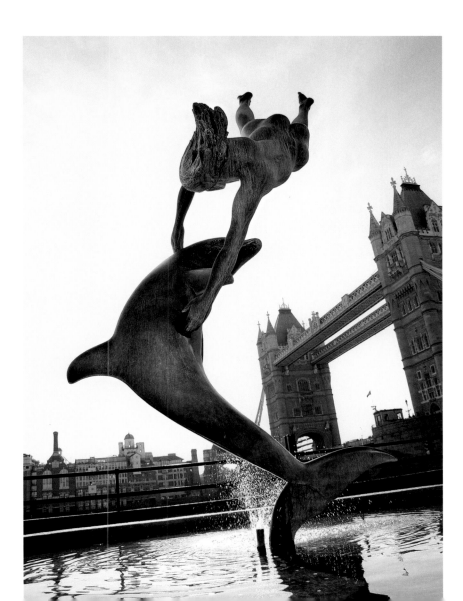

Dolphins in Furniture & the Decorative Arts

We have already come across the dolphin as an aesthetically pleasing form of support on several occasions earlier in the book.

Dolphin-feet appear in the decorative arts occasionally: for example on a wine-dispenser in the form of a barrel with a slimmer than usual infant Bacchus astride it: the use of dolphins suggests a learned connection with the Greek myth about Dionysus turning the pirates into dolphins, as they leapt off a ship (cf. p. 92), which here has been transformed into the similarly planked wine-barrel. At much the same time in Portugal, a brightly coloured ceramic dolphin, with a fantastic rendering of its eyes and beak, was made in Rato to serve as a table-fountain. As has been remarked, 'By the 17th century, rinsing hands had become an essential element of dining etiquette in wealthy European households. To this end, decorative fountains were increasingly installed in adjacent closets or even incorporated into elaborate, multi-tiered buffets.' In the age of elegance in France, the curves of the dolphin were exploited to enliven gilt-bronze mounts on elaborate furniture and clocks, while in England at much the same date Josiah Wedgwood used an upright dolphin to support a candle-nozzle on its tail.

A specially engaging dolphin is this Portuguese tin-glazed earthenware table-fountain, with a tap emerging from its mouth, made in Rato c. 1775.

This wine-dispenser in polychrome glazed ceramic was made in the last quarter of the 18th century in Hannoversch Gmünd, in north Germany.

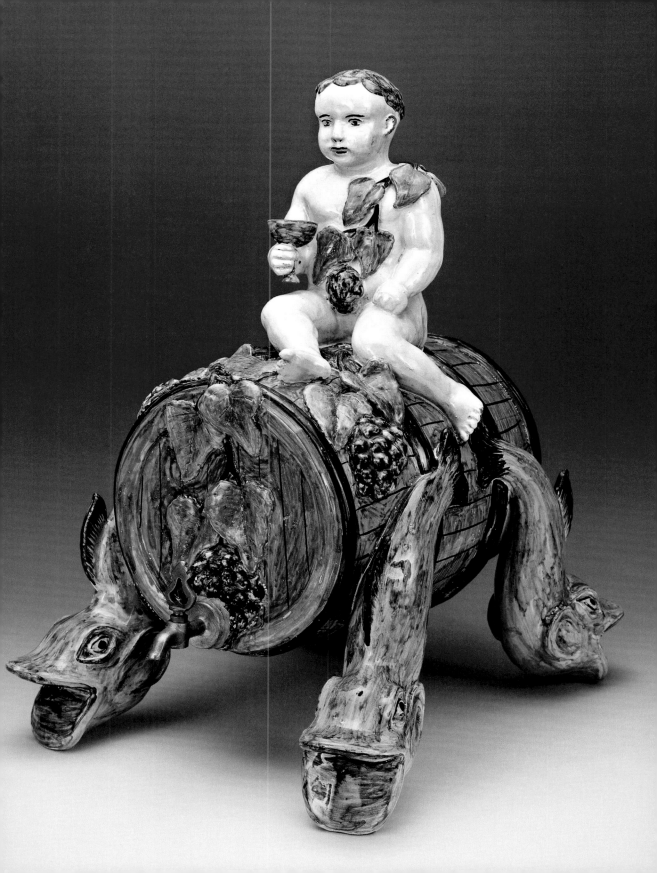

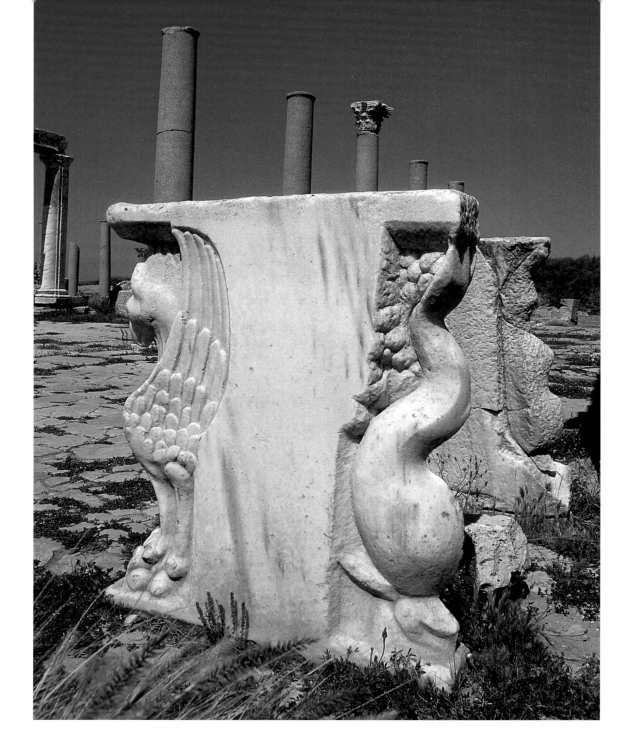

*A provincial Roman market table belonging to one Annobal
Tapapius Rufus at Lepcis Magna in Libya, carved in the
decade before the birth of Christ with a dolphin and a griffon.*

Where did the basic design idea for supports shaped as dolphins originate? We have seen how such a creature was integrated as a disguised support into a standard type of statue of Venus, where its spreading shape, hewn out of the same block of marble as the delicate legs of the goddess, helped to retain the strength of the statue at a point that would otherwise have been vulnerable – the ankles (p. 56). Virtually the same form of dolphin was also used to decorate the ends of a marble sales counter in the ancient Roman marketplace of Lepcis Magna in modern Libya, built in the years 9-8 BC. Griffons feature on the other side: they may have had some bearing on the business being conducted, or been chosen at random. These are not unique, and the idea was passed down by archaeological discoveries made in the Eternal City, until, as late as 1775-85, two pairs of dolphins with entwined, but largely independent, tails were used to support a slab of red oriental granite to form a handsome pair of side-tables for the Borghese princes. A variant of the same motif had been used a little earlier to support a big water basin, in the form of a fluted shell resting on a stylized classical steering-oar, in a hallway in the Château of Versailles.

This pair of fierce dolphins supporting a water basin in the Château of Versailles may just conceivably be a reference to the Dauphin of France, though as we have seen dolphins are natural companions of fountains. Their details are correctly classical, with their elegant ruffs of acanthus.

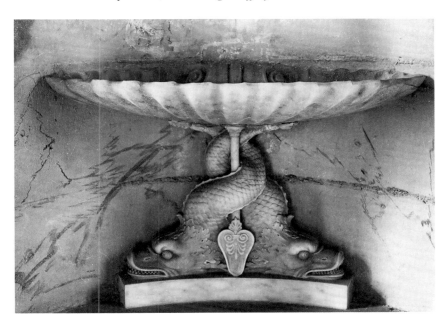

Turning now to furniture proper, two very lively dolphins thrash their tails round the standard of a shapely tripod in a design published by Thomas Johnson in 1758, helping to enliven its delicate Rococo silhouette (it inspired a piece now in the Victoria & Albert Museum in London). Four years later, in his *Director*, Thomas Chippendale followed suit and, not to be outdone by Johnson, introduced a trio of dolphins as feet for a dainty table, with tritons and cupids round the stem above.

The sinuous form of our chosen creature lent itself to other roles within furniture of the period, as for instance a support for the armrest of an otherwise fairly restrained giltwood chair dating from the reign of King George III. It is not known whether any nautical reference was intended here, but it certainly was in the case of a suite of dolphin furniture made to commemorate Lord Nelson's naval victories (now in the Royal Pavilion, Brighton).

Even when the playful style of such furniture was replaced by the sober Empire style favoured by Nelson's arch-enemy, Napoleon, dolphins succeeded in working their way into the new designs. At a time of continuous maritime conflict, the dolphin continued to perform sterling service in the ever more sober and heavier furniture that became fashionable internationally.

A Rococo design for a tripod with entwined dolphins above fictive water by Thomas Johnson, published in London in 1758.

An early 19th-century giltwood bergère attributed to the English makers Marsh and Tatham, with obliging dolphins supporting on their tails the fronts of the armrests, directly beneath any incumbent's hands.

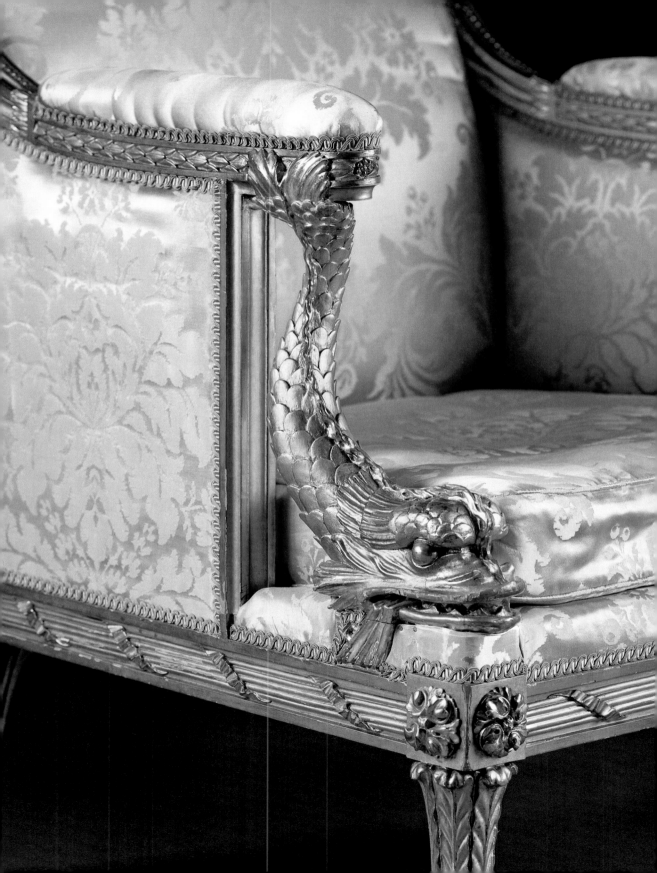

Let us end with a love-affair between a great artist of the 20th century and a dolphin-armed chair, notionally made to go in a Rococo grotto. Chippendale had proposed as long ago as the 1750s such a design of chair, with an open shell forming the back and seat (of which there is an example from Woodhall Park, Hertfordshire, in the Victoria & Albert Museum). The firm of Pauly & Co. in Venice decided in the 1880s to reproduce such entertaining furniture for the then fashionable winter gardens of the well-to-do, illustrating it in their catalogue, and a set of theirs is on view in the (much earlier) grotto of Woburn Abbey in England. This line of furniture remained in production until about 1930 and enjoyed great success with celebrities such as Helena Rubinstein, Indira Gandhi, and the protagonist of our love-affair, Henri Matisse.

On 20 April 1942 Matisse wrote to his friend Louis Aragon: 'I have finally found the object I have wanted for a year. It is a Venetian baroque chair, in varnished silver, like enamel. When I saw it in an antique shop a few weeks ago, I was completely bowled over by it. It is splendid, I am smitten.'

'This was not the first time that he was taken with a chair', writes the painter's friend, Marie-France Boyer. 'During a stay in Ciboure in 1940 he put an empty Voltaire chair in front of an open window and set it in the very centre of his painting *The Yellow Room,* having drawn it incessantly, until, as he said to Aragon in a letter, "I was able to lift the veil on its secret."' Then she continues the story of the rocaille chair: 'with "positively reptilian" armrests and feet reminiscent of a lizard's or the shape of sea horses, this baroque chair, brought to Le Rêve [Matisse's villa at Vence in the south of France] in 1943, took on the full role of a model and, with an old coffee glass on it filled with white flowers, completely invaded the *Rocaille Armchair* canvas (1946). Hélène Adant took many photographs of this chair, with and without these flowers, paired with other armchairs or seats, next to pedestal or Moorish tables, with or without printed fabrics behind it, until Matisse settled on a "pose," as if painting the portrait of a person.'

The arms that so caught the painter's attention are slimmer and more serpentine than in the usual depiction of a dolphin, but it was this voluptuous sinuosity that engaged his eye, his imagination, and – eventually – his brush. Loaded with bright green paint (bearing little relation to the actual hue of the furniture), he manipulated it with rapid swirling movements, almost as it were a real dolphin swimming in water; in the painting the orangy-yellow seat, however, almost looks as though it were upholstered – perhaps it became so in his mind – and bears no relation to the original silvered open-shell design. This dolphin chair beloved by a great modern painter brings to a close this survey of the dolphin in Western art.

In 1942 the painter Henri Matisse acquired an armchair
by the Venetian firm of Pauly, which had dolphins as the arms.
It became something of an obsession and appears in several
of his paintings; and it survives in his studio today. This is one
of the photographs of it taken for Matisse by Hélène Adant.

EPILOGUE

The Thames, the Hudson, & the Dolphin

The Thames and the Hudson are, of course, the rivers of London and New York, and the name of the publishing house was chosen by the firm's founder, Walter Neurath, in 1949, to symbolize the fact that it had offices on both sides of the Atlantic – something of a necessity in those days, when both art and the history of art were thought to be a minority interest in the English-speaking world, and illustrated books with colour reproductions were expensive, best brought out at accessible prices by making them simultaneously available as widely as possible. The name proved popular and memorable.

What sort of logo would echo it? Surely something connected to or affiliated with water? Walter Neurath was an art historian and was probably familiar with many of the works shown in this book. So by the light of history and culture the dolphin was an all but inevitable choice. The fact that there are two dolphins visually reflects the Transatlantic links that the name Thames & Hudson itself refers to – one swimming east to west, the other west to east.

He gave the idea to a designer and calligrapher then on the staff, Reg Klein, who produced the design that soon became identified with the firm and appears overleaf. It remained unchanged until 1999, when the dolphins were given a new, more immediately visible form on the firm's fiftieth anniversary, to suit the more hurried pace of the late 20th century.

Walter Neurath was particularly drawn to these - in his own words - 'intelligent and friendly' creatures because these qualities were what he wanted the publishing house, its publications and its staff to emulate. Such multiple levels of symbolism no doubt appealed to his Renaissance sensibility, and hopefully would also appeal to the man and woman in the street - and indeed, these proverbial persons were given a chance to respond to this directly when in the 1950s he commissioned a version for the tiles on the doorstep of the new office in Bloomsbury Street, which became a well-known landmark, and which are now displayed on the wall of the present offices on High Holborn.

The tiles installed on the doorstep of No. 30 Bloomsbury Street, London, to which the firm moved in 1957, centre on a freely drawn version of the logo — or colophon — of Thames & Hudson.

6th century BC AESOP

The Monkey and the Dolphin

A sailor, bound on a long voyage, took with him a Monkey to amuse him while on shipboard. As he sailed off the coast of Greece, a violent tempest arose in which the ship was wrecked and he, his Monkey, and all the crew were obliged to swim for their lives. A Dolphin saw the Monkey contending with the waves, and supposing him to be a man (whom he is always said to befriend), came and placed himself under him, to convey him on his back in safety to the shore. When the Dolphin arrived with his burden in sight of land not far from Athens, he asked the Monkey if he were an Athenian. The latter replied that he was, and that he was descended from one of the most noble families in that city. The Dolphin then inquired if he knew the Piraeus (the famous harbour of Athens). Supposing that a man was meant, the Monkey answered that he knew him very well and that he was an intimate friend. The Dolphin, indignant at these falsehoods, dipped the Monkey under the water and drowned him.

The Dolphins, the Whales, and the Sprat

The Dolphins and Whales waged a fierce war with each other. When the battle was at its height, a Sprat lifted its head out of the waves and said that he would reconcile their differences if they would accept him as an umpire. One of the Dolphins replied, 'We would far rather be destroyed in our battle with each other than admit any interference from you in our affairs.'

The Lion and the Dolphin

A Lion roaming by the seashore saw a Dolphin lift up its head out of the waves, and suggested that they contract an alliance, saying that of all the animals they ought to be the best friends, since the one was the king of beasts on the earth, and the other was the sovereign ruler of all the inhabitants of the ocean. The Dolphin gladly consented to this request. Not long afterwards the Lion had a combat with a wild bull, and called on the Dolphin to help him. The Dolphin, though quite willing to give him assistance, was unable to do so, as he could not by any means reach the land. The Lion abused him as a traitor. The Dolphin replied, 'Nay, my friend, blame not me, but Nature, which, while giving me the sovereignty of the sea, has quite denied me the power of living upon the land.'

The Tunny-Fish and the Dolphin

A Tunny-fish was chased by a Dolphin and splashed through the water at a great rate, but the Dolphin gradually gained upon him, and was just about to seize him when the force of his flight carried the Tunny on to a sandbank. In the heat of the chase the Dolphin followed him, and there they both lay out of the water, gasping for dear life. When the Tunny saw that his enemy was doomed like himself, he said, 'I don't mind

having to die now: for I see that he who is the cause of my death is about to share the same fate.'

<div align="right">Fables</div>

4th century BC ARISTOTLE

All these creatures which have a blow-hole, breathe and inhale air; and the dolphin has been observed while asleep with the muzzle above the water, and it snores in its sleep. The dolphin and phocæna give milk and suckle their young. They also receive their young into themselves. The growth of the young dolphins is rapid, for they attain their full size in ten years. The female is pregnant for ten months. The dolphin produces her young in the summer-time, and at no other season. They seem also to disappear for thirty days during the season of the dog-star. The young follow their dam for a long while, and it is an animal much attached to its offspring. It lives many years; for some have been known to live twenty-five or thirty years; for fishermen have marked them by cutting their tails and then giving them their liberty. In this way their age was known.

<div align="right">History of Animals (translated by Richard Cresswell), book VI</div>

1st century AD PLINY

The swiftest of all other living creatures whatsoever, and not of sea-fish only, is the Dolphin; quicker than the flying foule, swifter than the arrow shot out of a bow. And but that this fish is mouthed farre beneath his snout, and in manner towards the mids of his belly, there were not a fish could escape from him, so light and nimble he is. . . . When the Dolphins are driven for verie hunger to course and pursue other fishes downe into the bottome of the sea, and thereby are forced a long while to hold their breath, for to take their wind againe, they launce themselves aloft from under the water as if they were shot out of a bow; and with such a force they spring up againe, that many times they mount over the verie sailes and mastes of ships.

This is to be noted in them, that for the most part they sort themselves by couples like man & wife. They are with yong nine moneths, and in the tenth bring forth their little ones, and lightly in summer time; and otherwhiles they have two little dolphins at once. They suckle them at their teats . . . and so long as their little ones are so yong that they be feeble, they carry them too and fro about them: nay when they are growne to be good bigge ones, yet they beare them companie still a long time, so kind and loving be they to their young. . . .

Their voice resembleth the pittifull groning of a man: they are saddle-backed, and their snout is camoise and flat, turning up. And this is the cause that all of them (after a wonderfull sort) know the name Simo [simus is the Latin word for snub-nosed], and take great pleasure that men should so call them. The Dolphin is a creature that carrieth a loving affection not only unto man, but also to musicke: delighted he is with harmonie in song, but especially with the sound of the water instrument, or such kind of pipes. Of a man he is nothing affraid, neither avoideth from him as a stranger; but of himselfe meeteth with their ships, plaieth and disporteth himselfe, and fetcheth a thousand friskes and gambols before them. . . .

In the daies of Augustus Cæsar the Emperour, there was a Dolphin entred the gulfe or poole Lucrinus, which loved wonderous well a certain boy, a poore mans sonne: who using to go every day to schoole from Baianum to Puteoli, was woont also about noone-tide to stay at the water side, and to call unto the Dolphin, Simo, Simo, and many times would give him fragments of bread, which of purpose hee ever brought with him, and by this meane allured the Dolphin to come ordinarily unto him at his call. . . . Well, in processe of time, at what houre soever of the day, this boy lured for him and called Simo, were the Dolphin never so close hidden in any secret and blind corner, out he would and come abroad, yea and skud amaine to this lad: and taking bread and other victuals at his hand, would gently offer him his backe to mount upon, and then downe went the sharpe pointed prickes of his finnes, which he would put up as it were within a sheath for fear of hurting the boy. Thus when he had him once on his back, he would carrie him over the broad arme of the sea as farre as Puteoli to schoole; and in like manner convey him backe againe home: and thus he continued for many yeeres together, so long as the child lived. But when the boy was falne sicke and dead, yet the Dolphin gave not over his haunt, but usually came to the woonted place, & missing the lad, seemed to be heavie and mourne again, untill for verie griefe and sorrow (as it is doubtles to be presumed) he also was found dead upon the shore.

Another Dolphin there was not many yeeres since upon the coast of Affricke, neere to the cittie Hippo, . . . which in like manner would take meat at a mans hand, suffer himselfe gently to be handled, play with them that swom and bathed in the sea, and carrie on his backe whosoever would get upon it. . . .

In the citie Iassos . . . there was another boy named Hermias, who having used likewise to ride upon a Dolphin over the sea, chaunced at the last in a sodaine storme to be over-whelmed with waves as hee sate upon his backe, and so died, and was brought backe dead by the Dolphin: who confessing as it were that hee was the cause of his death, would never retire againe into the sea, but launced himselfe upon the sands, and there died on the drie land . . . there is no end of examples in this kind . . . which induceth me the rather to beleeve the tale that goeth of Arion. This Arion being a notable musitian and plaier of the harpe, chaunced to fall into the hands of certain mariners in the ship wherein he was, who supposing that he had good store of money about him, which he had gotten with his instrument, were in hand to kill him and cast him over-bourd for the said money, and so to intercept all his gaines: he, seeing himselfe at their devotion and mercie, besought them . . . to suffer him yet before he died, to play one fit of mirth with his harpe; which they graunted: (at his musicke and sound of harpe, a number of dolphins came flocking about him:) which done, they turned him over ship-bourd into the sea; where one of the dolphins tooke him upon his backe, and carried him safe to the bay of Tænarus.

To conclude and knit up this matter: In Languedoc within the province of Narbon [there is a pool] wherein men and Dolphins together, use to fish: for at one certain time of the yeere, an infinite number of fishes called Mullets, taking the vantage of the tide when the water doth ebbe, at certain narrow weares and passages with great force

breake foorth of the said poole into the sea: and . . . their onely hast is for this, to escape and passe that narrow place which affourdeth opportunitie to the fishers to stretch out and spread their nets. The fisher-men being ware thereof . . . crie as lowd as ever they can to the Dolphins for aid, and call Simo, Simo, to help to make an end of this their game and pastime of fishing . . . the Dolphins resort thither flock-meale, sooner than a man would thinke, for to assist them in their fishing. . . . But after this service perfourmed, the Dolphins retire not presently into the deepe againe, from whence they were called, but stay untill the morrow, as if they knew verie well that they had so carried themselves, as that they deserved a better reward than one daies refection and victuals: and therefore contented they are not and satisfied, unlesse to their fish they have some sops and crummes of bread given them soaked in wine, and that their bellies full. . . .

Over and besides, the Dolphins have a kind of common-wealth and publick societie among themselves: for it chaunced upon a time, that a king of Caria had taken a Dolphin, and kept him fast as a prisoner within the harbor: whereupon a mightie multitude of other Dolphins resorted thither, and by certaine signs of sorrow and mourning that they made, evident to be perceived and understood, seemed to crave pardon and mercie for the prisoner and never gave over untill the king had given commaundement that he should be enlarged and let go. Also the little ones are evermore accompanied with some one of the bigger sort, as a guide to guard and keep him. To conclude, they have been seen to carrie one of their fellowes when he is dead, into some place of securitie, that he should not be devoured and torne of other sea-monsters.

Natural History (translated by Philemon Holland as
The Historie of the World, London, 1610), book VI

2nd century AD AELIAN

The story of a Dolphin's love for a beautiful boy at Iassus has long been celebrated, and I am determined not to leave it unrecorded; it shall accordingly be told.

The gymnasium at Iassus is situated close to the sea, and after their running and their wrestling the youths in accordance with an ancient custom go down there and wash themselves. Now while they were swimming about, a Dolphin fell passionately in love with a boy of remarkable beauty. At first when it approached, it frightened the boy and completely scared him; later on, however, through constant meeting, it even led the boy to conceive a warm friendship and kindly feelings towards it. For instance, they began to sport with one another; and sometimes they would compete, swimming side by side in rivalry; sometimes the boy would mount, like a rider on a horse, and be carried proudly along on the back of his lover. And to the people of Iassus and to strangers the event seemed marvellous. For the Dolphin would go a long way out to sea with its darling on its back and as far as it pleased its rider; then it would turn and bring him close to the beach, and they would part company and return, the Dolphin to the open sea, the boy to his home. And the Dolphin used to appear at the hour when the

gymnasium was dismissed, and the boy was delighted to find his friend expecting him and to play together. And besides his natural beauty, this too made him the admired of all, namely that not only men but even dumb animals thought him a boy of surpassing loveliness.

In a little while however even this mutual affection was destroyed by Envy. Thus, it happened that the boy exercised himself too vigorously, and in an exhausted state threw himself belly downwards on to his mount, and as the spike on the Dolphin's dorsal fin chanced to be erect it pierced the beautiful boy's navel. Whereupon certain veins were severed; there followed a gush of blood; and presently the boy died. The Dolphin perceiving this from the weight – for the boy lay heavier than usual, as he could not lighten himself by breathing – and seeing the surface of the water crimson with blood, realized what had happened and could not bear to survive its darling. And so with all the gathered force of a ship dashing through the waves it made its way to the beach and deliberately cast itself upon the shore, bringing the dead body with it. And there they both lay, the boy already dead, the Dolphin breathing its last.

<div align="right">

On the Characteristics of Animals (translated by A. F. Scholfield, London: Heinemann/Cambridge, Mass.: Harvard University Press, 1959), book VI

</div>

c. 1200 *Bestiary*

Dolphins have that particular name either as a description because they follow the human voice or else because they will assemble together in schools for a symphony concert.

Nothing in the sea is faster than they are, for they often outrun ships, leaping out of the water. When they are sporting in the waves and smashing themselves into the masses of combers with a headlong leap, they are thought to portend storms.

They are properly called 'Simones'.

There is a species of Dolphin in the River Nile, with a saw-shaped dorsal fin, which destroys Crocodiles by slicing up the soft parts of the belly.

<div align="right">

Cambridge University Library, MS Ii.4.26 (translated by T. H. White)

</div>

13th century *Kyng Alisaunder*

Heo noriceth delfyns, and cokadrill

<div align="right">

Bodleian Library, Oxford, MS Laud 622

</div>

1387 JOHN DE TREVISA

. . . here bee ofte i-take dolphyns, and see calues, and baleynes

<div align="right">

Polychronicon Ranulphi Higden

</div>

You teach a dolphin to swim.

This fits those who try to give advice to another person on a subject of which he has great experence, and so needs no teacher. The dolphin has the swiftest impetuosity in swimming, so that it not only exceeds in speed every kind of swimming creature, but all land animals too. . . . It even leaps over ships, and holding its breath propels itself forward like a missile. . . . As is the dolphin among fish, so is the eagle among birds. They have one thing in common, that it is said each has a love for boys.

Adages, 97–98 (translated by Margaret Mann Phillips, Toronto/ London: University of Toronto Press, 1982)

1576 ABRAHAM FLEMING

The Dalphine feedeth her young with milke.

A Panoplie of Epistles

1580S ANDREA ALCIATI

Arion, who sits on a dolphin, cleaves the blue waves of the sea and with his song soothes the animal's ears and bridles its mouth. The mind of beasts is not as savage at that of an avaricious man. Those seized or oppressed by men are rescued by fish.

Emblemata

1595 EDMUND SPENSER

Soone as on them the Suns life-giuing light,
had powred kindly heat and formall feature,
Thenceforth they gan each one his like to loue,
And like himselfe desire for to beget:
The Lyon chose his mate, the Turtle dove
Her deare, the Dolphin his owne Dolphinet

Colin Clouts Come Home Again

c. 1590–1604 WILLIAM SHAKESPEARE

[Oberon, behind the back of the departing Titania]

Well, go thy way: thou shalt not from this grove
Till I torment thee for this injury.
My gentle Puck, come hither. Thou remember'st
Since once I sat upon a promontory,
And heard a mermaid on a dolphin's back
Uttering such dulcet and harmonious breath,
That the rude sea grew civil at her song,
And certain stars shot madly from their spheres
To hear the sea-maid's music . . .

A Midsummer Night's Dream, act II, scene I

[The Captain, to Viola, who thought that her brother Sebastian had been drowned]

> . . . to comfort you with chance,
> Assure yourself, after our ship did split,
> When you and those poor number saved with you
> Hung on our driving boat, I saw your brother,
> Most provident in peril, bind himself,
> Courage and hope both teaching him the practice,
> To a strong mast that lived upon the sea,
> Where, like Orion on the dolphin's back,
> I saw him hold acquaintance with the waves
> So long as I could see.

Twelfth Night, act i, scene 2

[Cleopatra, mourning her dead lover Antony]

> . . . His delights
> Were *dolphin* like; they shew'd his back above
> The elements they liv'd in.

Antony and Cleopatra, act v, scene 2

1747 THOMAS GRAY

> Eight times emerging from the flood
> She mewed to every watery god,
> Some speedy aid to send.
> No Dolphin came, no Nereid stirred;
> Nor cruel Tom, nor Susan heard.
> A favorite has no friend!

'Ode on the Death of a Favourite Cat, drowned in a Tub of Gold Fishes'

1751/72 DENIS DIDEROT

DOLPHIN, *delphinus* . . . The skin of this fish is hard and smooth, its body long, its back arched, its snout long, its mouth large, its teeth small and pointed, its tongue fleshy and mobile and notched at the edges; its eyes are large and covered over by skin so that only the pupils are visible; the opening of the ear is behind the eye, but so small that it is scarcely visible. Above its snout is a crescent-shaped opening, which leads to a paired duct through which the dolphin breathes in air and expels water. This fish has two strong fins attached to its chest, and another placed vertically . . .

It is well known that the real figure of the dolphin bears little resemblance to that of dolphins in heraldry, or what sculptors and painters present us with in the name of that animal. We shall not concern ourselves with the love that it is said to have for children, nor with its supposed fondness for music . . . What has been recounted on this subject by various authors, both ancient and modern, seems so fantastic that a Naturalist could hardly be tempted to consider it seriously.

Encyclopédie, ou, Dictionnaire raisonné des sciences, des arts et des métiers, vol. x

1844 ELIZABETH BARRETT BROWNING

> ... Faint and dim
> His spirits seemed to sink in him;
> Then, like a dolphin, change, and swim
> The current ...

A Vision of Poets, xcvi

1930 WILLIAM BUTLER YEATS

> That dolphin-torn, that gong-tormented sea.

'Byzantium', from *The Winding Stair and Other Poems*

1934 DYLAN THOMAS

> There round about your stones the shades
> Of children go who, from their voids,
> Cry to the dolphined sea.

'Where Once the Waters of Your Face', from 18 *Poems*

1979 DOUGLAS ADAMS

It is an important and popular fact that things are not always what they seem. For instance, on the planet Earth, man had always assumed that he was more intelligent than dolphins because he had achieved so much – the wheel, New York, wars and so on – whilst all the dolphins had ever done was muck about in the water having a good time. But conversely, the dolphins had always believed that they were far more intelligent than man – for precisely the same reasons.

Curiously enough, the dolphins had long known of the impending destruction of the planet Earth and had made many attempts to alert mankind of the danger; but most of their communications were misinterpreted as amusing attempts to punch footballs or whistle for tidbits, so they eventually gave up and left the Earth by their own means shortly before the Vogons arrived.

The last ever dolphin message was misinterpreted as a surprisingly sophisticated attempt to do a double-backwards-somersault through a hoop whilst whistling the 'Star Spangled Banner', but in fact the message was this: So long and thanks for all the fish.

In fact there was only one species on the planet more intelligent than dolphins, and they spent a lot of their time in behavioural research laboratories running round inside wheels and conducting frighteningly elegant and subtle experiments on man. The fact that once again man completely misinterpreted this relationship was entirely according to these creatures' plans.

The Hitchhiker's Guide to the Galaxy (London: Pan Books/
New York: Harmony Books), chapter 23

FURTHER READING AND SOURCES

Antony Alpers, *Dolphins*, London: John Murray, 1963, pt 1, 'Dolphins in Antiquity'

Aristotle, *Aristotle's History of Animals* (trans. Richard Cresswell), London: H. G. Bohn, 1862, and later editions

Charles Avery, *Bernini, Genius of the Baroque*, London: Thames & Hudson, 1997

—— *Giambologna: The Complete Sculpture*, Oxford: Phaidon Christie's, 1987

—— 'The History of Bernini's Fountain of the Moor', in Andrew Butterfield, ed., *Bernini: The Modello for the Fountain of the Moor*, exh. cat., Salander-O'Reilly Galleries, New York, 2002

Geoffrey Beard, 'William Kent and the Royal Barge', in *The Burlington Magazine*, CXII, no. 809, August 1970, pp. 487-92

Phyllis Pray Bober and Ruth Rubinstein, *Renaissance Artists and Antique Sculpture: A Handbook of Sources*, London: Harvey Miller, 1986

Stephen J. Campbell, *Cosmè Tura of Ferrara: Style, Politics and the Renaissance City*, New Haven/London: Yale University Press, 1997

Pamela Cowen, *Fanfare for the Sun King: Unfolding Fans for Louis XIV*, London: Fan Museum, 2003

Denis Diderot, *Encyclopédie*, Paris, 1751-72: *Dauphin* (the crown prince) in vol. IV, *dauphin* (the animal) in vol. X

Wilhelm Fraenger, *The Millennium of Hieronymus Bosch: Outlines of a New Interpretation* (trans. Eithne Wilkins and Ernst Kaiser), London: Faber & Faber, 1952

Erwin R. Goodenough, *Jewish Symbols in the Greco-Roman Period*, New York: Pantheon Books, Bollingen Series XXXVII, 1956, 5, 2

Deborah Howard, 'Venice as a Dolphin: Further investigations into Jacopo de' Barbari's View', in *Artibus et Historiae*, 18, no. 35, 1997, pp. 101-11

Michael Jacobsen and Vivian Jean Rogers Price, 'The Dolphin in Renaissance Art', in *Studies in Iconography* (Arizona State University), 9, 1983, pp. 31-56

Douglas Keister, *Stories in Stone: A Field Guide to Cemetery Symbolism*, Salt Lake City: Gibbs Smith, 2004

John Lemprière, *A Classical Dictionary*, Routledge's Popular Library of Standard Authors, London/Glasgow/New York, n.d., and other editions

Anna Laura Momigliano Lepschy, ed., *Viaggio in Terrasanta di Santo Brasca,* 1480. *Con l'Itinerario di Gabriele Capodilista,* 1458, Milan: Longanesi, 1966

Joseph Manca, *Cosmè Tura: The Life and Art of a Painter in Estense Ferrara*, Oxford: Clarendon Press, 2000

Cesare d'Onofrio, *Le Fontane di Roma*, Rome: Romana società, 1986

Jean-Baptiste de Panafieu, *Evolution*, Paris: Xavier Barral and Muséum National d'Histoire Naturelle/London: Thames & Hudson/New York: Seven Stories Press, 2007

Eunice Burr Stebbins, *The Dolphin in the Literature and Art of Greece and Rome* PhD dissertation, Johns Hopkins University, Menasha, Wisconsin, 1929, Chapter II, 'Types of the dolphin in art. Conventions in the representation of the dolphin in art'

Allan Sykes, *The Wallace Fountains of Paris*, London: Wallace Collection, 2003/2008

Charles Wheeler, *High Relief: The Autobiography of Sir Charles Wheeler, Sculptor*, Feltham: Country Life Books, 1968

T. H. White, *The Book of Beasts*, London: Jonathan Cape, 1954

ACKNOWLEDGMENTS FOR ILLUSTRATIONS

Scala, Florence, 2003 — 97 Walters Art Museum, Baltimore, Maryland — 98-99 San Vitale, Ravenna; photos Sadea Editore — 100-101 (a) Museo Nacional del Prado, Madrid; photo Scala, Florence, 1995 — 101 (b) British Library, London — 103 Museo Gregoriano Etrusco, Vatican City, Rome; photo Scala, Florence — 104 Germanisches Nationalmuseum, Nuremberg — 107 Photo Maryvonne Rocher-Gilotte — 108 British Museum, London — 110 Photo John Williams and Saul Peckham/ British Museum, London — 111 Photo © Richard Cummins/ Alamy — 112 (a), (b) Photo © Charles Avery — 113 Photo Estelle Brettman, The International Catacomb Society — 114-115 De Agostini Picture Library/ Scala, Florence, 2008 — 116, 117 British Library, London — 118 (a), (c) Bibliothèque Nationale de France, Paris — 118 (b) British Library, London — 119 Christie's Images — 121 National Gallery, London — 122 Piccolomini Library, Siena Cathedral; photo Opera Metropolitana, Siena 1999/ Scala, Florence — 124 (a) Vatican Library, Rome — 124 (b) Photo Archivi Alinari — 125 Photo Bolo 77 — 127 Bargello, Florence — 128 Volterra Cathedral; photo Scala, Florence, 2004/ Diocesi di Volterra. Ufficio Beni Culturali — 130 Gallerie dell'Accademia, Venice — 131 Photo © Andrew Boddington — 132 Siena Cathedral, Chapel of St John — 133 Staatliche Museen zu Berlin — 134 Uffizi, Florence; photo Scala, Florence, 1990, courtesy MiBAC — 135-137 Bibliothèque Nationale de France, Paris — 138-139 (a) Musée Carnavalet, Paris; photo Roger-Viollet/ Topfoto — 139 (b) Christie's Images — 140 Château de Versailles — 141 Museo Nacional del Prado, Madrid — 142-143 Pitti Palace, Florence; photo Scala, Florence, 1990, courtesy MiBAC — 144 Museo Civico d'Arte Antica and Palazzo Madama, Turin; Gonella Foto, 2008 — 146 British Museum, London — 148 Palazzo Massimo alle Terme, Rome; photo Scala, Florence, 1990, courtesy MiBAC — 149 Photo Oscar Bohm/ Bridgeman Art Library, London — 150 Photo © Charles Avery — 151 State Hermitage Museum, St Petersburg — 152, 155 (l), (r) Photo © Charles Avery — 156 Agenzia Hellovenezia/ Vela — 157 Private Collection — 158 Museo Correr, Venice — 159 (a), (b) Courtesy Thomas Del Mar Ltd — 160 Photo Edwin Smith — 162 British Library, London — 163 By Courtesy of the Watermen's Hall, London — 164-165 The Royal Collection 2008 Her Majesty Queen Elizabeth II. Photo National Maritime Museum, Greenwich, London — 166 Private Collection — 168, 169 Photo © Nigel Paterson — 170 Photo © Emily Lane — 172 Museo Nazionale, Naples — 173 Victoria & Albert Museum, London — 175 Photo Anderson — 176 Bargello, Florence — 178 Photo Archivio Villani/ Alinari Archives-Florence — 179 Photo Courtauld Institute of Art, London — 180 Metropolitan Museum of Art, New York — 181, 182 Photo © Francesco Venturi — 183 Photo © Charles Avery — 184 Photo Italian Government Tourist Office — 186 Photo © Francesco Venturi — 187 Photo © Charles Avery — 188 (l), (r) The Royal Collection, Her Majesty Queen Elizabeth II — 189 Kimbell Art Museum, Fort Worth, Texas — 190 Bargello, Florence — 191 Nationalmuseet, Stockholm — 192, 193 Photo © Francesco Venturi — 194-195 Photo © Andrew Fox/ Alamy — 196 Photo by Courtesy of the Boston Atheneum — 197 Photo © Nigel Paterson — 198 By Courtesy of Partridge Fine Art, London — 199 Christie's Images — 200 Photo Erich Lessing/ akg-images — 201 Photo Roger-Viollet — 202 From a collection of plates by Thomas Johnson dedicated to Lord Blakeney, London 1758 (subsequently republished in *One Hundred and Fifty New Designs*, London 1761) — 203 Christie's Images — 204 Photo Hélène Adant, Fonds Hélène Adant - Bibliothèque Kandinsky, Centre Georges Pompidou, Paris — 207 Thames & Hudson collection; photo © Alice Foster

INDEX

Page numbers in *italic* indicate illustrations.